the GREAT

Women CARTOONISTS

by Trina Robbins

Watson-Guptill Publications / New York

First published in 2001 by
Watson-Guptill Publications
770 Broadway
New York, New York 10003
www.watsonguptill.com

Senior Acquisitions Editor: Candace Raney
Editor: Audrey Walen
Production Manager: Ellen Greene

Cover and interior design by pink design, inc. (www.pinkdesigninc.com)

Library of Congress Cataloging-in-Publication Data

Robbins, Trina.
 The great women cartoonists / Trina Robbins.
 p. cm.
 Includes index.
 ISBN 0-8230-2170-X
 1. Women cartoonists--United States--Biography. I. Title

PN6725. R585 2001
741.5'082'0973--dc21
[B]

2001026655

Manufactured in the United States
First printing, 2001
1 2 3 4 5 6 7 8 9 / 09 08 07 06 05 04 03 02 01

Acknowledgments

This book would be a slim volume indeed if not for the following people (in no particular order): Bill Blackbeard, Gary Arlington, Carol Hudzietz Woo, Sally C.B. Lee, Donald Goldsamt, Steve Thompson, Richard Howell, Christine and Nobby Wiley, Ilza Carvalho, Lucy Caswell and Amy McRory of Ohio State University, Jay Kennedy, Steve Bissette, Allan Holtz, Sy Schechter, Don Kurtz, Alan Harvey, Jim Vadeboncoeur, Michael Norwitz.

Contents:

Explanations

As the title of this book suggests, this book is about women cartoonists, and only women cartoonists. Women writers are only mentioned when they've worked with a woman cartoonist. If my dear friends who are writers can understand and forgive, so can the readers.

In order to keep this book from becoming a lifetime task (which it is anyway), it was necessary to limit it to women who drew comics, and also to define comics as differing from say, single panel cartoons. My definition: It's a comic if it includes even one of the following — two or more panels, continuity, or speech balloons inside the panel. In the case of some early comics, the speech was not yet enclosed in the balloons, but took the form of a line going from words to the character speaking them. In these cases, I stretched my definition a little.

Finally, I am all too aware that the situation of which I write in the last chapter affects independently published and self-published men as well as women, and they have my sympathy and empathy. Someone needs to write a book about them.

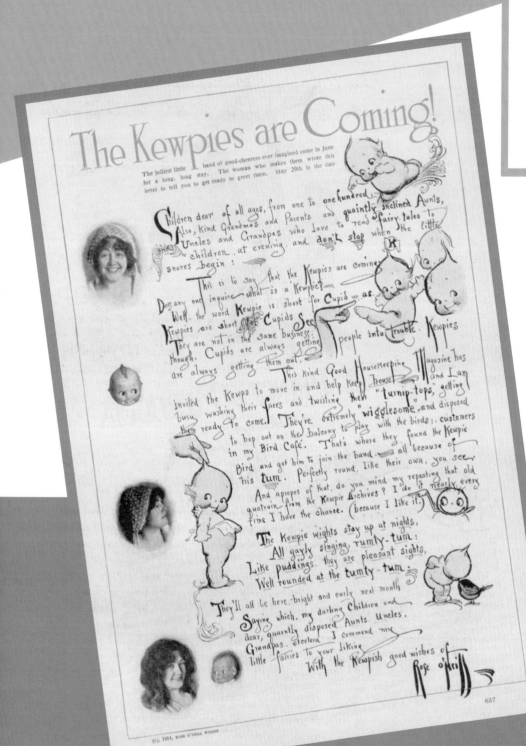

Part One

The Queens of Cute

In 1881, an 18-year-old Montanan named Fanny Y. Cory was attending the Metropolitan School of Fine Arts in New York City, living with her brother, his wife, and her invalid sister. Cory's mother had died of tuberculosis when she was 10. Money was tight, and though Cory was a top student, she didn't stay in school long. Wanting to contribute to the family's income, the young art student took portfolio in hand and approached **Harper's Magazine**.

In her memoirs, hand-written almost three-quarters of a century later on small sheets of lined paper, the artist recalled:

"I was walking fast through the Bowery (a downtown district in New York that had a rather bad reputation). I had my portfolio of pictures under my arm, determined to attempt selling some to Harper's, which was the last of the big publishing houses left down there, the others having gone uptown some years before. I reached the old building — gloomy looking and forbidding. Entering, I found no elevator so started up the iron stairs so old the steps were worn down the middle.

"I trudged up and up — could look down over the railway into the entrance room below — people coming and going — at last on the third floor I found the 'art editors' room — pushed open the door — a young man at the desk greeted me condescendingly. I said I would like to sell some pictures — he took them and dealt them out like a pack of cards giving them scant attention — asked a question or two — then bundled them back together and handing them back said — 'We seldom take beginners' work. If you work hard you may in time hope to place your work here — I advise you to come again when that reputation is made.' I left, mad as hops."

In 1895, a young illustrator named Rose O'Neill was living with the Sisters of St. Regis at their New York convent, selling illustrations to a host of books and magazines and visiting editors accompanied by a nun. Seven years earlier she had won an art contest sponsored by an

WOMAN'S HOME COMPANION announces the KEWPIES, 1910.

Omaha newspaper with a drawing titled **Temptation Leading to an Abyss**. When the judges saw that a 13-year-old girl had won the prize, they made her sit down and produce a drawing on the spot, to prove she was the artist. Two years later she sold her first illustration to **TRUTH** magazine, and at 15 began a career that would span half a century, and bring her world fame.

TRUTH magazine seems to have specialized in hiring beginners. At the same time Rose O'Neill was living in a convent, 18-year-old Grace Gebbie sold the magazine her second professional work, a cover drawing of a girl and her cat. The previous year she had drawn placecards of cupids and pretty women, selling them for $2.50 per dozen.

In that year, 1895, if any of the three young artists had opened up Joseph Pulitzer's **New York World** newspaper, they would have seen a full-page, color cartoon called **Down in Hogan's Alley**, starring a peculiar bald kid in a blue nightshirt. Seven months later, printers experimenting with a new quick-drying yellow ink arbitrarily decided to color the boy's shirt bright yellow. Thus was born what is generally regarded as the first comic strip, R.F. Outcault's **The Yellow Kid**.

By the time **The Kid** was 6 years old, comic strips by women had begun to appear on the Sunday pages of

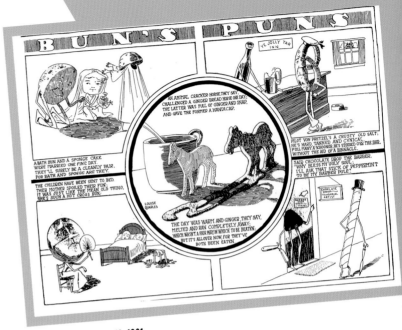

Louise Quarls, BUN'S PUNS, 1901.

"Americans Are Funny Children and New York is Pastoral, Says Rose Cecil O'Neill."

America's newspapers. In 1901, Louise Quarles' **Bun's Puns** and Grace Kasson's **Tin Tan Tales for Children** were appearing in the **New York Herald**, and Agnes Repplier III's **The PhilaBusters** ran in the **Philadelphia Press**. By that time, Rose O'Neill had divorced her first husband, Gray Latham. A year later, she would marry again, this time to writer Harry Leon Wilson. Their marriage proved productive, with O'Neill illustrating her husband's books and writing her own first novel, **The Loves of Edwy**, in 1903. However, by 1908, the couple had parted company, and the following year saw the birth of the creatures that were to give O'Neill immortality — the Kewpies.

According to O'Neill, these cupid-like creatures came to her in a dream. Kewpies appeared from 1909 in the

Ladies Home Journal, **Woman's Home Companion**, and **Good Housekeeping**, in the form of one-to-three-page stories usually accompanied by verse, a form many of the early comics used. O'Neill's creations sold a multitude of goods, and, like her contemporary, Nell Brinkley, her opinions were considered important enough to warrant newspaper headlines.

In her personal and professional life, Rose O'Neill often seemed to be two different people. She dressed and looked like a pre-Raphaelite heroine, yet she was divorced twice in an age when divorce was regarded as a domestic heresy second only to adultery. With her sister, Callista, she held salons at her studio in Greenwich Village attended by most of New York's bohemian crowd; indeed, the song **Rose of Washington Square** was inspired by her.

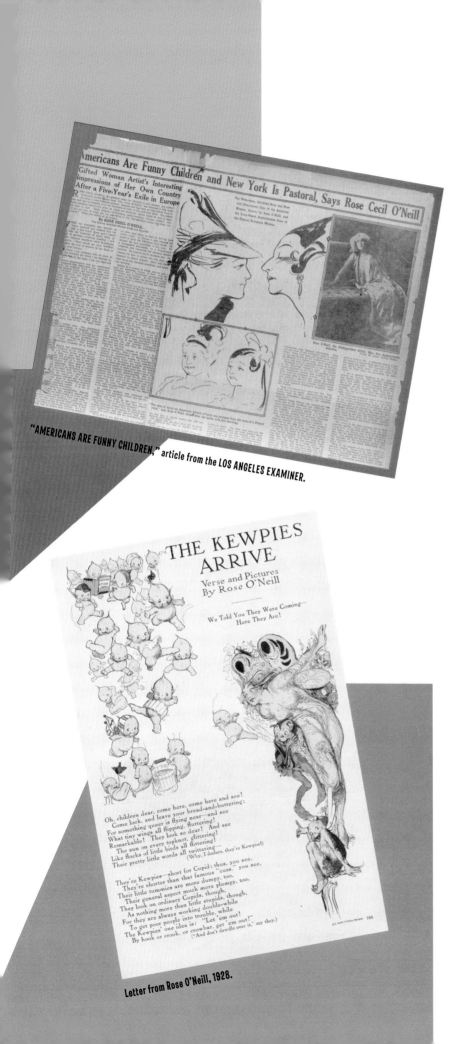

O'Neill was also the creator of a series of drawings that she referred to as "my secret play." This was a more serious experimental work that she kept private; powerful images conjured from dreams and mythology.

In 1921, she took this art to Paris for a one-woman show, where she was hailed by critics as a reincarnation of the nineteenth-century romantic illustrator Gustave Doré. Along with other souvenirs of the visit, she appears to have brought back a French lover, World War I army officer Jean Gallenne. Journalist Virginia Lynch Maxwell, covering O'Neill's return for the Hearst papers, assumed the couple was married. In the piece entitled "How Cupid Brought the Kewpies Their Ideal Stepfather," Maxwell refused to take seriously O'Neill's somewhat flustered denial:

> **"When the news of her third marriage leaked out, Miss ONeill denied it with a pretty shake of her curly head.**
>
> **'It isn't so,' she laughed, 'I'm still Miss ONeill.'**
>
> **"Which, of course, proved nothing, since all the feminine artists of the Village cling to the tradition of their code and flatly refuse to use the prefix 'Mrs.,' preferring to retain their maiden names."**

O'Neill spent five years in Paris. Upon her return to America, the **Los Angeles Examiner** published an article headlined, "Americans Are Funny Children and New York is Pastoral, Says Rose Cecil O'Neill." In the article, O'Neill, who was called "The Famous American Woman Artist and Novelist," opined:

> **"I amuse myself with the idea that my kewpies are a symbol of the American spirit. I have tried to put into the little fellows, and make them show forth, the national naivetè, jocularity, amiability, adventure, philosophy, and benevolence."**

Today, almost a century later, original O'Neill Kewpies sell to collectors for hundreds of dollars, and there still exists an organized Kewpie fandom who meet yearly at "Kewpiestas."

Notably, even before the Kewpies, O'Neill had specialized in producing an artistic combination of adorable children and sentimental verse, making her an

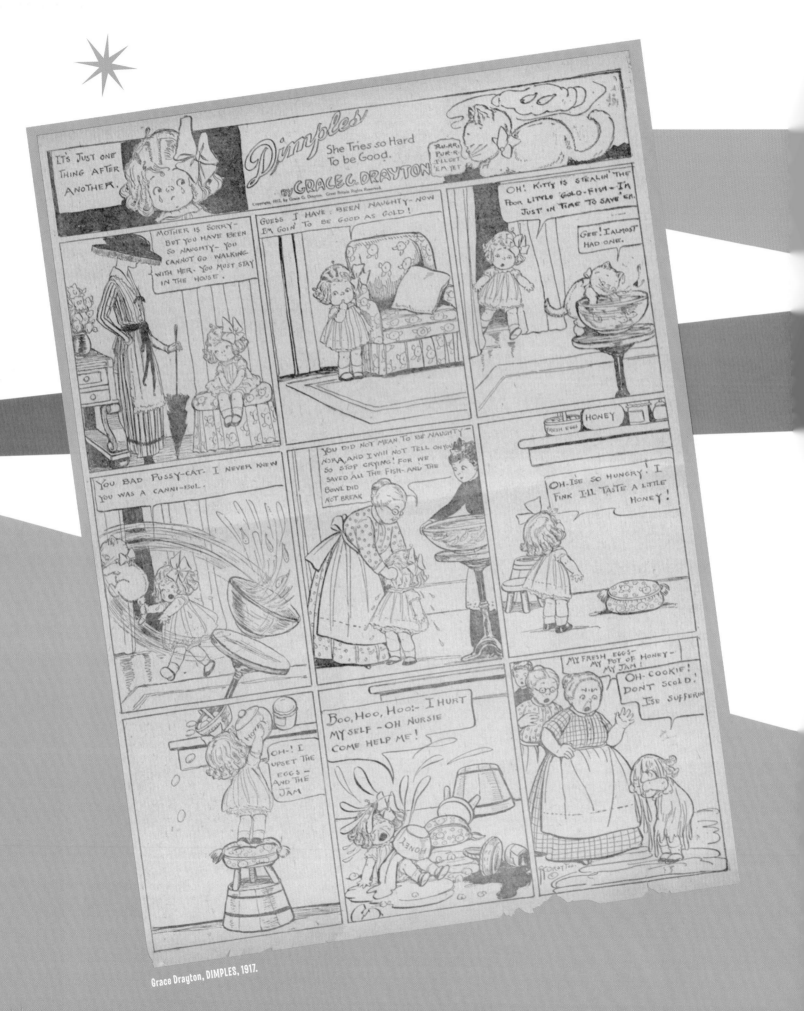

Grace Drayton, DIMPLES, 1917.

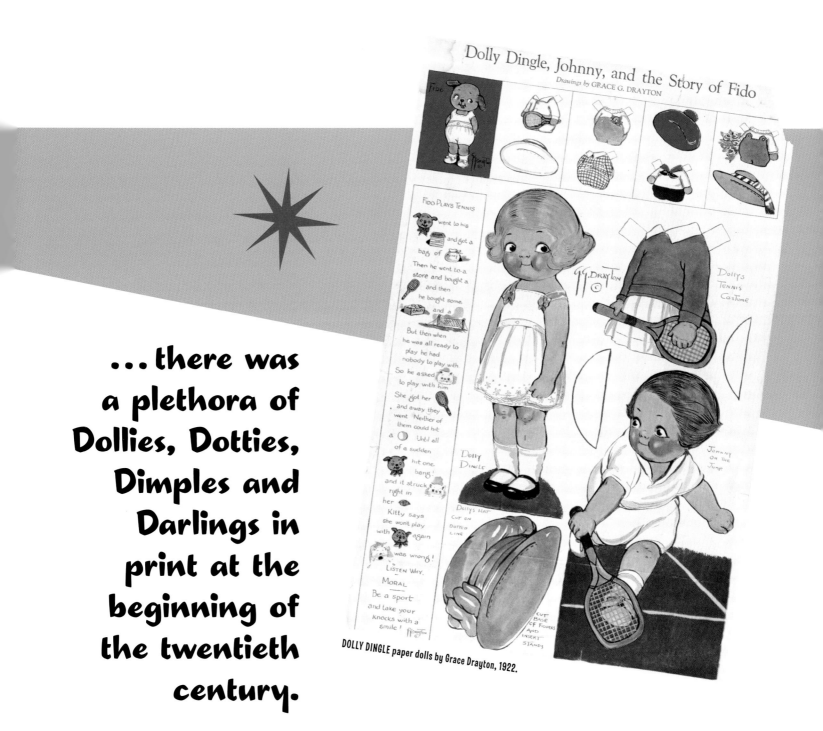

Dolly Dingle, Johnny, and the Story of Fido
Drawings by GRACE G. DRAYTON

FIDO PLAYS TENNIS

DOLLY DINGLE paper dolls by Grace Drayton, 1922.

...there was a plethora of Dollies, Dotties, Dimples and Darlings in print at the beginning of the twentieth century.

outstanding contender for the title "Queen of Cute." Tiny drawings of Kewpies can be found scattered through her personal letters, and her habit of speaking in baby talk is said to have so annoyed her second husband that it contributed to their divorce.

The uncontested Queen of Cute, Grace Gebbie, began producing **Toodles**, her first strip, under her married name of Grace Weidersheim. It set the style for over thirty years of comics by Grace, who after her second marriage became known as Grace Drayton. Though the names of her comic strips changed through the years, essentially the same cherubic, apple-cheeked children toddled through her comic pages under such titles as

The Strange Adventures of Pussy Pumpkin and her Chum Toodles, **Dolly Drake and Bobby Blake**, **The Turr'ble Tales of Kaptin Kiddo**, **Dolly Dingle**, **Dolly Dimples and Bobbie Bounce**, and **Dottie Darling**. Regarding the last three characters (which also ran as paper-doll pages in various magazines), it should be noted that there was a plethora of Dollies, Dotties, Dimples and Darlings in print at the beginning of the twentieth century. O'Neill was producing a page for the **Woman's Home Companion** called **Dottie Darling**, Jean Mohr produced a comic strip for the Pulitzer newspapers called **Dolly Dimple**, and in 1913, a male cartoonist named Van Beekman was producing yet another **Dolly Dimple** strip, this one featuring a little girl with a

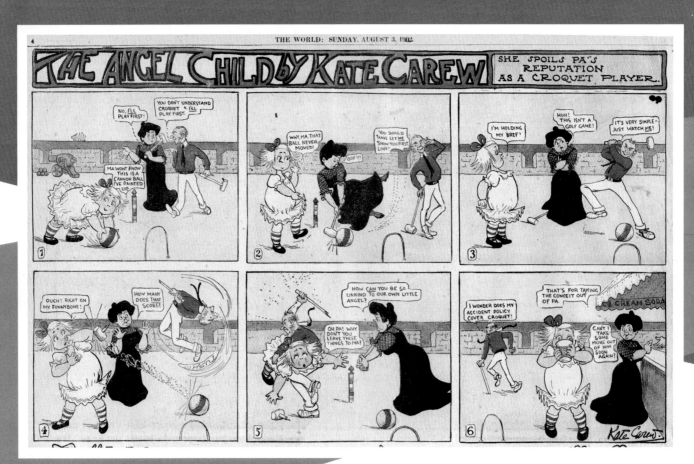

Kate Carew, THE ANGEL CHILD, 1902.

"Strangely enough, among all the artists and cartoonists, Kate Carew is the only exponent of the funny side of life."

suffragette doll. (To add to the confusion, in the 1920s there was a comic called **Dashing Dot**, drawn by Marge Henderson Buell, who later created **Little Lulu**.)

Jean Mohr, one of the **Dolly Dimple** artists, started in 1902 with an unsettling strip called **Sallie Slick and her Surprising Aunt Amelia**, the story of a pretty girl and her aunt from hell. The **Sallie Slick** strips were a departure from virtually every other early comic by women (and a great many by men) which always featured cute children, either devilish or angelic, and often speaking baby talk.

Mohr's other strip, **Easy Edgar**, which ran above **Sallie Slick** in the **Philadelphia North American** in 1903, was a more traditional kid strip, although still a bit grotesque, at least by today's standards. The title character, Edgar, in the style of the day, is clad in skirts and petticoats, and modern readers might assume he was a girl.

Another early strip was Kate Carew's **The Angel Child**, a comic about the ubiquitous baby-talking little girl in maryjanes, who gets into fresh trouble each day. (This strip is not to be confused with **Momma's Angel Child**, 1908–1920, by Penny Ross, which, despite the name, was

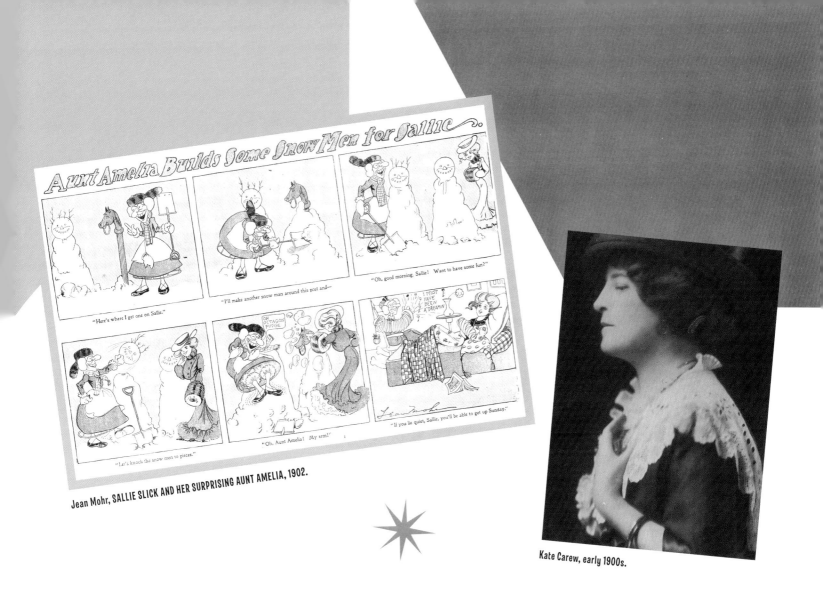

Jean Mohr, SALLIE SLICK AND HER SURPRISING AUNT AMELIA, 1902.

Kate Carew, early 1900s.

by a man.) Kate Carew was the pseudonym of Mary Williams Chambers Reed, older sister of **New Yorker** cartoonist Gluyas Williams. In 1889, at the age of 20, Carew had started working at the **San Francisco Examiner** as one of seventeen staff illustrators. By 1900, she had married journalist Harrie Kellett Chambers and was living in New York City's Greenwich Village. That fall, she started drawing caricatures of famous personalities, from Sarah Bernhardt to Mark Twain, for the **New York World**. She was billed as "The Only Woman Caricaturist." In 1902, when **The Angel Child** debuted, there were so few women drawing comics that **The Bookman**, a magazine of that period, can be forgiven for writing about her, "Strangely enough, among all the artists and cartoonists, Kate Carew is the only exponent of the funny side of life." By 1911, Carew was writing and illustrating a page of political commentary and satire for the **New York American**. One of her pages, "The Sacred Right of Franchise for Women = Rubbish!" pokes gentle fun at the anti-suffrage movement, telling of a fictitious interview with "Mrs. Gilbert E. Jones," the society lady leader of an anti-suffrage league. She writes:

> "... the point is that so long as no woman is allowed to vote there is no danger of Mrs. Gilbert E. Jones's being compelled to vote against her will — she being a woman, although a lady. The league embraces the cream of the ladies who desire not to vote and the cream of the gentlemen who desire not to let them vote, so it's a very harmonious affair."

Carew lived a bohemian lifestyle, traveled extensively throughout Europe, and lived in England for many years. She was married three times, including to a playwright and a British Lord. By the late 1920s, Carew's health and eyesight were failing, and she retired to the artists' community of Monterey, California, where she produced fine art until her death at the age of 91.

"IT'S FROM MY FATHER'S SPEECH IT IS."

Miss Laurette Taylor as "Peg" in that immortal comedy, "Peg o' My Heart," now at the Globe.

Early caricature by Kate Carew.

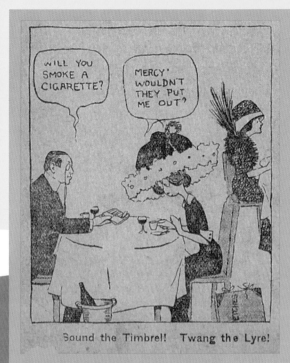

WILL YOU SMOKE A CIGARETTE?

MERCY! WOULDN'T THEY PUT ME OUT?

Sound the Timbrel! Twang the Lyre!

Kate Carew becomes "emancipated" by lighting up in public, from the LOS ANGELES EXAMINER, 1911.

In 1902, at the age of 16, Marjorie Organ became the only woman on the art staff of the **New York Journal**, for which she created a number of strips, including **Reggie and the Heavenly Twins**, **The Wrangle Sisters**, and **Strange What a Difference a Mere Man Makes**. Poor short Reggie, the protagonist of the first strip, was forever trying to win the affections of the two beautiful sisters in the title, only to have them stolen away in the last panel by two equally divine-looking men. The **Mere Man** strip, though beautifully drawn, reflected the direct opposite view to Kate Carew's feminism.

Many of the early women cartoonists besides Kate Carew seem to have been feminists. Rose O'Neill produced posters and postcards for the suffrage movement in America and England. One of her postcards, titled

Give Mother the Vote: We Need It, depicts a parade of kewpie-esque toddlers bearing signs reading, "Votes for Our Mothers." The verse running beneath the picture reads:

Isn't it a funny thing

That Father cannot see

Why Mother ought to have a vote

On how these things should be?

Edwina Dumm, who would later produce the long-running strip, **Cap Stubbs and Tippie**, drew pro-suffrage cartoons for the **Columbus Daily Monitor** during the 1910s, and

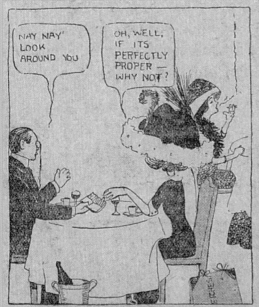
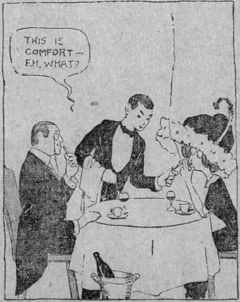
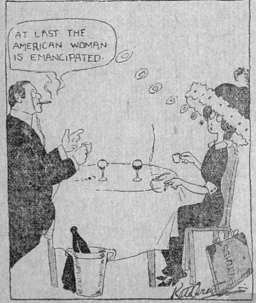

At Last the American Woman Can Woo the Narcotic Weed as Her European Sister—and Behold! Your Aunt Kate Has Proved It.

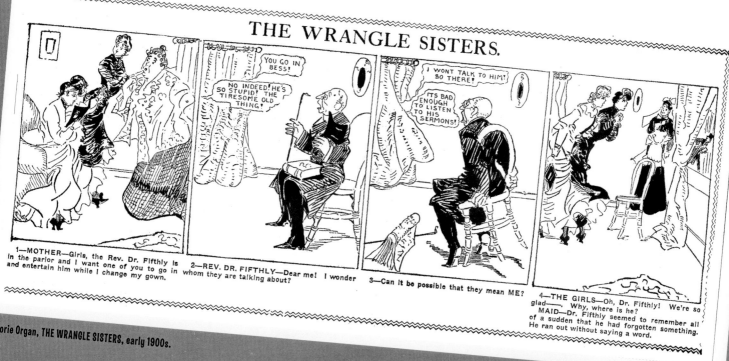

Marjorie Organ, THE WRANGLE SISTERS, early 1900s.

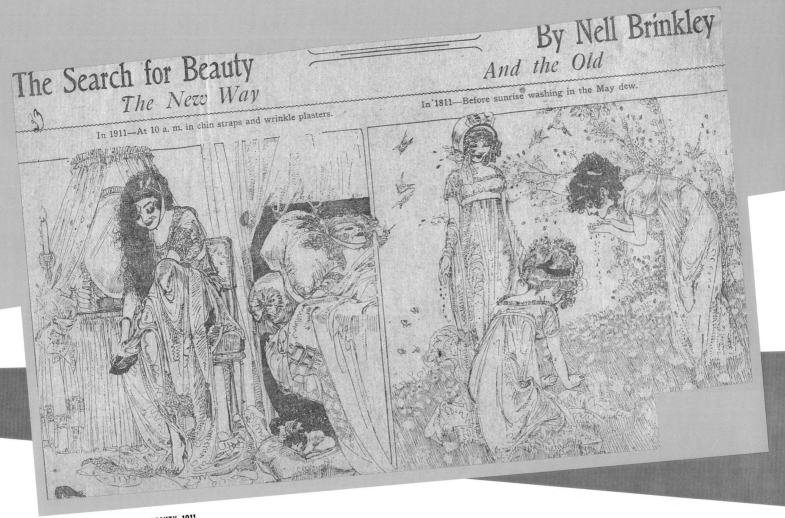

The Search for Beauty

The New Way

In 1911—At 10 a. m. in chin straps and wrinkle plasters.

By Nell Brinkley

And the Old

In 1811—Before sunrise washing in the May dew.

Nell Brinkley, THE SEARCH FOR BEAUTY, 1911.

"Any man who loves and reveres his mother and his country should idolize, if he worships at all, the three graces, Suffrage, Preparedness, and Americanism."

Nell Brinkley, superstar cartoonist of the 1910s and 1920s, returned over and over again in her syndicated daily newspaper panels to the subject of women working and getting the vote.

In 1916, America would not be entering World War I for another year, but Brinkley was already drawing patriotic cartoons, to which she added a feminist element. One of these drawings depicted three of the typically beautiful women for which Brinkley was famous, one dressed as the goddess Liberty, one in uniform, and the third wrapped in a banner that said, "Suffrage." The copy running beneath this picture read, "Any man who loves and reveres his mother and his country should idolize, if he worships at all, the three graces, Suffrage, Preparedness, and Americanism."

As a 16-year-old student in 1902, Nell Brinkley had shown her portfolio to the editor of the **Denver Post** and was hired as an illustrator for $7 a week. Within a year, she had moved to the **Denver Times**, and four years later she came to New York to work for Hearst at his **Evening Journal**. By 1908, she was illustrating the Harry K. Thaw murder trial. Thaw stood accused of killing famed architect Stanford White over the affections of beautiful Evelyn Nesbitt, Thaw's wife and White's ex-lover. Nesbitt, an ex-Floradora Girl who had modeled for Charles Dana Gibson, was a perfect candidate for Brinkley's pen, and the artist drew her over and over again. The glamorous "Brinkley Girls," with their floating masses of curls, ruffles, and laces,

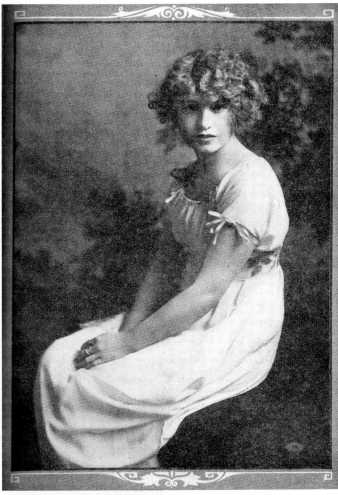

Nell Brinkley, from THE CARTOONIST, 1917.

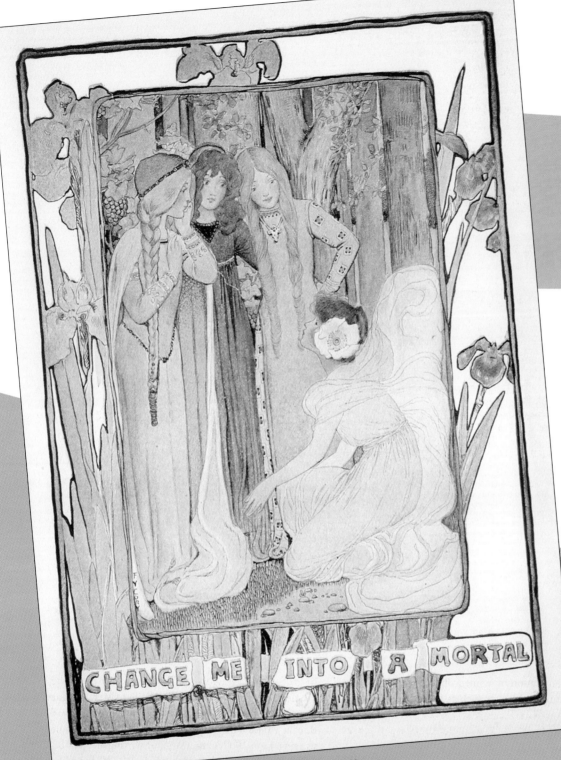

Fanny Y. Cory, illustration for THE ENCHANTED ISLAND OF YEW, by L. Frank Baum, 1903.

Fanny Y. Cory, early 1900s.

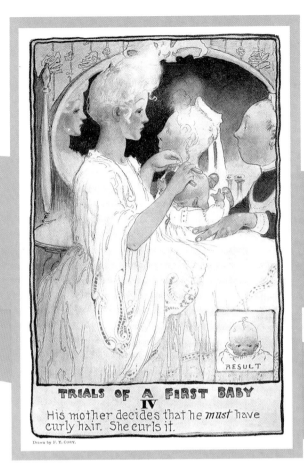

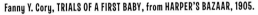

Fanny Y. Cory, TRIALS OF A FIRST BABY, from HARPER'S BAZAAR, 1905.

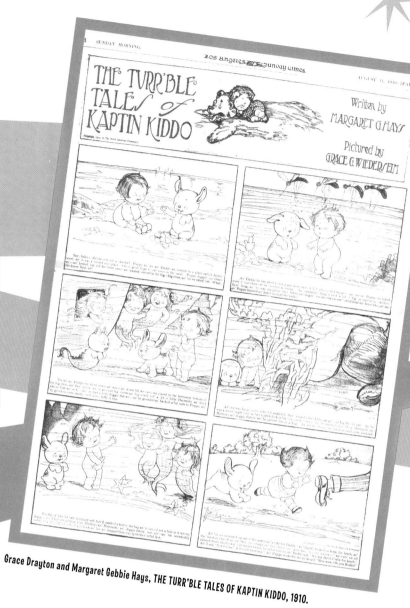

Grace Drayton and Margaret Gebbie Hays, THE TURR'BLE TALES OF KAPTIN KIDDO, 1910.

would thrill a generation of women throughout the 1920s and inspire future cartoonists such as Phyllis Muchow, Valerie Barclay, Hilda Terry, Marty Links, Selby Kelly, and especially Dale Messick, who created **Brenda Starr** in 1941.

In 1902, Fanny Y. Cory, by then a succcessful illustrator, moved back to Montana. Two years later she married childhood friend Fred Cooney and settled at his ranch near the tiny community of Canyon Ferry. Living in what was still the Wild West, she continued to work, illustrating six books between 1905 and 1913. Cooney would take her packaged art on horseback to the post office. Gradually, however, Cory's art became secondary to raising a family, and it wasn't until the 1920s that she returned to her art, this time in the form of comics.

In 1905, Grace Drayton, still working under the name Weiderseim, drew a strip written by her sister, Margaret Gebbie Hays, **The Adventures of Dolly Drake and Bobby Blake in Storyland**. She would work with her sister again in 1909, with Margaret writing and Grace drawing **The Turr'ble Tales of Kaptin Kiddo**. The sisters also collaborated for publications such as **Youth's Companion**, where Grace would illustrate short poems by Margaret. In the same year, between the numerous comics, magazine illustrations, paper dolls, and children's books she was turning out, Grace Drayton somehow found the time to create the Campbell Kids. The Campbell Soup Co. could not have asked for a better image, since every cherubic child drawn by Drayton looked like the Campbell Kids. (Neither O'Neill nor Cory is likely to have resented Drayton's prize account, since O'Neill was at

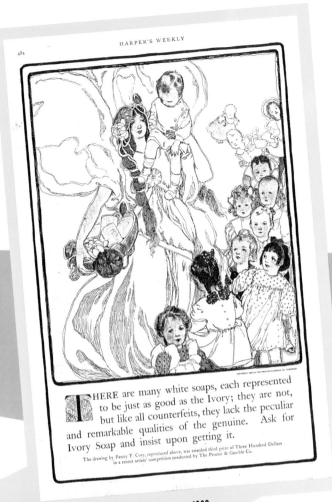

THERE are many white soaps, each represented to be just as good as the Ivory; they are not, but like all counterfeits, they lack the peculiar and remarkable qualities of the genuine. Ask for Ivory Soap and insist upon getting it.

The drawing by Fanny Y. Cory, reproduced above, was awarded third prize of Three Hundred Dollars in a recent artists' competition conducted by The Procter & Gamble Co.

Fanny Y. Cory, advertisement for Ivory Soap, 1902.

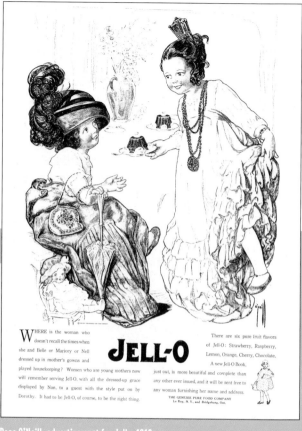

WHERE is the woman who doesn't recall the times when she and Belle or Mariory or Nell dressed up in mother's gowns and played housekeeping? Women who are young mothers now will remember serving Jell-O, with all the dressed-up grace displayed by Nan, to a guest with the style put on by Dorothy. It had to be Jell-O, of course, to be the right thing.

There are six pure fruit flavors of Jell-O: Strawberry, Raspberry, Lemon, Orange, Cherry, Chocolate. A new Jell-O Book, just out, is more beautiful and complete than any other ever issued, and it will be sent free to any woman furnishing her name and address.

THE GENESEE PURE FOOD COMPANY
Le Roy, N. Y., and Bridgeburg, Ont.

Rose O'Neill, advertisement for Jello, 1910.

A popular convention was drawing children in fashions of the previous century.

that time drawing all the Jello ads and Cory was working for Ivory Soap.)

Margaret Gebbie Hays attempted a strip of her own in 1908, both writing and drawing **Jennie and Jack, also the Little Dog Jap**. The influence of her sister's style is evident. Although Jennie and Jack is no worse than many of the mediocre strips that ran at the time, it's obvious that Margaret did not possess her sister's artistic talent.

A popular convention was drawing children in fashions of the previous century. Illustrations of this sort can be found in old Mother Goose books and children's books by Johnny

Gruelle and others. Inez Townsend used the style when she drew **Gretchen Gratz** in 1904 and 1905, and later in 1913 when, now signing her work Inez Tribit, she produced **Snooks and Snicks, the Mischievous Twins**. The stories follow a familiar pattern: Adorable children getting into trouble.

Another strip that featured old-fashioned children was Mary A. Hays's **Kate and Karl, the Cranford Kids**, from 1911 and 1912. The use of the name Cranford is an in-joke. Fred Crane, editor of the **Philadelphia North American's** comic syndicate, published Mary Hays as well as Jean Mohr, Inez Tribit, Grace Drayton, and Katherine

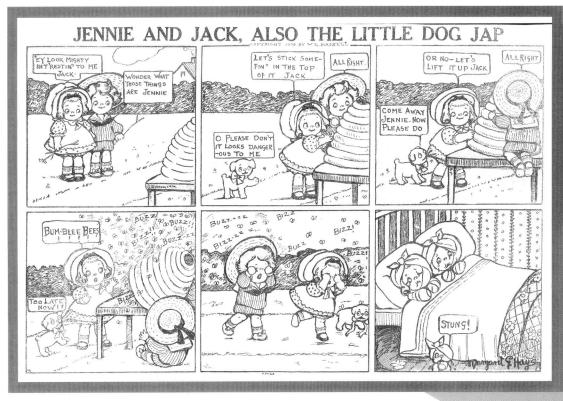

Margaret Gebbie Hays, JENNIE AND JACK, ALSO THE LITTLE DOG JAP, 1908.

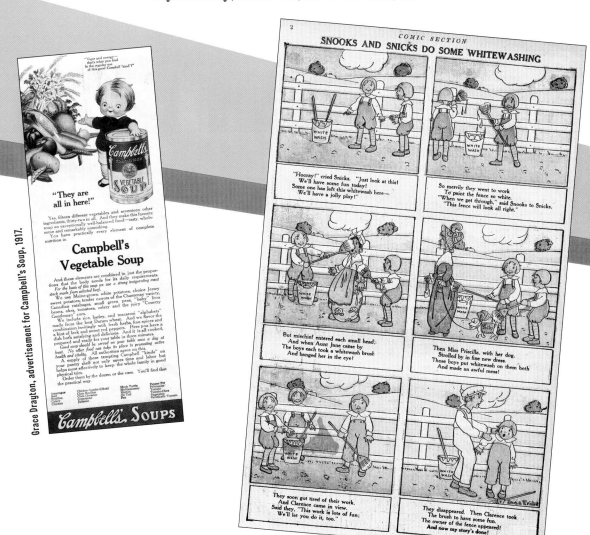

Inez Tribit, SNOOKS AND SNICKS, THE MISCHIEVOUS TWINS, 1913.

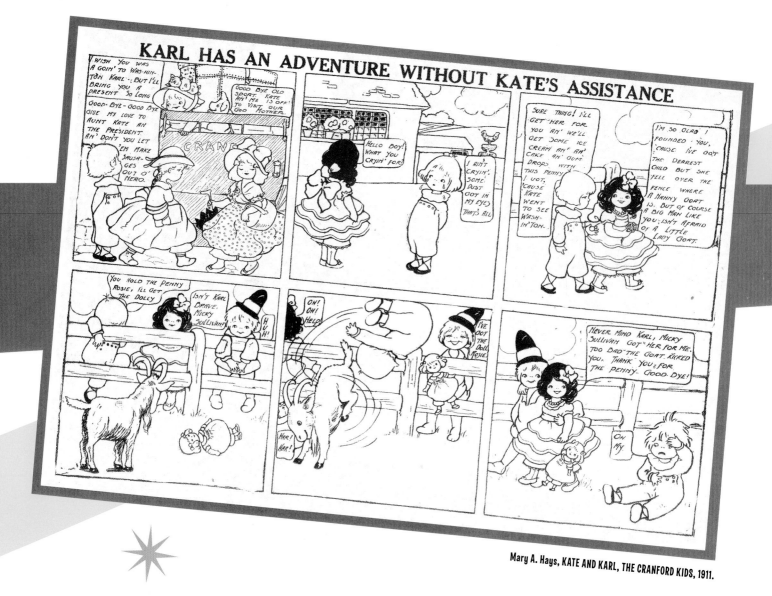

Mary A. Hays, KATE AND KARL, THE CRANFORD KIDS, 1911.

Price (who drew **Flora Flirt**). Crane, who probably printed more women cartoonists than anyone else, came from Cranford, New Jersey, a town founded in colonial days by his ancestors.

When looking at Mary A. Hays's comics, one is struck by the art's resemblance to Grace Drayton's style, a resemblance that provoked at least one collector to speculate that Mary A. Hays and Margaret Gebbie Hays were one and the same person. However, in a bit of sleuthing worthy of V.I. Warshawsky, Lorraine Burdick, in her 1974 publication, **Celebrity Doll Journal**, determined the connection. On a paper-doll page drawn by Grace Drayton in 1928 for **Woman's World**, Drayton had written, "Dear Children, I have a little grandniece Peggy Anne Huber. She is also my godchild." Then Burdick found a 1919 **Delineator** page containing a Mary A. Hays comic, but signed Mary Hays Huber.

Burdick writes, "Back-tracking from grandniece Peggy Anne Huber leads to niece Mary Hays Huber; Mary A. Hays leads to sister Margaret Gebbie Hays. This means that Margaret must have been some five to ten years older than Grace for Mary to be old enough to be drawing well in 1911 (the earliest known artwork by Mary A. Hays)."

Burdick also points out a page of Drayton's paper dolls from the year that Mary A. Hays changed her name to Huber, in which Dolly Dingle is a flower girl at her aunt's wedding, "perhaps a carry-over from real life."

Until someone else comes up with evidence to refute Lorraine Burdick's conclusions, I think it can be assumed that Grace Gebbie Drayton, Margaret Gebbie Hays, and Mary A. Hays represent two generations of women cartoonists — a case of sisterhood being powerful.

FLORA FLIRTS WITH A CHARMING SANTA CLAUS

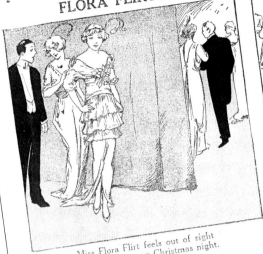

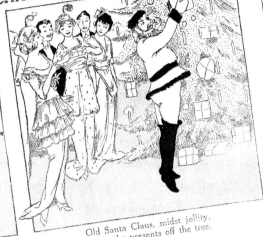

Miss Flora Flirt feels out of sight
At a party gay on Christmas night.

Old Santa Claus, midst jollity,
Takes the presents off the tree.

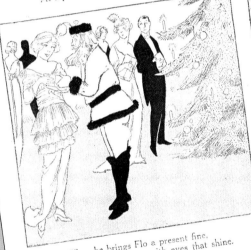

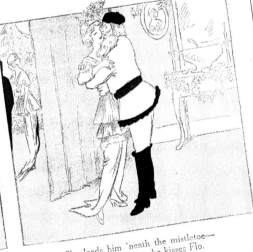

When he brings Flo a present fine,
She flirts with him with eyes that shine.

She leads him 'neath the mistletoe—
And then, of course, he kisses Flo.

By the punchbowl their action's 'most a "scandal'—
But he leans too close to a lighted candle.

Poor Flora shrieks—his beard's aflame,
Which spoils their little flirting game.
The Moral—On Christmas, 'neath the mistletoe
Is the "safest" place to keep a beau.

Katherine Price, FLORA FLIRT, 1913.

Nell Brinkley in 1925.

MOTION

PICTURE

SECTION

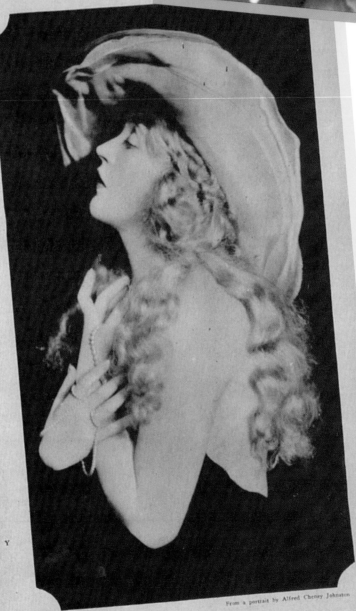

MAY MURRAY

The radiant Nell Brinkley girl of the "Follies" who afterwards danced to success in other stage productions, is now a popular and beauteous star of the screen. A film actress of ability, she has caught the public fancy in the George Fitzmaurice productions of the Paramount-Artcraft Pictures "On With the Dance," "The Right to Love" and "Idols of Clay"

From a portrait by Alfred Cheney Johnston

Mae Murray, "THE RADIANT NELL BRINKLEY GIRL OF THE 'FOLLIES.'" From THEATER MAGAZINE, 1920.

Part Two

The Pursuit of Flappiness

At the 1992 opening of a women cartoonists show at the San Francisco Cartoon Art Museum, attendees watched in awe as guest of honor Dale Messick, creator of **Brenda Starr**, strolled through the exhibit. The 86-year-old dean of women cartoonists paused before a page by Nell Brinkley, and her eyes shone like the starry orbs of her creation as she studied the delicate pen work on the ruffles, lace, and windblown hair of the elegantly drawn "Brinkley Girl." Brinkley had been Messick's greatest influence.

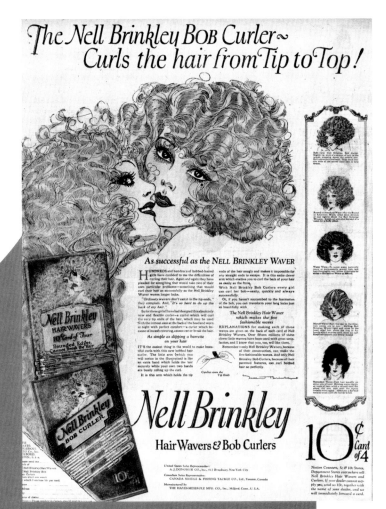

Advertisement for Nell Brinkley Bob Curlers, 1924.

If one person can be said to have set the style for the majority of women cartoonists during the 1920s, that person was Nell Brinkley. As early as 1908, the glamorous creatures she created were inspiring controversy and fan mail. After a critical letter asking, "Is there any good reason why a woman's head should be portrayed as weather-beaten moss instead of human hair?" the **Los Angeles Examiner** felt compelled to defend their young star artist by stating that Brinkley herself possessed the kind of hair she drew. "Miss Brinkley pictures chiefly hair, which a reader sacreligeously calls 'moss,' and Miss Brinkley, curiously enough, at the first superficial glance, is chiefly hair — certainly she wears not less than a bushel of the very lightest, curliest kind." The article went on to compare her art to Raphael, Michaelangelo, Boucher, Titian, Botticelli, and Da Vinci.

Another issue of the **Examiner** printed tributes to the Brinkley Girl from readers, some of whom were moved to verse. W.L. Larned wrote:

> **The sweetest, neatest, fleetest maid — the leader in her class, Give me the stylish, smilish, wilish, dashing Brinkley Lass.**

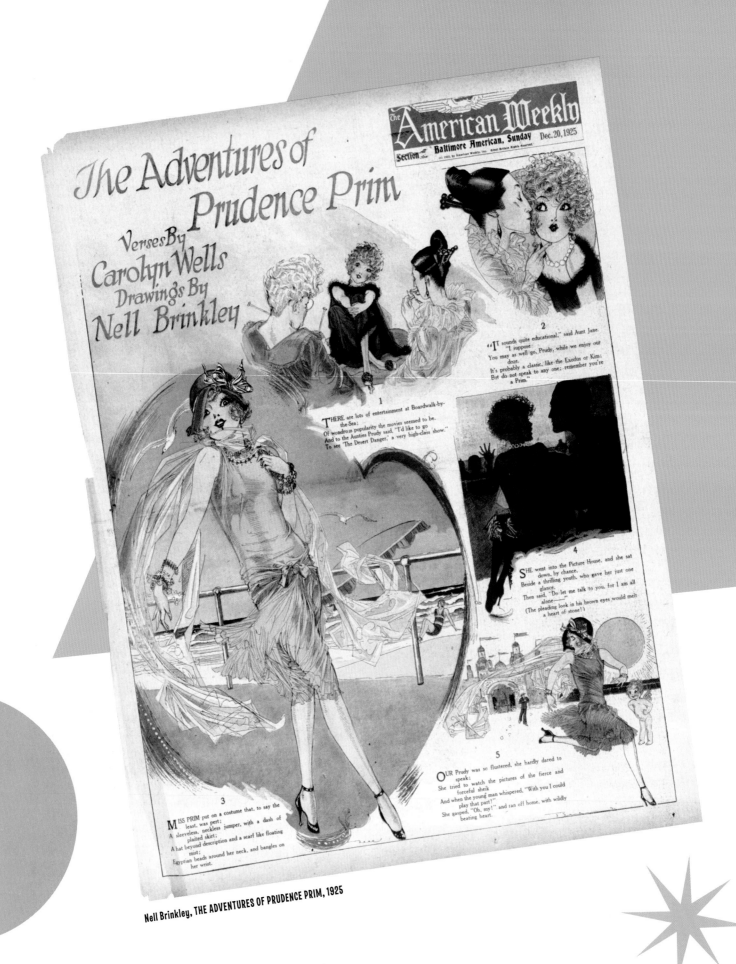

Nell Brinkley, THE ADVENTURES OF PRUDENCE PRIM, 1925

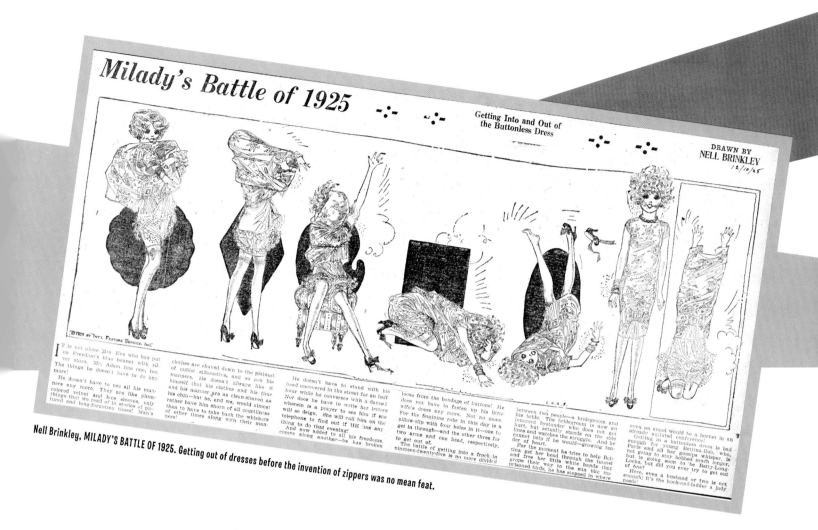

Nell Brinkley, MILADY'S BATTLE OF 1925. Getting out of dresses before the invention of zippers was no mean feat.

Despite the romanticism of her work, Brinkley was a feminist.

Another poet who signed herself "A Young Woman Who Admires Her Work," wrote:

You are spritely and you're tinkley,
You seem just on the Brink-ley
Of putting all the others in the shade;
So blessings on you, girlie,
With the pen so whirley-twirley,
May your newspaper shadow never fade!

Florenz Ziegfeld, the showman who made his fortune "glorifying the American girl" on stage, featured in his Follies a Brinkley Girl, one of whom was the future silent film star May Murray. At least two songs dedicated to Brinkley and her creations came out of the Ziegfeld Follies, and George M. Cohan also wrote a song about her. And by the 1920s, female Brinkley fans who aspired to the clouds of curls worn by the heroines of such strips as **The Fortunes of Flossie**, **Romances of Gloriette**, or **The Adventures of Prudence Prim**, could choose between Nell Brinkley Hair Wavers or The New Nell Brinkley Bob Curler, at nine cents per card.

Despite the romanticism of her work, Brinkley was a feminist. Although she is chiefly remembered and was probably most loved for her Art Nouveau depictions of exquisite women, handsome men, and cupids, her daily panels also provided commentary on women of her times. For about every twenty drawings of long-lashed curly-headed Brinkley Girls, the artist would manage to squeeze in one important comment on working women, suffrage, and — her favorite subject — women in sports.

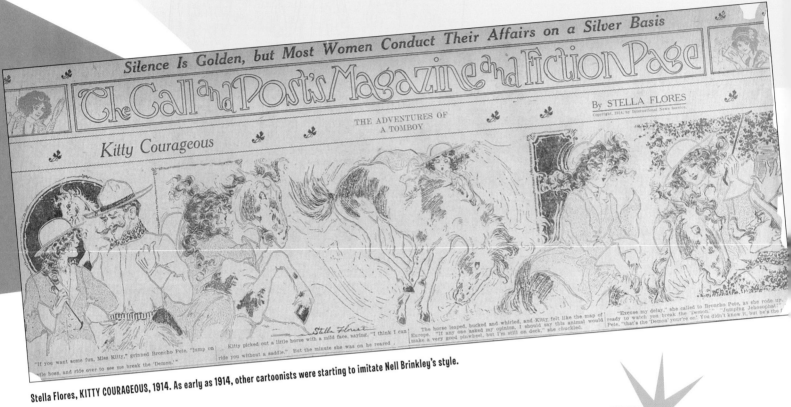

Silence Is Golden, but Most Women Conduct Their Affairs on a Silver Basis

The Call and Post's Magazine and Fiction Page

By STELLA FLORES
Copyright, 1914, by International News Service.

Kitty Courageous

THE ADVENTURES OF
A TOMBOY

Stella Flores, KITTY COURAGEOUS, 1914. As early as 1914, other cartoonists were starting to imitate Nell Brinkley's style.

Brinkley herself appears to have lived comparatively quietly. Unlike Rose O'Neill and Grace Drayton, she had only one husband, although her marriage ended in divorce in 1935. Brinkley continued working well into the 1930s, and although her later style became more simplified, it never lost the characteristic elegance which personified the Brinkley Girl. She retired in 1937, at age 51, although she continued to illustrate books and occasionally draw for magazines.

Coincidentally, both Rose O'Neill and Nell Brinkley died in 1944. An obituary commented on Brinkley's great influence and compared her to O'Neill: "The late Nell Brinkley attracted more amateur copyists than did Charles Dana Gibson. Like Rose O'Neill, who came before her, she was quite an eyeful herself, and was past master as a cheesecake artist."

By the end of the 1920s and well into the 1930s, a score of talented women, following in Brinkley's satin-shod footsteps, were turning out comics featuring chic and clever flappers. Probably the most famous of these was the multi-talented Ethel Hays, creator of comics, single panel cartoons, paper doll books, children's book illustrations, and full-color Sunday pages. The Sunday pages, while similar to and obviously inspired by those of Brinkley, were done in Hays's cleaner, more Art Deco style. In a newspaper interview from 1927, Hays admitted a strong John Held, Jr. influence: "I adore John Held, Jr.... When I was battling with my first drawings in the newspaper office I had to keep his drawings out of sight; his influence was so strong that I was prone to imitate."

Her favorite woman artist, she said, was Nell Brinkley: "Her work is exquisite."

Brought up in Billings, Montana, Ethel Hays studied art at the Los Angeles School of Art and Design and the Art Students League in New York. After the United States entered World War I, she taught art to disabled soldiers at government hospitals in Washington, Colorado, Tennessee, and Ohio, meanwhile taking a correspondence

a real feather in the feminists's cap....

Ethel Hays, from a newspaper article.

Ethel Hays, AIR-MINDED, 1933.

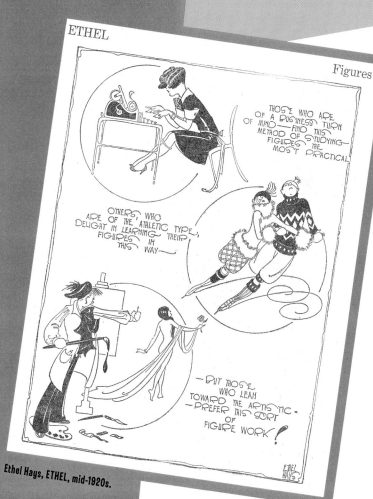

Ethel Hays, ETHEL, mid-1920s.

course in drawing herself. The director of her school showed her work to the editor of the **Cleveland Press**, who immediately called Hays and hired her. A 1928 newspaper article described the artist's drawings for a feature called "Vic and Ethel":

> **"She and a girl reporter did a picture feature every day.... They climbed church steeples and went down in diving suits. They rode speedboats and broke ice in the lake in order to go swimming. Ethel's girl drawings were a city fixture."**

The article went on to describe her as "a real feather in the feminists' cap.... "

Within a year Hays had become a nationally syndicated cartoonist. Her first syndicated strip, aptly named **Ethel**, consisted of satire and social commentary. **Flapper Fanny**, a single-panel cartoon, followed soon after, and by 1928 she was producing Sunday pages.

Ethel Hays, FLAPPER FANNY, mid-1920s.

Gladys Parker.

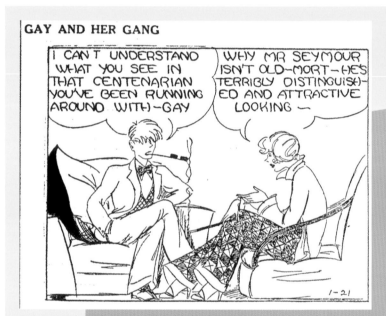

Gladys Parker, GAY AND HER GANG, circa 1925.

Hays had married in 1924 and soon after started a family. By the time she gave birth to her second daughter, the artist's workload had simply become too heavy. Rather than give up her lavishly illustrated Sunday color pages, Hays passed **Flapper Fanny**, her single-panel cartoon, on to Gladys Parker, who had previously drawn a sophisticated flapper strip called **Gay and Her Gang**. The dry wit in **Gay and Her Gang** often reminds the reader of another Parker, the famed writer and wit of the Algonquin Round Table, Dorothy Parker. When a character talks about her rights to "life, liberty, and the pursuit of flappiness," she seems to speak for all the strips of that decade which featured stylish, wise-cracking young women.

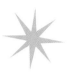

AND PEARLS IN THE OYSTERS — By GLADYS PARKER

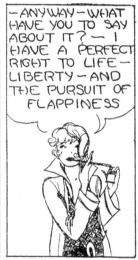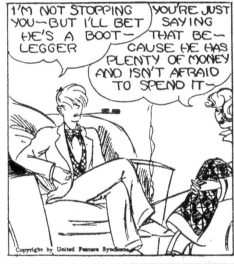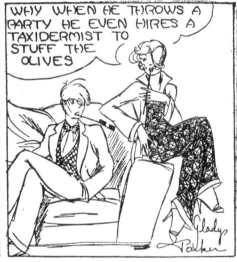

JUST UNCONSCIOUS — By GLADYS PARKER

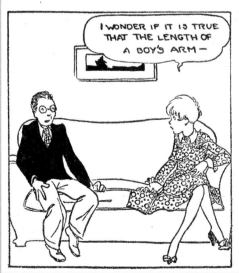

Under Parker, the single-panel strip took on a cartoonier style, and its flapper protagonist grew to closely resemble her artist, one of several cases where a woman drew herself as the heroine of her own strip. During this time, Parker was also drawing a series of comic strip ads for Lux soap.

By the late 1930s, Parker had moved to another syndicate, where she created the long-lasting character, Mopsy. **Flapper Fanny** was taken over by Sylvia Sneidman, who signed her work only with her first name, Sylvia. Sylvia added a kid sister to the panel and continued it into the 1940s. Meanwhile, Hays, who obviously couldn't stop, drew one last flapper strip in 1936, **Marianne**.

Virginia Krausmann drew the strip after Hays left, copying Hays's style at first, but soon giving it a more detailed, though still stylishly Deco look. Hays went on to a long career illustrating children's books and paper dolls.

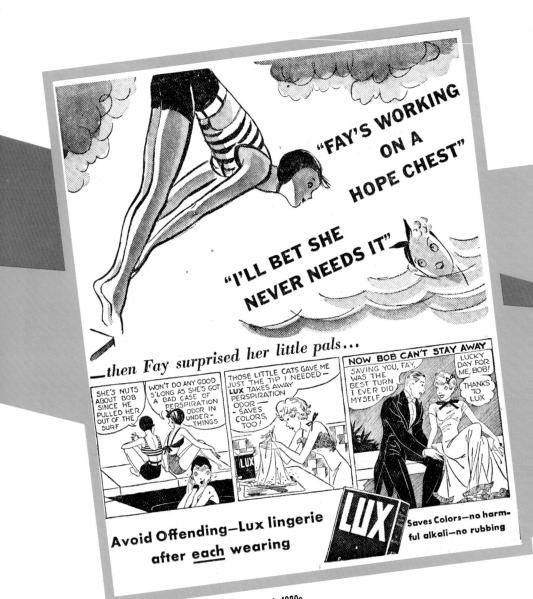

Gladys Parker, advertisement for Lux soap, early 1930s.

Sylvia Sneidman, FLAPPER FANNY, early 1930s.

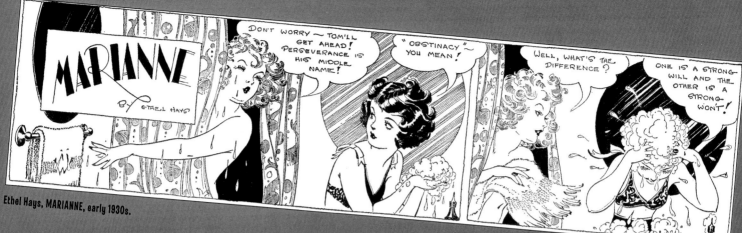

Ethel Hays, MARIANNE, early 1930s.

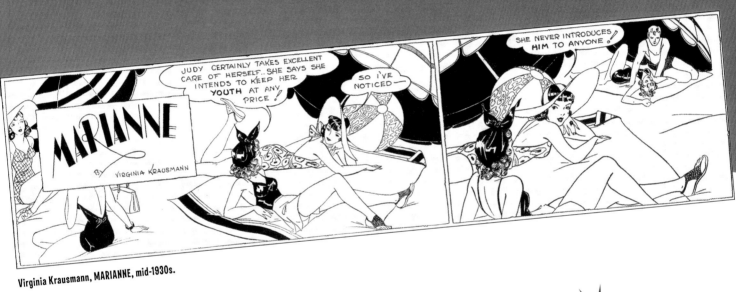

Virginia Krausmann, MARIANNE, mid-1930s.

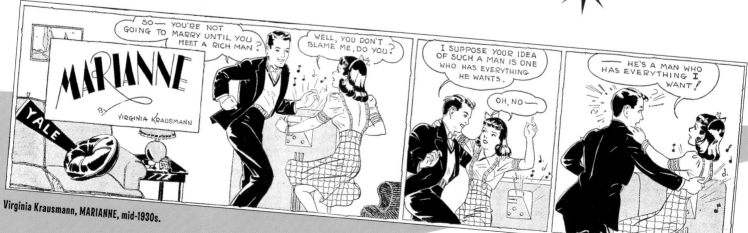

Virginia Krausmann, MARIANNE, mid-1930s.

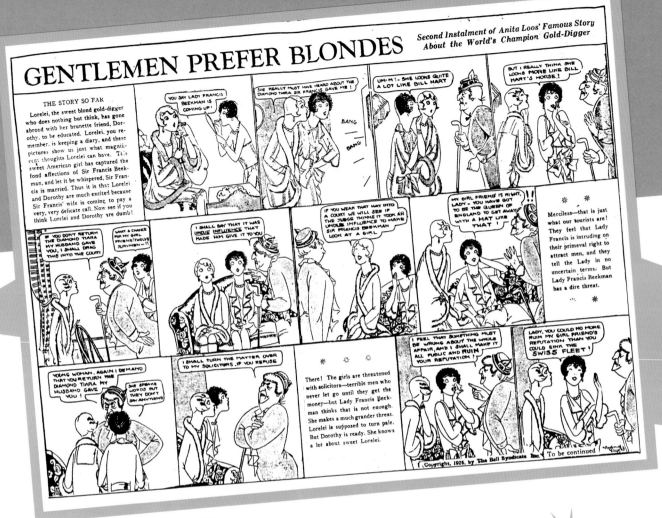

Virginia Huget, GENTLEMEN PREFER BLONDES, 1926.

Another remarkably talented and prolific creator...

Another remarkably talented and prolific creator was Virginia Huget, who during the late 1920s and early 1930s seemed to produce a new strip every year. Born Virginia Clark in Dallas, Texas in 1900, she married her childhood sweetheart, Coon Williams Hudzietz, and moved to Chicago, where she attended the Art Institute. The name Hudzietz was pronounced Huget, so in 1926, when the artist sold her first strip, **Gentlemen Prefer Blondes**, to the Bell syndicate, it was natural that she signed it not with a suspiciously "foreign" name that was difficult to pronounce, but with the more glamorous "French" sounding Huget.

By 1927, Huget was drawing **Babs In Society**, a full-color strip that chronicled the adventures of a spunky little flapper working in a department store, who inherits a fortune from her long-lost uncle Ebenezer. Other color Sunday pages followed: **Flora's Fling**, in 1928, and **Miss Aladdin**, in 1929. In **Babs**, obviously under the influence of Ethel Hays, the artist gave her heroine a dark, curly Flapper Fanny hairdo, while Miss Aladdin sports a blonde Louise Brooks bob. The heroine of **Molly the Manicure Girl**, a daily black-and-white strip done in 1929, also has a Louise Brooks haircut, and looks exactly like the heroine of Huget's 1928 strip, **Campus Capers**. Huget appears to have done a series of these strips, all in the mode of **Gentlemen Prefer Blondes**, featuring two young women, a blonde and a Louise Brooks lookalike brunette. Like Gladys Parker, Huget somehow found the time to draw Lux soap ads, which won a first prize from the Art Directors League of New York.

MOLLY THE MANICURE GIRL

By JOHN P. MEDBURY
Drawings by VIRGINIA HUGET

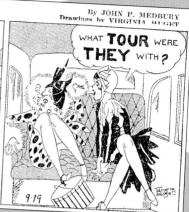

Virginia Huget, MOLLY THE MANICURE GIRL, 1929.

CAMPUS CAPERS

by Virginia Huget

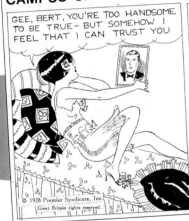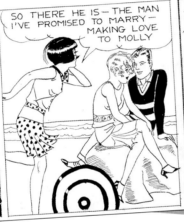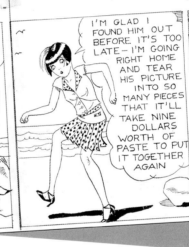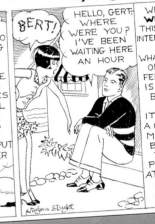

Virginia Huget, CAMPUS CAPERS, 1928.

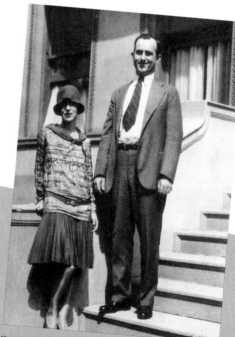

Virginia Huget, looking every bit like the flappers she drew, poses with her husband, Coon Hudzietz, in the mid-1920s.

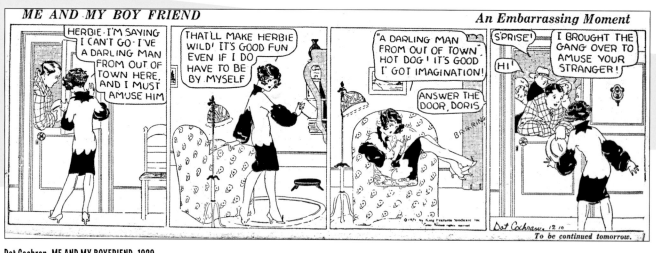

Dot Cochran, ME AND MY BOYFRIEND, 1929.

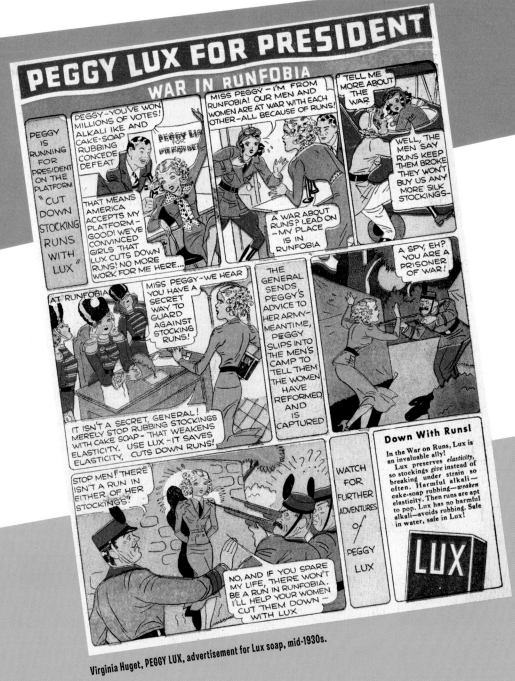

Virginia Huget, PEGGY LUX, advertisement for Lux soap, mid-1930s.

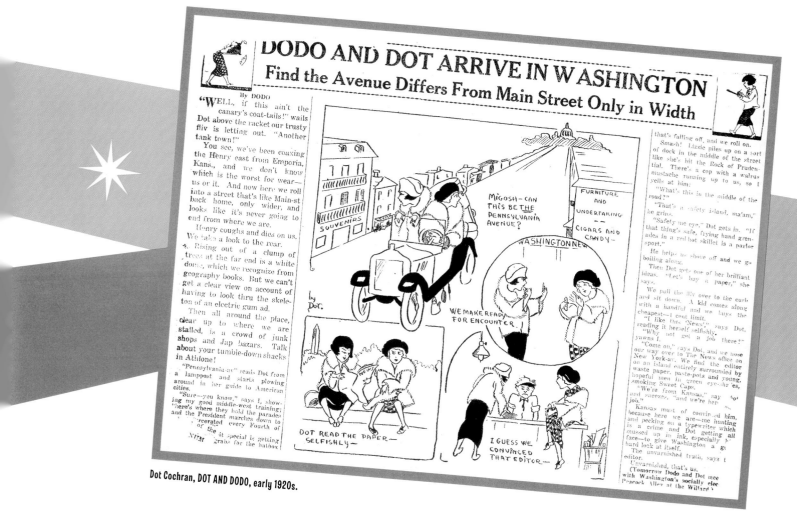

Dot Cochran, DOT AND DODO, early 1920s.

By 1936, Huget's style was subtly changing with the fashions of the times. She seemed to possess the ability to change her style as needed and was so proficient at mimicking other styles that she sometimes substituted for other artists. In 1937, during a time when Percy Crosby, creator of the popular strip **Skippy**, went through a period of alcoholism so severe that he could not meet his deadlines, she carried it on under his name. Her imitation of Crosby's style is flawless. By 1944, under her maiden name of Virginia Clark, she had taken over **Oh Diana!** from artist Don Flowers, and was rendering it beautifully in his style.

Dot Cochran was born in Toledo, Ohio in 1901. Her father, Negley Cochran, was editor and publisher of the **Toledo Bee**, one of her brothers was a cartoonist, and her sister and other brothers were journalists. She was also the aunt of Martha Blanchard, whose single-panel cartoons appeared in such magazines as **Collier's** and **The Saturday Evening Post**, and she was sister-in-law to Frederick Opper, creator of **Alphonse and Gaston** and **Happy Hooligan**. With a family like that, it seems natural that while still in her early 20s she should have sold her first feature, **Dot and Dodo**. As with Hays's **Vic and Ethel**, the young Cochran illustrated the adventures of herself and Dodo, the writer. This was followed by **Me and My Boyfriend**. When Cochran sold her charming

flapper strip, **Me and My Boyfriend**, she chose the Hearst chain's King Features Syndicate, rather than the Bee's Scripps-Howard Syndicate, so no one could accuse her of using her father's influence. **Me and My Boyfriend** lasted only until 1927, when Cochran married and moved to England, where she illustrated several books.

Joining the flapper party in 1933 was the strip **Annibelle** drawn by Dorothy Urfer, and taken over in 1936 by Virginia Krausmann, who seemed to specialize in taking over other women's strips.

During the 1910s, young Marjorie Henderson was a regular letter writer to **For Boys and Girls**, the children's page of the **Sunday Philadelphia Public Ledger**. In the July 30, 1916 issue, editor and author of the **Oz** series books, Ruth Plumly Thompson wrote:

> **"'Tell Mr. Bookmarker I am going to be an artist,' writes Marjorie Henderson, and if she keeps trying, I am sure she will succeed."**

Henderson was 25 years old in 1929 when she wrote and drew **Dashing Dot**. She would gain fame in 1934 as the creator of the immortal **Little Lulu**, and her familiar **Little Lulu** style is already recognizable in this flapper

strip, combined with the obvious influence of John Held, Jr. The strip is signed simply, Marge, the same way she later signed her **Saturday Evening Post** cartoons.

Fay King, a top cartoonist for over two decades, was referred to by Chuck Thorndike in his 1939 book, **The Business of Cartooning**, as one of the top five women cartoonists in America. Her work was an exception to the pretty girl flapper strips drawn by women in the 1920s and 1930s. While drawing other characters in a breezy, stylish manner, King put herself into the strips, and drew herself as looking like Olive Oyl. With herself as the main

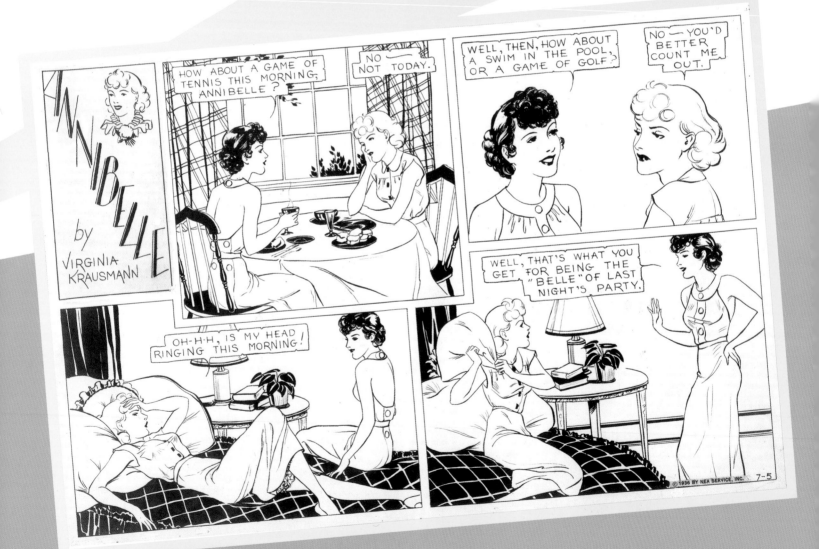

Virginia Krausmann, ANNIBELLE, 1936.

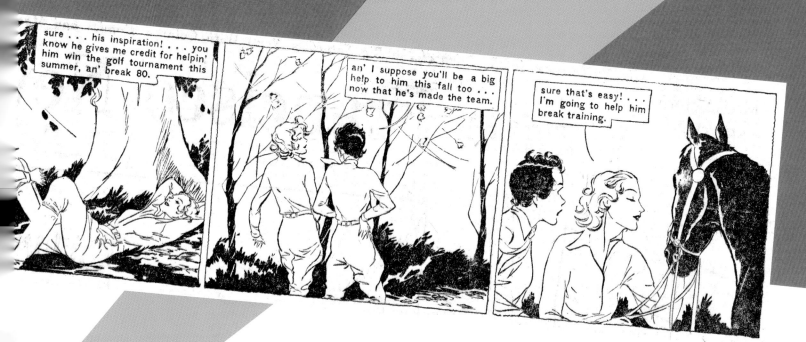

Virginia Krausmann seemed to specialize in taking over other women's strips.

character, King's strips consisted of personal opinions, and included her personal life. Interestingly, autobiographical comics by women would become a phenomenon fifty years later, flooding the pages of small-press comic books at the end of the twentieth century.

Newspapers covered King's marriage to world lightweight boxing champion Oscar Matthew "Battling" Nelson in 1913 and also covered their colorful divorce. A 1916 article reports: "The 'Durable Dane,' as Nelson is known professionally, charges that Mrs. Nelson never loved him,

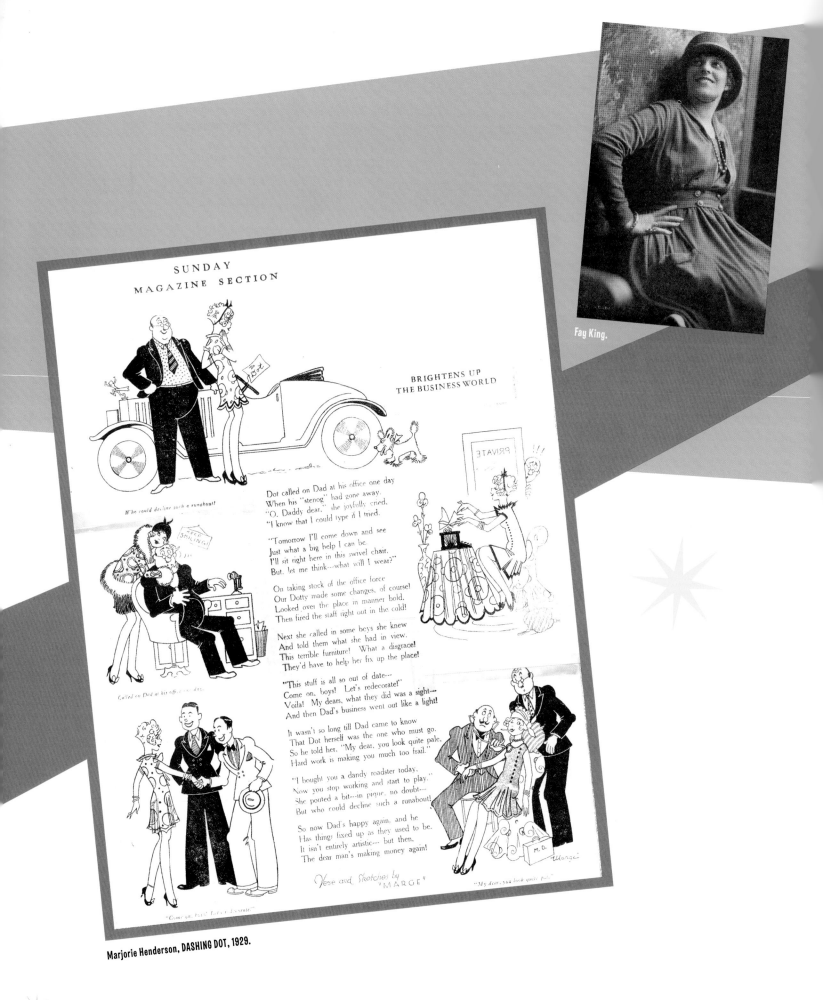

SUNDAY
MAGAZINE SECTION

BRIGHTENS UP
THE BUSINESS WORLD

Who could decline such a runabout!

Called on Dad at his office one day.

"Come on, boys! Let's redecorate."

Verse and Sketches by "MARGE"

"My dear, you look quite pale."

Dot called on Dad at his office one day
When his "stenog." had gone away.
"O, Daddy dear," she joyfully cried,
"I know that I could type if I tried.

"Tomorrow I'll come down and see
Just what a big help I can be.
I'll sit right here in this swivel chair,
But, let me think---what will I wear?"

On taking stock of the office force
Our Dotty made some changes, of course!
Looked over the place in manner bold,
Then fired the staff right out in the cold!

Next she called in some boys she knew
And told them what she had in view.
This terrible furniture! What a disgrace!
They'd have to help her fix up the place!

"This stuff is all so out of date---
Come on, boys! Let's redecorate!"
Voila! My dears, what they did was a sight---
And then Dad's business went out like a light!

It wasn't so long till Dad came to know
That Dot herself was the one who must go.
So he told her, "My dear, you look quite pale,
Hard work is making you much too frail."

"I bought you a dandy roadster today,"
Now you stop working and start to play."
She pouted a bit---in pique, no doubt---
But who could decline such a runabout!

So now Dad's happy again, and he
Has things fixed up as they used to be.
It isn't entirely artistic--- but then,
The dear man's making money again!

Fay King.

Marjorie Henderson, DASHING DOT, 1929.

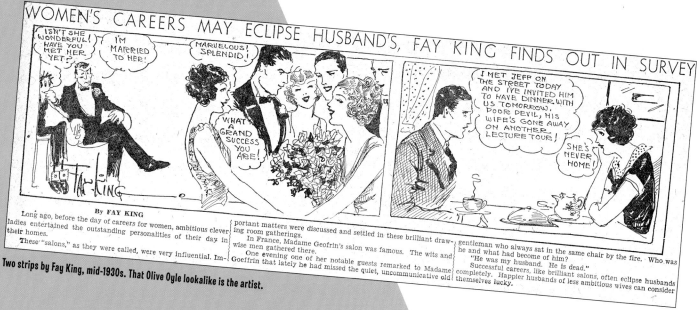

WOMEN'S CAREERS MAY ECLIPSE HUSBAND'S, FAY KING FINDS OUT IN SURVEY

By FAY KING

Long ago, before the day of careers for women, ambitious clever ladies entertained the outstanding personalities of their day in their homes.

These "salons," as they were called, were very influential. Im-portant matters were discussed and settled in these brilliant draw-ing room gatherings.

In France, Madame Geofrin's salon was famous. The wits and wise men gathered there.

One evening one of her notable guests remarked to Madame Goeffrin that lately he had missed the quiet, uncommunicative old gentleman who always sat in the same chair by the fire. Who was he and what had become of him?

"He was my husband. He is dead."

Successful careers, like brilliant salons, often eclipse husbands completely. Happier husbands of less ambitious wives can consider themselves lucky.

Two strips by Fay King, mid-1930s. That Olive Oyle lookalike is the artist.

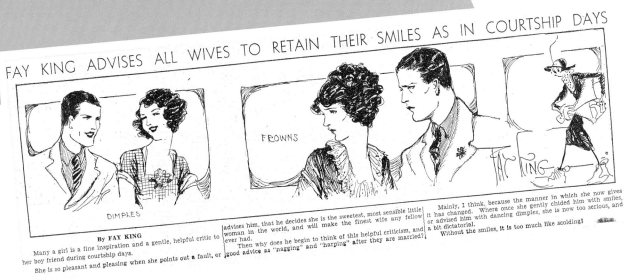

FAY KING ADVISES ALL WIVES TO RETAIN THEIR SMILES AS IN COURTSHIP DAYS

By FAY KING

Many a girl is a fine inspiration and a gentle, helpful critic to her boy friend during courtship days.

She is so pleasant and pleasing when she points out a fault, or advises him, that he decides she is the sweetest, most sensible little woman in the world, and will make the finest wife any fellow ever had.

Then why does he begin to think of this helpful criticism, and good advice as "nagging" and "harping" after they are married?

Mainly, I think, because the manner in which she now gives it has changed. Where once she gently chided him with smiles, or advised him with dancing dimples, she is now too serious, and a bit dictatorial.

Without the smiles, it is too much like scolding!

but regarded him merely as a 'li'l Pal' ... letters by Mrs. Nelson ... referring to the ex- champion, as a 'Dear little woolly lamb,' admitted she never loved him, but was 'very grateful — that's all.'"

In a 1918 cartoon, King drew a man labeled "My 'Fay'-vorite Pest," saying to her, "You married Battling Nelson, didn't you! He sure waz a great little scrapper…" while the scrawny, big-footed Fay caricature replies, "SAY-I'm tryin' to live that down!"

The Battling Nelson episode was the occasion for King to meet journalist Gene Fowler, sent to interview her for his newspaper. The two became friends, and his memoirs give us an excellent description of the artist:

"I was unprepared to come upon so much vitality in such a small package…. I observed that she was dark complexioned with very large dark eyes, and that she wore numerous pieces of jewelery which chimed like bells…. There were gold hoops in her ears, and on one forefinger she wore a heavy gold band to which was affixed a cartoon effigy of herself … she liked gay colors also and when she had assembled her various scarves and sashes, she reminded me of the mountain flowers of August."

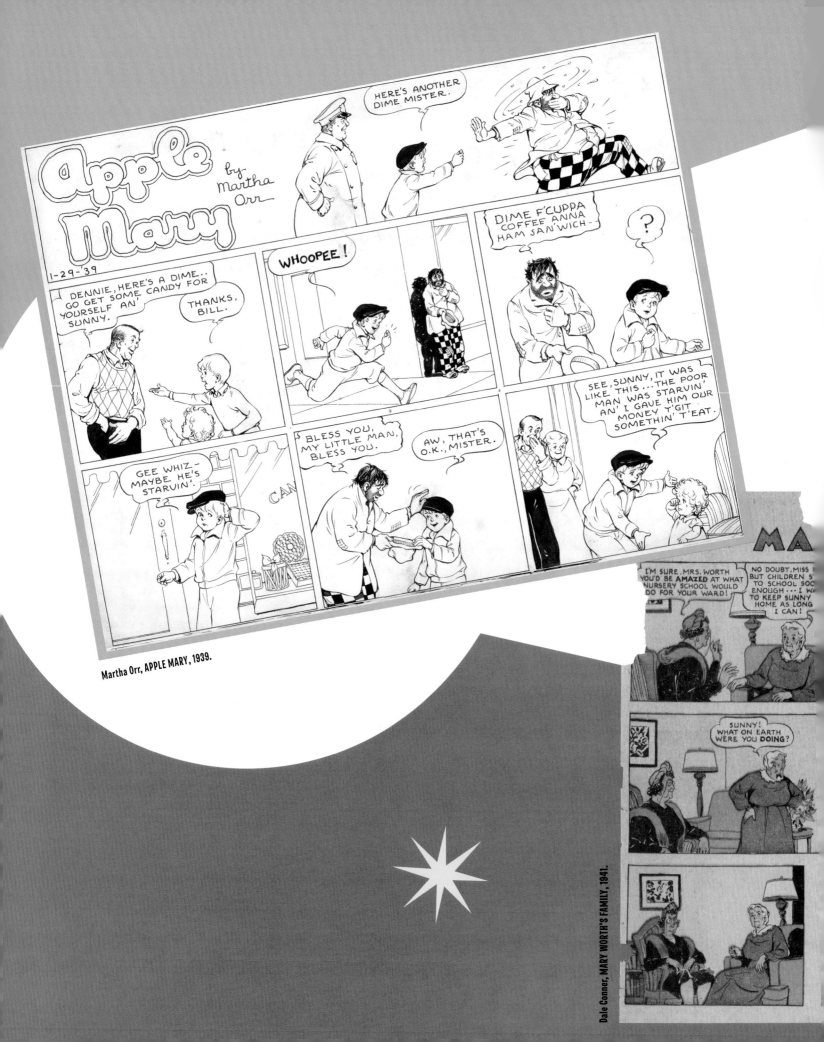

Martha Orr, APPLE MARY, 1939.

Dale Conner, MARY WORTH'S FAMILY, 1941.

Part Three

Depression Babies and Babes

The frenetic party that was the Roaring Twenties crashed to a close in 1929, bringing with it the slow fade of the flapper strip, although some of them hung on through the 1930s. The average heroine of these strips was a pretty girl, often a co-ed, with nothing on her mind but boys. But now America, plunged into the Great Depression, tossed aside the frivolity of the 1920s in favor of a new kind of comic: The Depression strip.

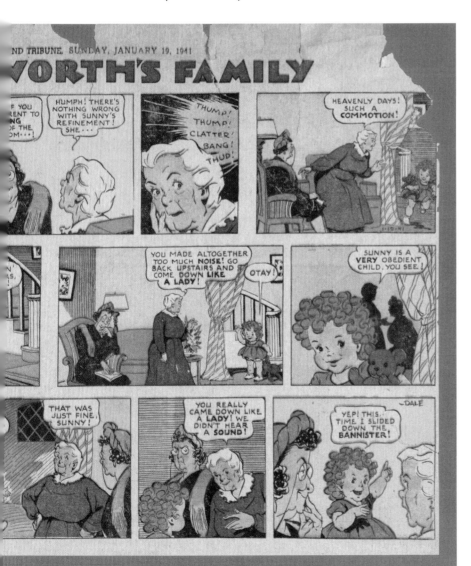

Echoing the new mood of the times, this type of strip featured unglamorous protagonists dealing with real problems: Poor but happy American households; upbeat, unflappable orphans; and plucky working girls out to earn a living rather than merely have a good time.

Martha Orr's **Apple Mary** can be considered the quintessential Depression strip. The stories revolved around old Mary, who sold apples on a street corner, and her friends and family, all of them as big-hearted as they were poor. After drawing **Mary** for seven years, Orr married and retired to raise a family. The strip was taken over by her talented assistant, Dale Conner. She changed the name to **Mary Worth's Family** and signed it simply "Dale." Soon Conner acquired a writer, Allen Saunders, at which time she started signing the strip with a combination of their two names, Dale Allen. Unhappy with the direction her strip was taking under Saunders, Conner eventually left **Mary Worth's Family** in order to team up with her husband, who was also a comic writer. Unfortunately, none of their projects panned out. Saunders found Ken Ernst to draw the art, and **Mary Worth**, in much changed form, survives today (although under other hands).

Another homey little American household consisted of a boy, his dog, and his granny. Edwina Dumm's **Cap Stubbs and Tippie** was at its peak of popularity during the Depression, although it had been running since 1918. In 1916, Edwina Dumm started her career in the **Columbus Daily Monitor**, as possibly America's first female political cartoonist. By the following year she was drawing a humor page, **Spot-light Sketches**, for the newspaper. The page consisted mostly of single panel cartoons, and had a strip running on the bottom entitled **The Meanderings Of Minnie**, always subtitled "passed by the board of censors," starring a little girl and her fluffy dog. **Minnie** must have been the most popular item on the page, because soon it was running on its own. When Dumm became nationally syndicated in 1918, **Minnie** underwent a sex change, the dog became a shorthair, and the artist began signing her work with just her first name, Edwina, a practice she continued for the run of the strip. In the early 1930s, Edwina was given a little long-haired dog, and Tippie became a longhair again and stayed that way for the next thirty years. The fluffy little guy proved more popular than his boy owner or his plump granny and even became the subject of songs written by the artist's longtime friend, musician and songwriter Helen Thomas.

Edwina Dumm started her career in the Columbus Daily Monitor, as possibly America's first female political cartoonist.

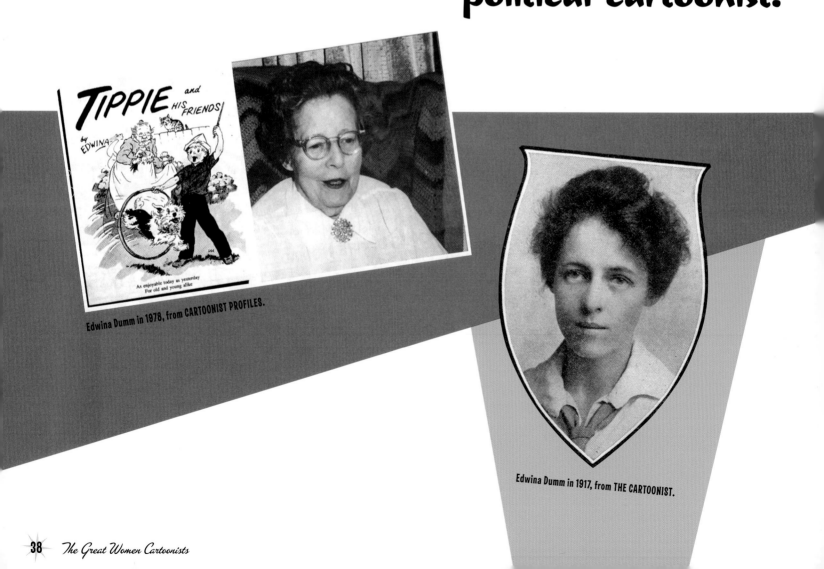

Edwina Dumm in 1978, from CARTOONIST PROFILES.

Edwina Dumm in 1917, from THE CARTOONIST.

Edwina Dumm, TIPPIE sheet music, 1946.

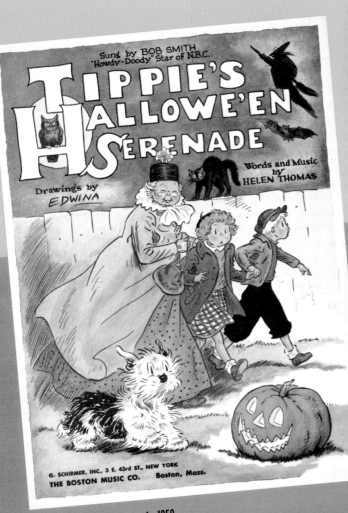

Edwina Dumm, TIPPIE sheet music, 1950.

Alec the Great

Nobody cares a fig
 for all
The big things you
 have <u>done</u> --
It's only what you're
 doing <u>now</u>
That counts with
 anyone.

The world is full
 of trouble, and
Chock-full of woe
 and strife --
Especially for people
 who
Refuse to compro-
 mise with life

That chap who made
 my statue has
An awful lot of
 crust.
It looks exactly like
 me, but
He calls the thing
 a bust!

Edwina Dumm, ALEC THE GREAT.

Edwina Dumm, TIPPIE, 1941.

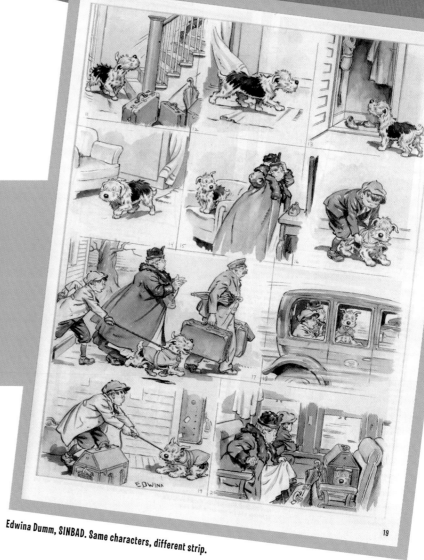

Edwina Dumm, SINBAD. Same characters, different strip.

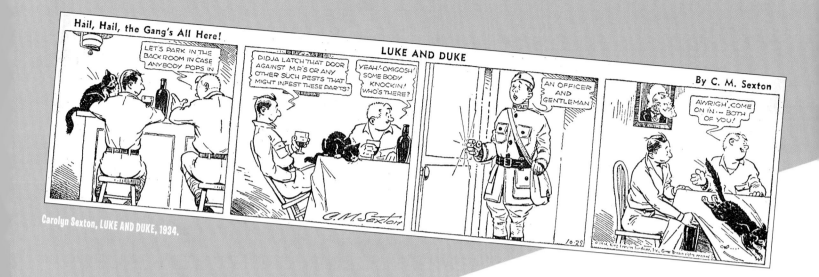

Hail, Hail, the Gang's All Here!

LUKE AND DUKE

By C. M. Sexton

LET'S PARK IN THE BACK ROOM IN CASE ANYBODY POPS IN

DIDJA LATCH THAT DOOR AGAINST M.P.'S OR ANY OTHER SUCH PESTS THAT MIGHT INFEST THESE PARTS?

YEAH! OMIGOSH! SOME BODY KNOCKIN! WHO'S THERE?

AN OFFICER AND GENTLEMAN

AWRIGH', COME ON IN -- BOTH OF YOU!

Carolyn Sexton, LUKE AND DUKE, 1934.

Edwina Dumm herself lived to be 95 years old, owning a succession of cute little longhaired dogs.

Edwina was a dog artist par excellence, possibly the best in the twentieth century. When she wasn't drawing **Cap Stubbs and Tippie**, she was producing a series about a little dog named **Sinbad**, which ran in the old humor magazine, **Life**, and was collected into two books. She also drew a daily newspaper panel about another dog, named **Alec the Great**, illustrating short verses by her brother, writer Robert Dennis. **Alec** also was collected into book form. All three dogs — **Tippie**, **Alec** and **Sinbad** — were similar in experience. Edwina also illustrated books by other writers with her great dog art. **Cap Stubbs and Tippie** ran until the mid-1960s, and Edwina Dumm herself lived to be 95 years old, owning a succession of cute little longhaired dogs.

While Tippie is considered the first continuity strip by a woman and **Apple Mary** the first dramatic continuity strip by a woman, the award for first action continuity strip must go to a now-forgotten artist named Caroline M. Sexton. In 1934, signing her work "C.M. Sexton," she produced **Luke and Duke**, a strip that took place during World War I, detailing the adventures of two American doughboys and Yvonne, the beautiful Belgian orphan they somehow acquire. It is drawn in a style reminiscent of Belgian cartoonist Herge's comic, **Tintin**, and also at times seems like an early version of Bill Mauldin's World War II cartoon, **Up Front**. It's understandable why Sexton would use her initials rather than her full name for this charming, but definitely male-oriented strip.

Rose O' Neill, THE KEWPIES, 1935.

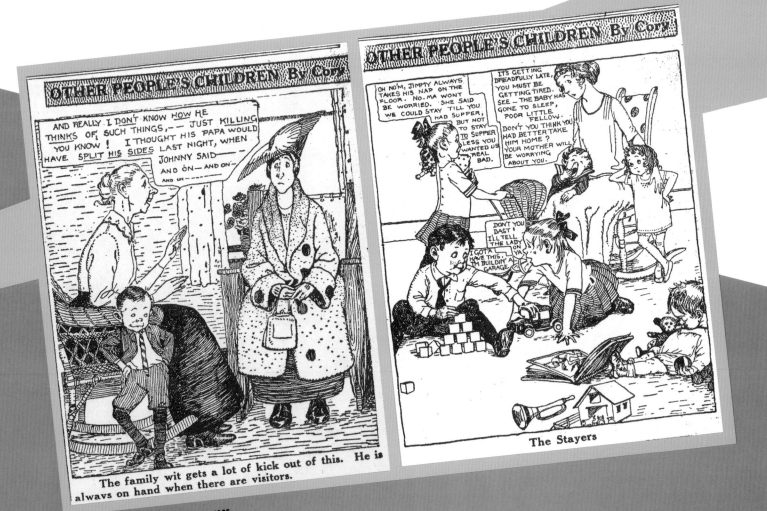

Fanny Y. Cory, OTHER PEOPLE'S CHILDREN, 1925.

Meanwhile, the original major women cartoonists from the beginning of the century had by no means retired. Rose O'Neill's **Kewpie** strips continued running in newspapers across the nation. She would continue to draw Kewpies until her death in 1944.

O'Neill's contemporary, Fanny Y. Cory, who, like many other women of the time, put aside her career to raise a family on the Montana ranch where she and her husband lived, had not been drawing professionally since 1913. In her unpublished memoirs, Cory recalls an incident from her life at the time; an incident that sounds like something from a John Wayne movie:

"Fred, my husband, had gone for the mail (7 miles away) taking our daughter (Sayre) and the girl who had recently come to work for us with him for the ride. I knew her very nice mother quite well, and her drunken father by hearsay. Our small son (Robert) was asleep in the bedroom.

"A thundering knock at the door — door bursting open — very drunk gentleman in the door-way — 'Where is my girl, ha? Come on. Where is she? No use hiding out ya know, I demand my daughter! Dede, where are ya? Lookye here, you're Fred Cooney's woman as thinks to make a hired girl of my daughter. Do ya see these here scars on my face? Do ya see this 'ere gun? I know how t'use it, ma'am — now where's my daughter?'

"To all of this I managed to turn a cold eye and indifferent aspect. 'You had better go away from here as fast as you can or when my husband comes in he will no doubt beat the life out of you' (and more to this effect). He seemed to think there might be something in what I said and began to lurch out, still loudly asserting his demands for his daughter. He had a horse outside and managing to climb on, rode away — I began to shake all over and to cry, not so brave after all."

Rose O'Neill's Kewpie strips continued running in newspapers across the nation... until her death in 1944.

Rose O'Neill in 1934.

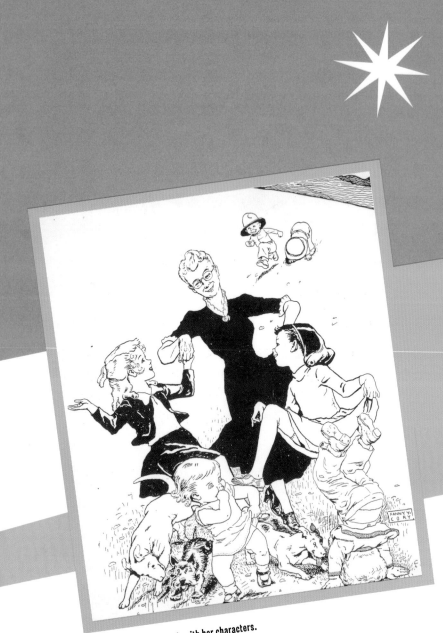

Fanny Y. Cory, self-portrait with her characters.

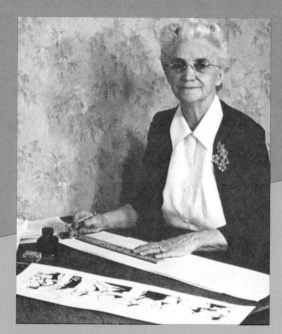

Fanny Y. Cory later in life.

In 1916, Cory briefly produced a single-panel cartoon called **Ben Bolt**, parodying the old song "Do You Remember Sweet Alice, Ben Bolt?," but by 1925, the need to put her eldest child through college prompted her to return to her art permanently, this time in the form of first a single-panel cartoon, and finally a comic strip. Her first panel was the hilarious **Other People's Children**, although the almost too precious **Sonny Sayings**, from 1926, remained the artist's favorite. By 1935 Cory was producing **Little Miss Muffet**, featuring another cheerful little orphan girl of the sort that were very big during the Depression. Cory also drew **Little Orphan Annie** and **Little Annie Rooney** (and their respective dogs), both of

whom had a huge following. Cory's heroine, Milly Muffet, had a dog too and was a dead ringer for Shirley Temple. The little darling smiled through her tears for twenty-one years, finally retiring when 76-year-old Cory's failing eyesight forced her to stop drawing in 1956. The artist moved to Camano Island, Washington, where despite her poor sight, she continued to paint. At the age of 90 she wrote:

"I live alone in a two-room cottage on the edge of an 80-foot bank above Puget Sound. The broad sweep of water before me — then Mercer Island and behind that the peaks of the Olympic mountains snow topped at most times. Mt. Olympus

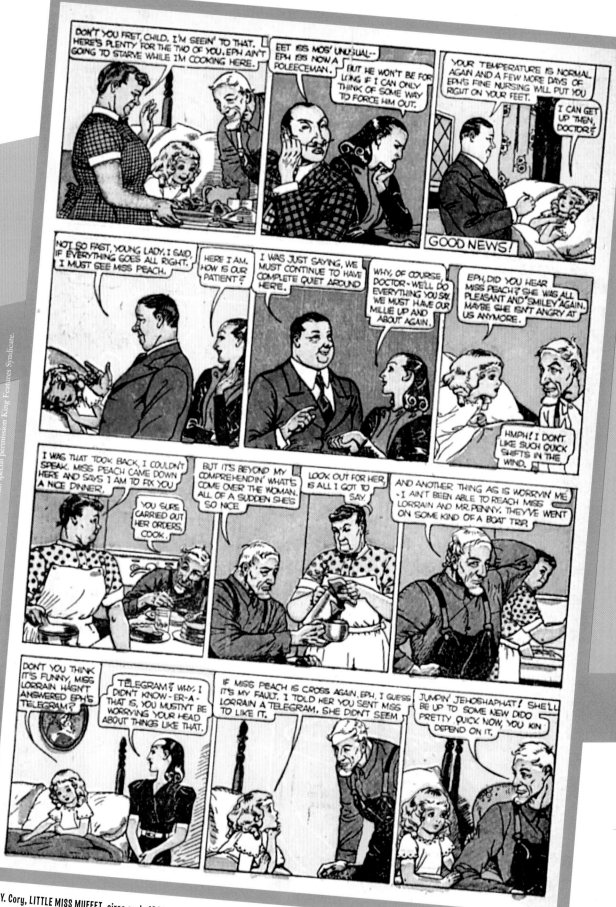

Fanny Y. Cory, LITTLE MISS MUFFET, circa early 1940s. These daily newspaper strips have been repasted and published in comic book form.

right directly across — then to my right if I face the Sound — the wood, lovely tall straight cedar pine and fir — thick underbrush — no attempt at cultivation. My road ... is winding and full of potholes for the rain to collect ... my place is a painful contrast to my neighbors — upon which not even a fallen leaf is allowed to be. No underbrush there.... How they must shudder at such a neighbor — and yet they are, I'm sure, fond of me and always willing to lend a hand should I need help...."

Fanny Y. Cory died in 1972 at the age of 95.

Meanwhile, Grace Drayton, the other contemporary of O'Neill and Cory, had fallen upon hard times. Like the carefree flappers, Drayton's **Dimples** and **Dingles**, with

their nannies and nursies, seemed out of place in Depression America. Her Sunday comic page, **Dolly Dimples and Bobby Bounce**, had been canceled in 1932 and the following year when her assistant, Bernard Wagner, wrote asking for work, she sent him this reply:

"I have no work and am almost down and out. I have tried everything. You may rest assured I shall send for you if I get another 'job.' I feel so sad whenever I look at our empty studio. To add to my agony, I lost my only dearly beloved sister a few weeks ago. So I am now all alone and poverty stricken in heart as well as in pocket."

But Drayton did rally one last time to successfully sell **The Pussycat Princess** in 1935. Her collaborator on the strip, writer Ed Anthony, gallantly writes that after Drayton's

Diana Thorne, TERRY, 1938. The author knows nothing about this strip, except that it is charming.

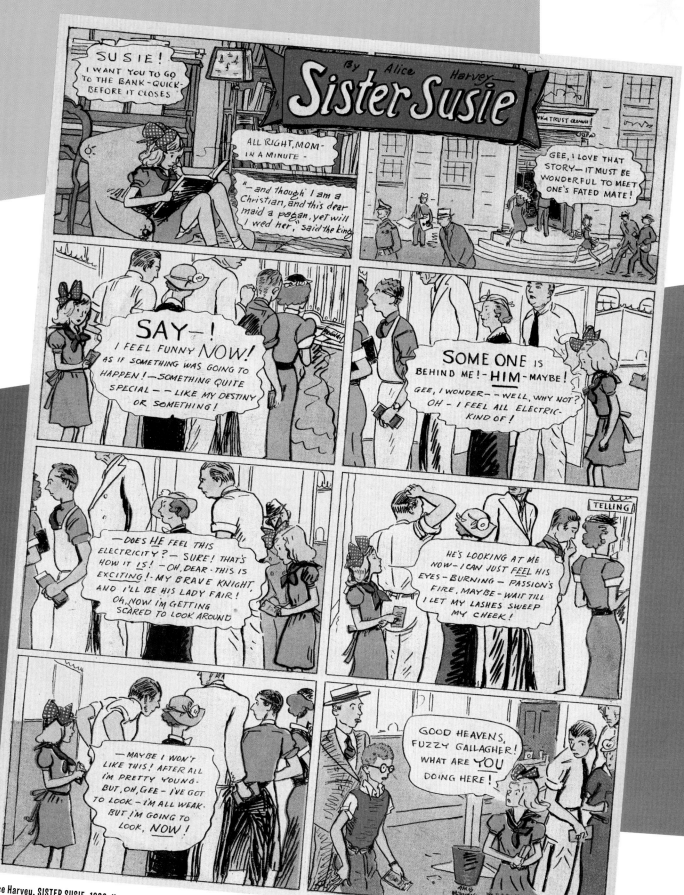

Alice Harvey, SISTER SUSIE, 1936. Harvey, better known as a cartoonist for the NEW YORKER, drew this short-lived strip for the NEW YORK DAILY NEWS.

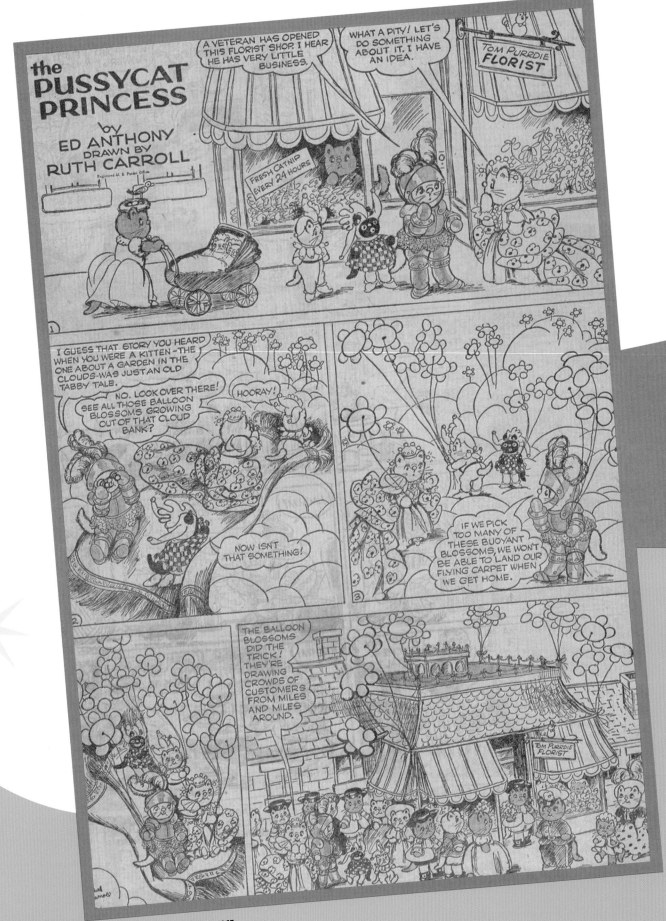

Ruth Carroll, THE PUSSYCAT PRINCESS, 1947.

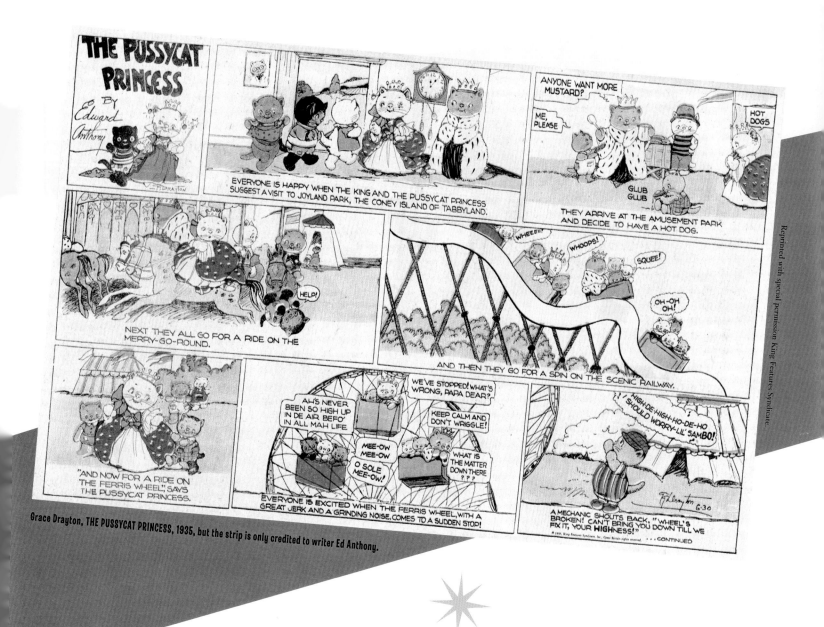

Grace Drayton, THE PUSSYCAT PRINCESS, 1935, but the strip is only credited to writer Ed Anthony.

untimely death from a heart attack one year later, "... nearly all the big papers canceled, which gave me a pretty good notion as to why it had been accepted in the first place." Ruth Carroll, a children's book writer and illustrator, took over the strip, but, writes Anthony, "we lacked the promotion value of the Drayton name ... and we were unable to regain the big papers we had lost."

Anthony was being too kind. The truth is that **The Pussycat Princess** drawn by Ruth Carroll did well,

lasting until 1947, and that the first strips drawn by Drayton didn't even credit her; they simply read "by Ed Anthony." The great Grace Drayton, creator of the Campbell Kids and in her time the favorite of millions, had become passè.

An exception to the unfortunate tradition of ending one's career in favor of marriage and motherhood was **Brenda Starr** creator Dale Messick, probably one of the most seriously committed and tenacious woman cartoonists of

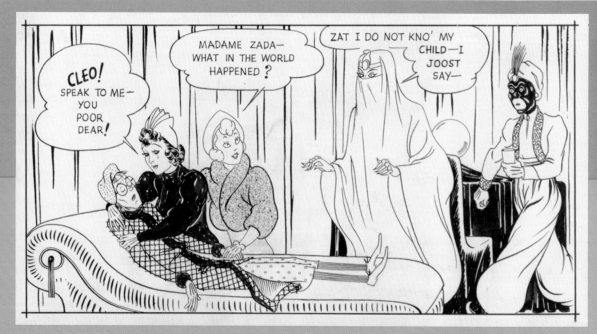

Mazie Krebs, CINDY OF THE HOTEL ROYALE, 1937. Krebs' Depression-era protagonist differs from her flapper sisters of the previous decade in that she works for a living.

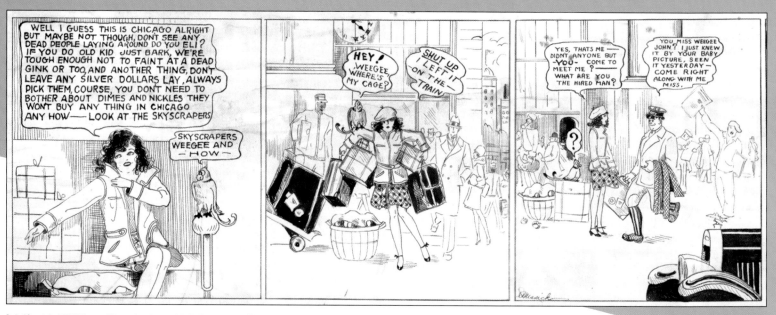

Dale Messick, WEEGEE, unsold, previously unpublished strip, mid-1920s.

the century. In a 1973 newspaper interview, she describes her pregnancy: "It was throw up, draw **Brenda**, throw up, draw **Brenda**." Before she sold the long-lasting strip that was to make her the grande dame of comics, Messick attempted to sell at least four others. Born Dalia Messick, the artist likes to relate that she changed her name to the more sexually ambiguous Dale because as Dalia editors would reject her strips and then put the make on her. The way she finally sold **Brenda**, she says in all her interviews,

was to become Dale and mail the strips in. However, only the first of her unsold strips, **Weegee**, drawn probably when the artist was just out of high school in the mid-1920s, is signed Dalia. The other three, all drawn during the 1930s, are already credited to her new name, Dale. So there must be another reason why they were rejected. It's certainly not the art; even **Weegee**, Messick's first strip, is at least as well drawn as some of the flapper strips from the period. What makes **Weegee** different is the subject

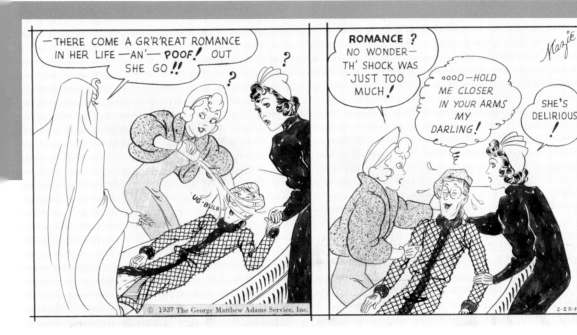

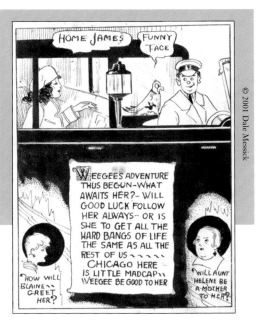

matter. The heroines of the flapper strips never had a care in the world; only Virginia Huget's characters even held a job, and they had a way of inheriting money from rich relatives. **Weegee** features a Depression-strip heroine born ahead of her time, a poor little country girl come to the big city to earn a living.

By the time she was drawing and attempting to sell **Mimi the Mermaid**, Messick's drawing style had improved immensely, but editors must have found her subject matter simply too weird. Not until 1990, with Walt Disney's **The Little Mermaid**, has there ever been a comic starring a mermaid. This time, Messick was roughly sixty years ahead of her time.

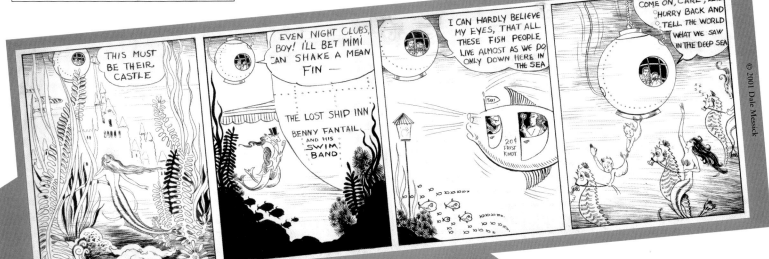

Dale Messick, MIMI THE MERMAID, unsold, previously unpublished strip, early 1930s.

Dale Messick, PEG AND PUDY, THE STRUGGLETTES, unsold, previously unpublished strip, mid-1930s.

...unable to control herself, with tears running down her cheeks, Messick told the editor that a comic about a wooden dummy would never last.

With the creation of **Peg and Pudy, the Strugglettes**, it looked like Messick was catching up with the times — or vice versa. **Strugglettes** metamorphosed into **Streamline Babies**, with the same characters and the same situations — two girls attempting to make it in the Big City. At last it looked like the persistent artist had finally hit it; the McNaught syndicate showed an interest in her strip. But after Messick had completed three Sunday pages, the syndicate decided to go instead with an Edgar Bergen and Charlie McCarthy strip. Comic editors appear to have always been a conservative lot, and still today will always buy a strip starring a licensed character rather than take a chance on an unknown. Messick remembers trying to be brave when she was told the news, but finally, unable to control herself, with tears running down her cheeks, she told the editor that a comic about a wooden dummy would never last.

She was right — the strip folded within a month. But by that time, Dale Messick was busily at work creating the right strip for the right time.

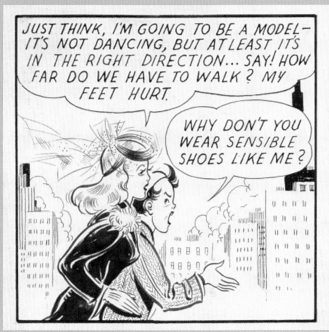

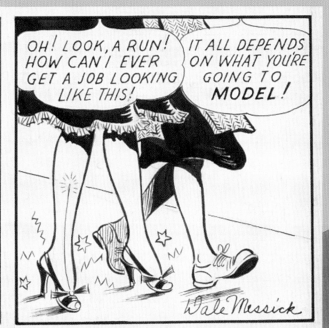

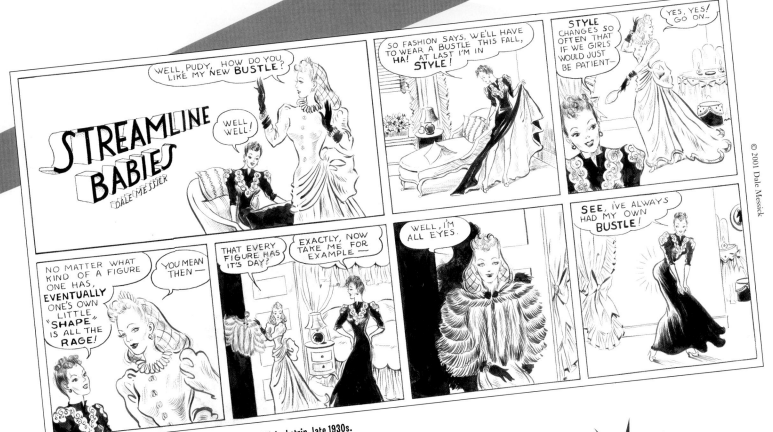

Dale Messick, STREAMLINE BABIES, unsold, previously unpublished strip, late 1930s.

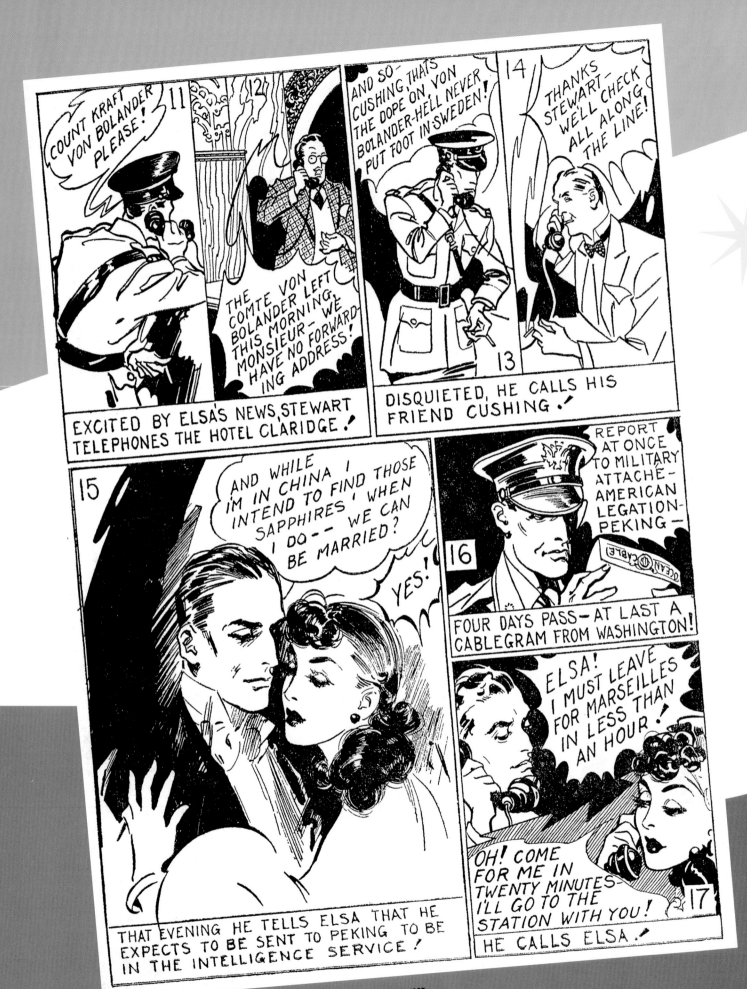

Cecilia Paddock Munson, THE MONASTERY OF THE BLUE GOD, from ADVENTURE COMICS, 1937.

Part Four

Blonde Bombers and Girl Commandos

*A*merica in 1940 was a country teetering on the brink of war. Although they were not to enter World War II for another year, the majority of citizens sympathized with the Allies, and since the mid-1930's, Americans had volunteered to join the fight against fascism overseas. Movies, pulp fiction, and the new medium of comic books all echoed the action-oriented theme of war and preparing for war. Almost from the beginning, comic books were employing women.

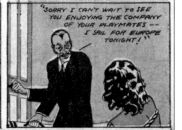

Tarpe Mills, DAREDEVIL BARRY FINN, from AMAZING MYSTERY FUNNIES, 1939.

In the June 1937 issue of **Adventure Comics**, Cecilia Paddock Munson, signing her work "Pad," illustrated **The Monastery of the Blue God**, a spy story involving stolen Swedish military secrets, Bolsheviki, and the beauteous Baroness Elsa Von Saxenberg. Two years later, Tarpe Mills, who in 1942 was to produce one of the best action strips of the century, was drawing **Daredevil Barry Finn** for Amazing Mystery Funnies. The comic's villain, Doctor Zaroff, tried to sell Hitler and Mussolini an infernal invention that "can prevent the United States from interfering with your plans for war!!" The fiendish plot is foiled by Finn with help from his friend Joan Hart, a young woman who looks exactly like Mills's later costumed heroine, Miss Fury.

The country was ready for a strong, action-oriented heroine, and Dale Messick was at last in the right place at the right time with **Brenda Starr**, her red-haired, starry-eyed girl reporter. Messick's sample strips had been submitted to Captain Joseph M. Patterson, publisher of the **New York Daily News** and chief of the Chicago Tribune-New York News Syndicate, and rejected by him. The reason given, according to a 1960 article in **The Saturday Evening Post**, was that "He had tried a woman cartoonist once ... and wanted no more of them." Mollie Slott, at the time Patterson's "Girl Friday" and later vice president and manager of the syndicate, found the discarded samples and recognized the potential in them. Together, she and Messick worked out a new submission. The heroine, named after glamorous debutante Brenda Frazier, had originally been a "girl

bandit." Heeding Slott's advice, the artist turned her into a reporter.

Patterson grudgingly agreed to carry **Brenda Starr** in his syndicate, but flatly refused to run it in the **Daily News**. Indeed, the **News** did not carry **Brenda Starr** until two years after Patterson's death in 1946.

Patterson was not the only male to have it in for Messick's creation. Although the strip inspired a huge female following from the beginning (when the **Tucson Daily Citizen**

dropped the strip in 1973, the editors received hundreds of angry letters and phone calls, the majority of which were from women), the artist never felt fully accepted by her male colleagues, and she resisted joining the National Cartoonists Society. As **The Saturday Evening Post** article delicately put it when writing about the male cartoonists' attitudes, "There are differences of opinion about her artistic talents." In a 1973 newspaper interview, Messick wryly gave her opinion of the mostly male organization: "I see where they're honoring Jack Dempsey. They never honored me for anything, but they honor Jack Dempsey."

"There are differences of opinion about her artistic talents."

Dale Messick in 1955.

Dale Messick at a San Diego comic convention in the late 1980s.

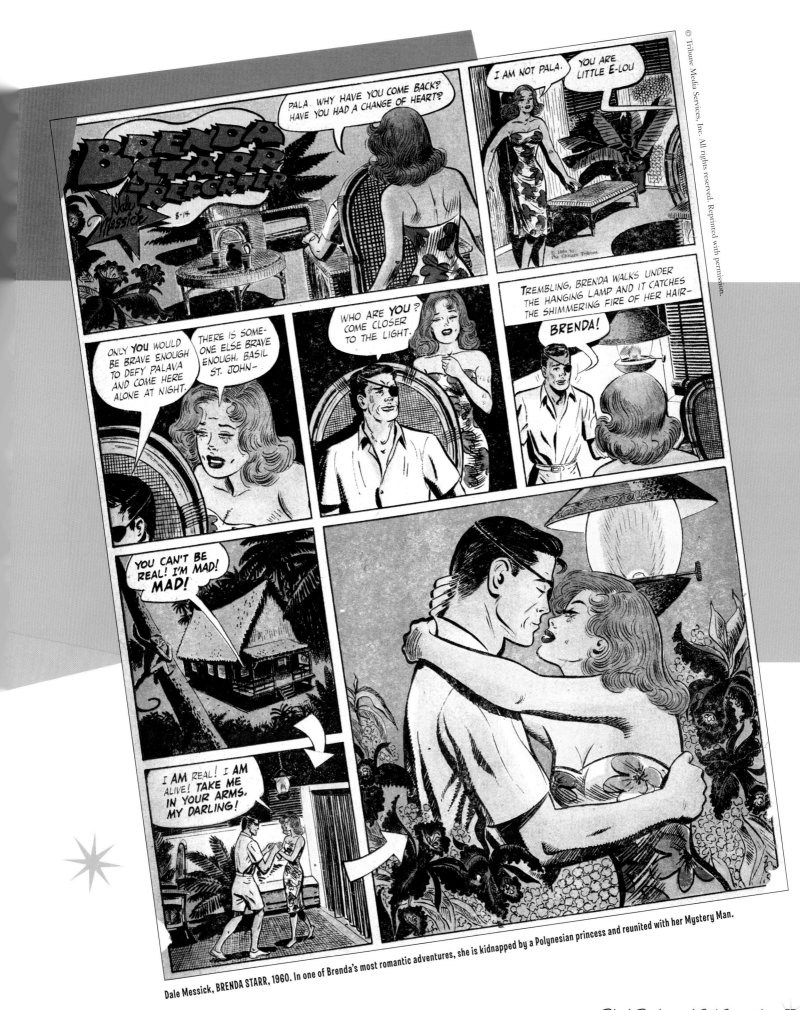

Dale Messick, BRENDA STARR, 1960. In one of Brenda's most romantic adventures, she is kidnapped by a Polynesian princess and reunited with her Mystery Man.

Even the writer of the 1960 **Post** article felt compelled to belittle Messick by stressing her "wacky dame" aspects. Here is a description of a typical day in the artist's studio:

"The hi-fi is on full blast. Miss Messick sings along lustily. If the music is appropriate, she jumps up and does a rhumba. In meditative periods she chews gum with popping sound effects."

Messick's heroine, whose looks were based on film star Rita Hayworth's, parachuted from planes, joined girl gangs, escaped from kidnappers, almost froze to death on snow-covered slopes, and got marooned on desert islands. Meanwhile, **The Gumps**, a strip created by Patterson, that moved as slowly as molasses and must be called boring by the kindest critic, had been carried by the same syndicate since 1919.

Messick's drawing style, strongly influenced by Nell Brinkley's, is romantic and feminine. Yet she drew excellent action scenes, and offered the reader a memorable cast of supporting characters: Flip Decker, teenage leader

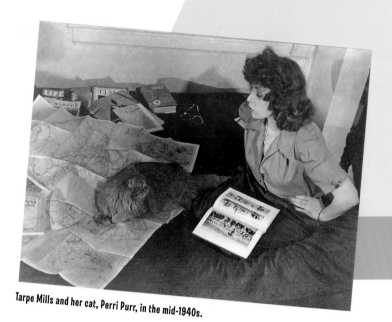

Tarpe Mills and her cat, Perri Purr, in the mid-1940s.

"It would have been a major letdown to the kids if they found out that the author of such virile and awesome characters was a gal."

of an all-blonde girl gang; The Nameless Doll, a pouf-haired Robin Hood; Palava, the albino Polynesian princess; and of course the handsome, one-eyed Mystery Man. Chester Gould's **Dick Tracy**, also carried by the same syndicate, boasted of equally, if not more bizarre, supporting characters. But of his art, James Steranko had this to say in his 1970 book, **The Steranko History of Comics**:

"His drawings had about as much depth as a cardboard cut-out. As a technician, he would be out-distanced by miles. If Gould had any knowledge of perspective he kept it to himself."

Why then this negativity aimed against Messick's creation by men in the industry? As demonstrated, there had been plenty of women drawing comics for the past forty years, and there is no record of men strongly criticizing their work. However, all the previous comics by women had been comparatively light — cute animals and kids, pretty girls without a care in the world, rotund grandmas

spouting homespun philosophy. These comics might be considered "girl stuff" — a genre the men didn't care to work in or take seriously. But with **Brenda Starr**, Messick was trespassing on male territory.

Messick opened the way for over a decade of action heroines in the comics. A year later, **Wonder Woman**, the creation of psychologist William Moulton Marston and artist Harry G. Peter, hit the newsstands in the December 1941, issue of **All Star Comics**. The immortal amazon was the first costumed action heroine in comic books, but it would be forty-five years before she was drawn by a woman.

Beating **Wonder Woman** for the title of first costumed action heroine in any form of comics was Tarpe Mills's **Miss Fury**, which made its debut as a newspaper strip in April 1941, eight months before the birth of Marston's creation. Since 1938, Mills had been contributing to comic books with such characters as **The Purple Zombie**, **Devil's Dust**, **The Cat Man**, and **Daredevil Barry Finn**, the last named after a relative of the artist. Born June Mills, like

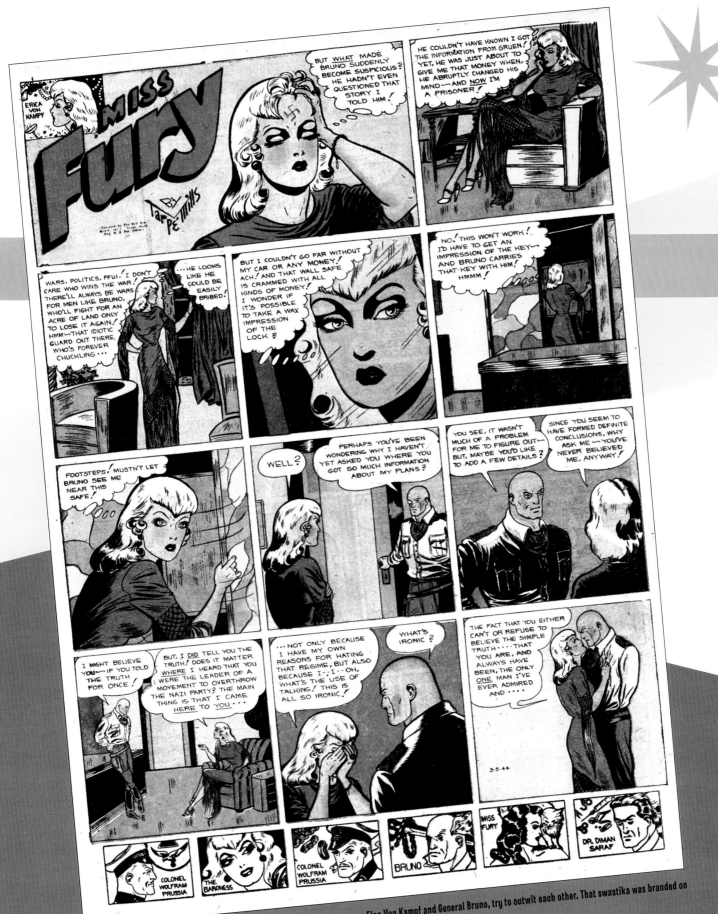

Tarpe Mills, MISS FURY, 1944. Two of the best villains in comics, the Baroness Elsa Von Kampf and General Bruno, try to outwit each other. That swastika was branded on the baroness' forehead!

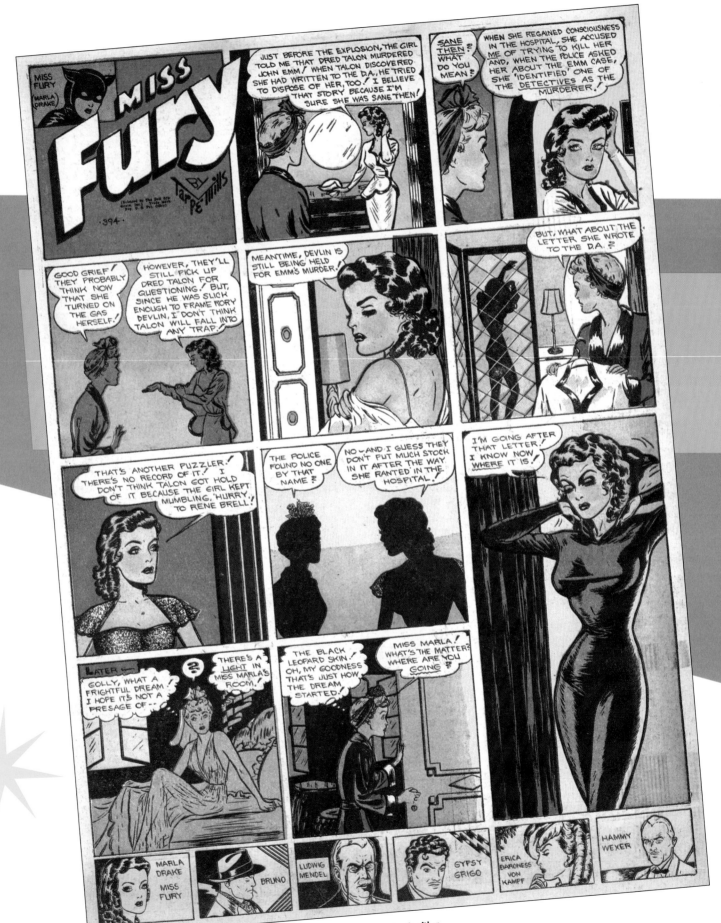

Tarpe Mills, MISS FURY, 1950. Marla Drake, in and out of her costume. Her maid is no slouch, either.

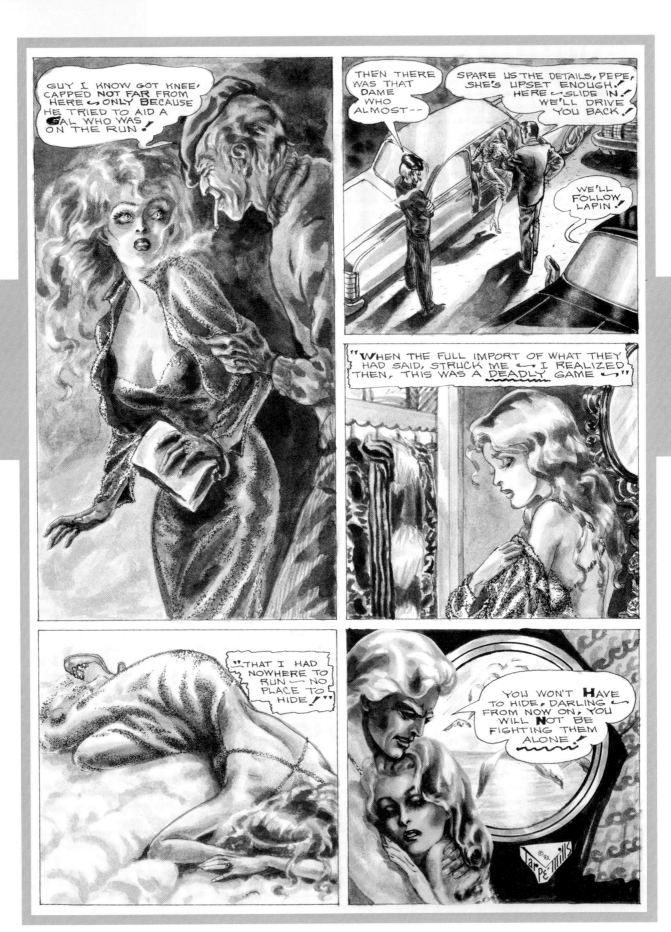

A page from Tarpe Mills's unpublished graphic novel.

Messick, she changed her name to a sexually ambiguous one, taking her mother's maiden name, Tarpe, upon entering the comics field. In a newspaper interview from the 1940s, she said, "It would have been a major letdown to the kids if they found out that the author of such virile and awesome characters was a gal."

Mills's gender did not stay secret for long. As her strip gained in popularity, newspapers carried articles about it, always including photos of its creator, who bore a startling resemblance to her protagonist, Marla Drake, the socialite who becomes Miss Fury upon donning a form-fitting panther skin.

Just as Messick had identified with her creation to the point of dyeing her own hair red and naming her daughter Starr, Mills put not only herself, but also her cat, into the strip. Both the artist and her protagonist had white Persian cats named Perri-Purr.

In 1945, the **Miami Daily News** ran a story titled, "Cartoon Strip Cat Goes Off To War," relating that Tarpe Mills had donated her cat to the war effort. Subtitled, "It's Sir Admiral Purr Now," the article related how Mills' Persian had become the mascot of an allied warship, and "... set out for distant places and unknown dangers, sound asleep in the commander's bunk." The article goes on to make it clear that the famous cat had the attitude of all cats through history: "'I'd be happier if he'd show a little emotion,' [Mills] said, before parting with the newly made admiral."

Mills had studied at New York's Pratt Institute, where she had modeled to pay her way through school. The training she received at Pratt, along with her early years in comics, stood her in good stead. From its first episode, **Miss Fury** was drawn beautifully. Like Messick, Mills filled her panels with glamour; both artists liked to depict their woman characters in frilly lingerie or bubble baths. Mills's strip was at times considered too racy. One episode, in which a character wore the equivalent of a bikini, so shocked the editors of thirty-seven newspapers that they canceled the strip that day. At a time when the average male cartoonist dressed his heroines in plain red dresses, the women cartoonists were paying attention to clothes. The continuities of **Miss Fury**, and those of **Brenda Starr**, can double as textbooks on fashions of the 1940s. Mills's strips, reminiscent of film noir, take the reader from the chic penthouses and nightclubs of wartime New York to underground Nazi installations and anti-Nazi guerrilla camps in Brazil. Along the way the reader meets some of the most unforgettable characters in the history of comics: Erica Von Kampf, the platinum blond adventuress with a swastika branded on her forehead; Albino Jo, the Harvard educated, albino Indian; Brazilian bombshell Era; and the one-armed German General Bruno Beitz.

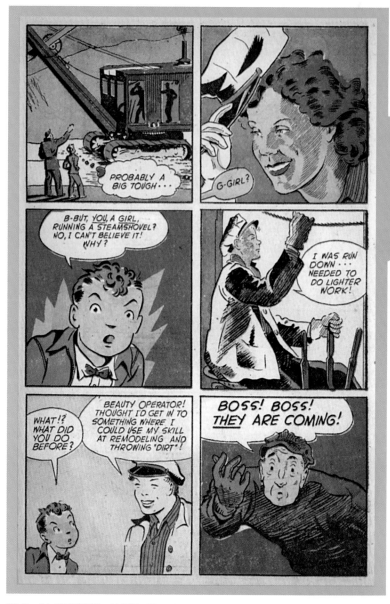

Odin Burvick, DICKIE DARE, mid-1940s. This strip has been repasted and reprinted in comic book form.

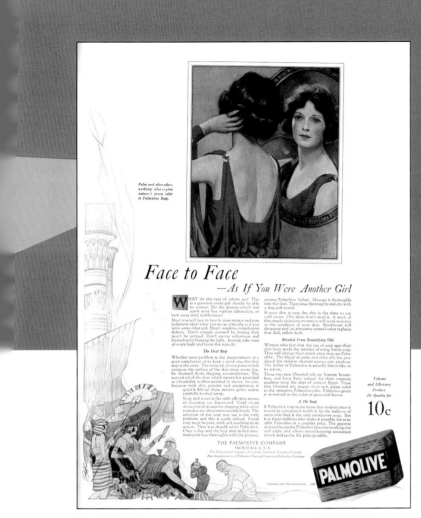

Neysa McMein, illustration for an advertisement for Palmolive soap, WOMAN'S HOME
COMPANION, 1923.

Neysa McMein, from a photo in MCCALL'S, 1933.

Because of this last character, **Miss Fury** got attention in the January 4, 1943 issue of **Time** magazine. An article, "Comic-strip Generals," likened "One-armed, egg-bald 'General Bruno' [who] is frustrated by Brazilian guerrillas in his campaign to open the way for an Axis invasion" to "his counterpart ... mysterious General Gunther Niedenfuhr ... military attachè in Brazil."

Miss Fury lasted through 1951, but Tarpe Mills was not finished with comics. In 1971, she returned briefly to illustrate a seven-page romance strip in Marvel Comics' **Our Love Story**. Unfortunately, her attempt to update her noir styling into something mod resulted in the equivalent of a vintage Joan Crawford dress that has been cut down into a mini. From 1979 until her death in 1988, the artist attempted unsuccessfully to sell a comic based on her wartime hero, Albino Jo. Sample pages demonstrate that Mills never lost her artistic touch, but editors of the 1980s were not receptive to the nostalgic look of her art.

There is a widely held belief that women cartoonists worked under male pseudonyms in order to sell their comic strips. This is only partially true. The artists Rose O'Neill, Grace Drayton, Ethel Hays, Nell Brinkley and their contemporaries had no trouble getting published under their own names. However, a male pseudonym did seem to be required for action strips, starting with Caroline Sexton who, in 1934, signed "C.M. Sexton" to **Luke and Duke**. From Cecilia Paddock Munson, who often signed her work either "Pad" or "Paddock Munson," to Ramona "Pat" Patenaude, to Dale Messick and Tarpe Mills, the women of the 1940s seemed to believe their success depended at least in part upon a male name.

Another woman who took a masculine name was Mabel Burwick; at the start of her career she changed her name to Odin Burvik. Originally hired as an assistant to cartoonist Coulton Waugh, by 1944, she had not only taken over his strip, **Dickie Dare**, but also married him. In the tradition of Marjorie Henderson ("Marge") and Edwina Dumm ("Edwina"), the artist signed her strip with her first name, "Odin."

Messick and Mills had changed their names to disguise their gender. Neysa McMein, born Marjorie, changed hers because she was advised to do so by a numerologist. A popular illustrator and portrait artist, McMein painted every cover of **McCall's** magazine from 1923 through 1938, and designed Gold Medal flour's trademark character, Betty Crocker, in 1936.

McMein had always been avant-garde in her lifestyle. In the 1910s, she had marched in pro-suffrage demonstrations, and in the 1920s, she was a member of the illustrious Algonquin Round Table. This group of well-known writers

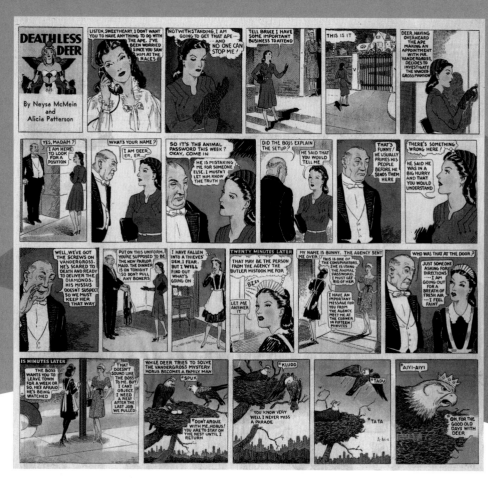

Neysa McMein, DEATHLESS DEER, 1942. The resurrected Egyptian Princess infiltrates a den of thieves, while her pet falcon, Horus, learns falcon domesticity.

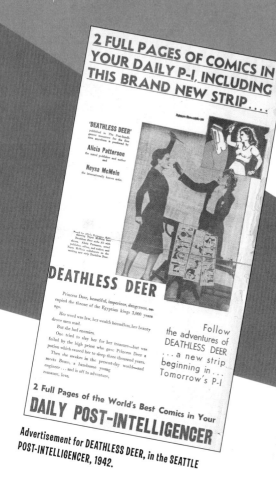

Advertisement for DEATHLESS DEER, in the SEATTLE POST-INTELLIGENCER, 1942.

and artists, who met at New York's Algonquin Hotel, included such luminaries as Dorothy Parker, Harpo Marx, and Alexander Woollcott.

Woollcott described her in an article for **McCall's**, 1933. He mentions a play called **The Joy of Living** and continues:

> **"I never knew what the phrase meant until I met Neysa McMein. And of the girls she draws for you, one and all, dark and fair, grave or gay, you know this one thing — that, like herself, they are enormously pleased with the privilege of being alive."**

If that sounds like the author may have been a little in love with his subject, the supposition is correct. In 1923, learning that McMein was on a ship about to depart for Europe, Woollcott boarded it, intending to propose to her. It was then that he learned that she had just married John Baragwanath, a mining engineer, and that the two of them were headed for separate honeymoons — she to Europe, and he to an expedition in Quebec. (Thanks to McMein's

many journalist friends, her unusual honeymoon prompted a flurry of newspaper and magazine articles with headlines like "A New Groom Sleeps Clean.")

Eventually this successful and unconventional woman tried her hand at a comic strip. **Deathless Deer**, drawn by McMein and written by newspaper publisher Alicia Patterson, made its newspaper debut in November 1942. Patterson, the daughter of Joseph Patterson, had also figured in the Dale Messick saga. When her father refusing to run **Brenda Starr**, she carried it in her newspaper, the **Long Island Free Press**. After Joseph Patterson died and the editors of the **Daily News** wanted to carry the strip, they tried to convince Alicia Patterson to drop it, because major newspapers prefer not to share their strips with smaller newspapers in surrounding neighborhoods. Patterson refused to part with **Brenda Starr**, and the strip appeared in both papers at the same time, an almost unheard-of occurrence.

An advertisement for **Deathless Deer** in the **Seattle Post-Intelligencer**, on November 1, 1942, describes it perfectly:

"**Princess Deer, beautiful, imperious, dangerous, occupied the throne of the Egyptian kings 3,000 years ago.**

"**Her word was law, her wealth boundless, her beauty drove men mad. But she had enemies.**

"**One tried to slay her for her treasure — but was foiled by the high priest who gave Princess Deer a potion which caused her to sleep 3,000 years.**

"**Then she awakes in the present day world — and meets Bruce, a handsome young engineer ... and thus is off to adventure, romance, love.**"

Today, **Deathless Deer** has fallen into total obscurity. One male collector has suggested that the strip was forgotten because the concept was so implausible. However, the story of a mummy coming back to life thousands of year later, done successfully in the mummy movies of the 1930s and more recently by novelist Anne Rice, is no more ridiculous than the idea of a baby from outer space landing on Earth and growing up to be Superman.

By 1942, America had gone to war. Most of the men drawing for comic books at that time were of draft age, and like men in all other industries in the country, they either volunteered or were drafted into the military. And, as in every other industry, women took their places. That year, the number of women working for comic books tripled, and their numbers stayed high until the end of the 1940s.

Few women drew the costumed heroes that had become so popular since the birth of Superman in 1938. Some exceptions were Ramona "Pat" Patenaude, who drew **Blue Beetle**, **V-Man**, **The Green Falcon**, **Dr Fung**, and **The Vision** during the early 1940s, and Peggy Zangerle, who drew **Doc Savage** and **Red Dragon** in 1948.

Most women artists seem to excel at drawing female characters, and that is what most of them did. In 1946 and 1947, Janice Valleau drew **Toni Gayle**, a glamorous fashion model/detective character, for Young King Cole comics, and in 1947, Nina Albright drew **The Cadet**,

"Her word was law, her wealth boundless, her beauty drove men mad. But she had enemies.

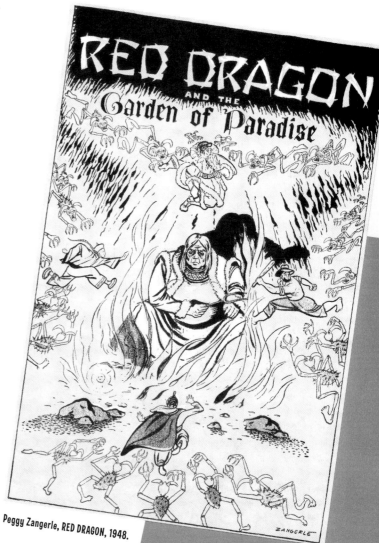

Peggy Zangerle, RED DRAGON, 1948.

Nina Albright, THE CADET, from TARGET COMICS, 1947.

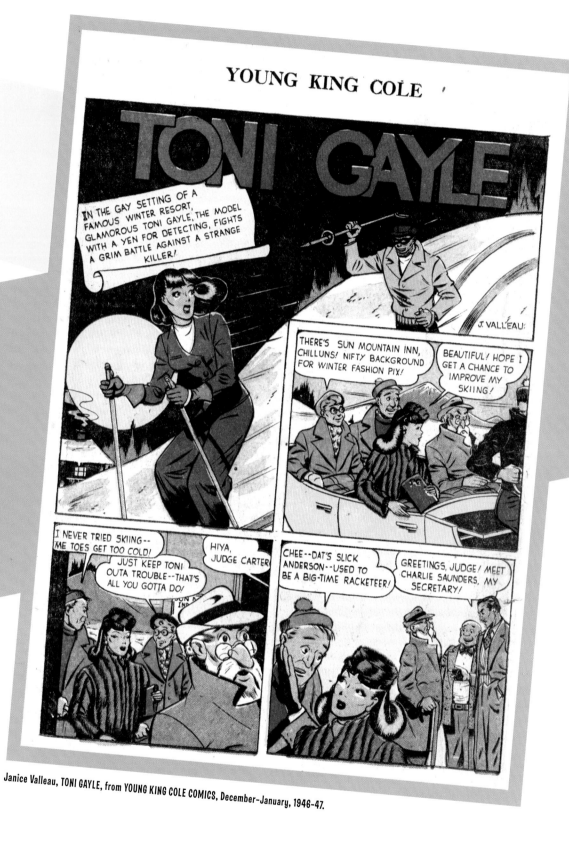

Janice Valleau, TONI GAYLE, from YOUNG KING COLE COMICS, December-January, 1946-47.

starring Kit Carter, for Target Comics. Although **The Cadet** had a male lead, it included strong female characters, in response to letters sent in by female readers asking for "special girl characters." The comic book printed a letter from Virginia Warsachi, of Omaha, Nebraska, who wrote: "Don't you think it would be a good idea to have a heroine in Target for a change?" and Sally Foos, of Warren, Ohio,

wrote : I think it would be very nice if there were some girls as it would make the comic more exciting."

Typical wartime heroine titles were **Yankee Girl**, drawn by Ann Brewster, or **Blond Bomber and Girl Commandos**, drawn by Jill Elgin from 1942–1945 and Barbara Hall from 1941–1943. Barbara Hall, now Barbara

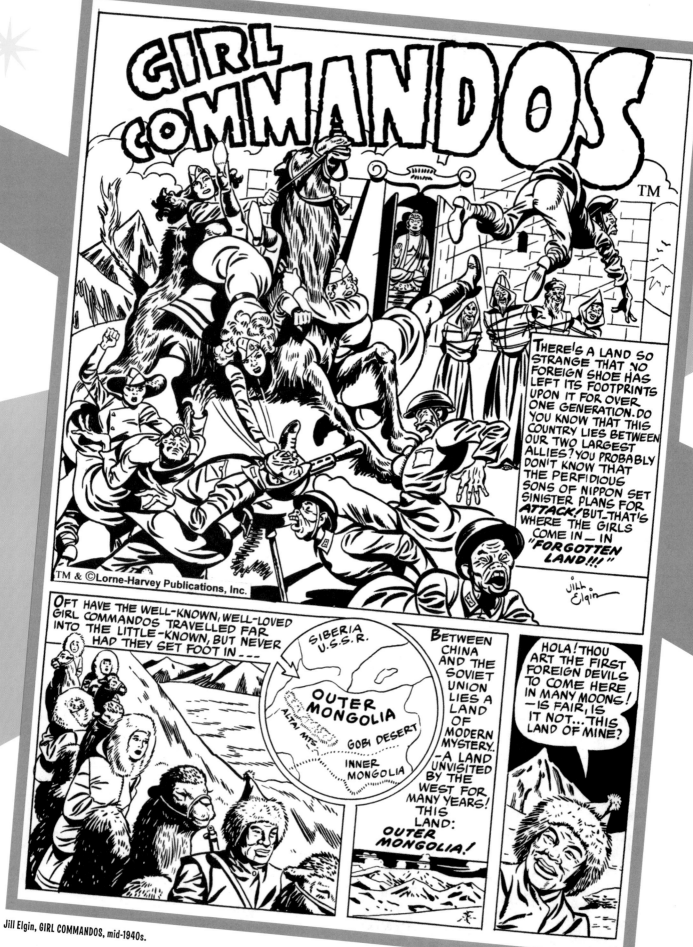

Jill Elgin, GIRL COMMANDOS, mid-1940s.

Calhoun, was showing her portfolios to science fiction magazines in hopes of obtaining some illustration work in 1941, when one of the editors suggested she try Harvey Comics. She was immediately hired to draw **Black Cat**, the first female superhero in comic books, and she went on to **Girl Commandos**, a strip featuring an international team of women, all fighting Nazis. She left comics when her husband-to-be persuaded her to give up cartooning and become an oil painter, a gain for the world of fine art, but a loss to comics.

Gladys Parker's **Mopsy** got into the act, and for the duration could be seen in her comics in the uniform of a Wac, a Wave, an army nurse, and a member of the motor

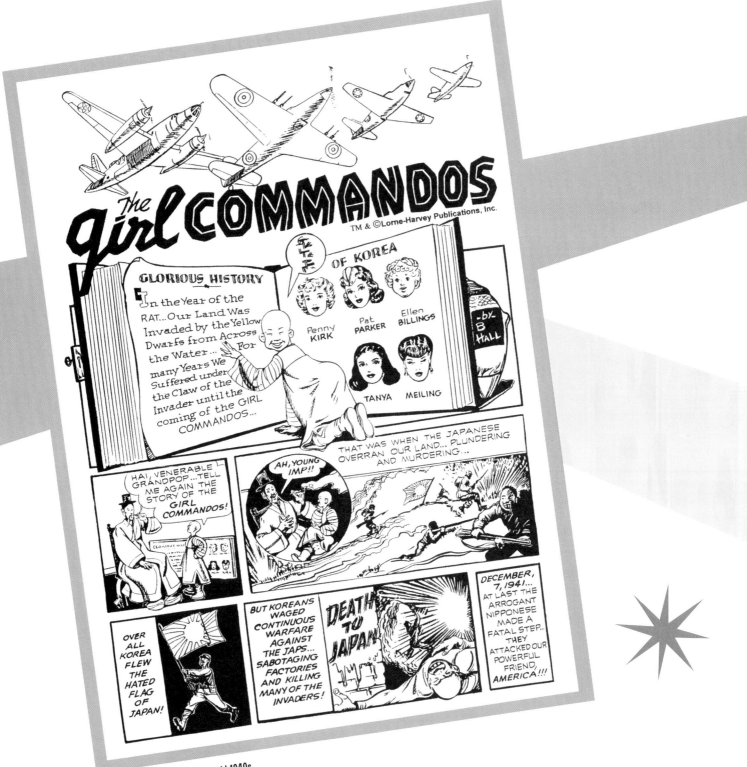

Barbara Hall, GIRL COMMANDOS, mid-1940s.

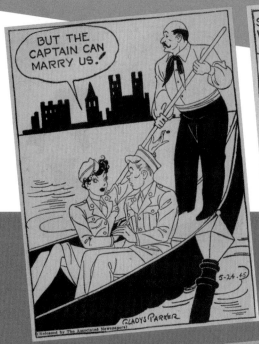

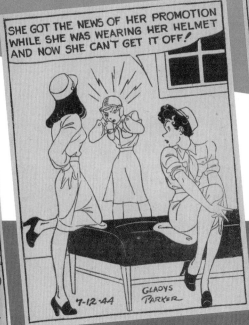

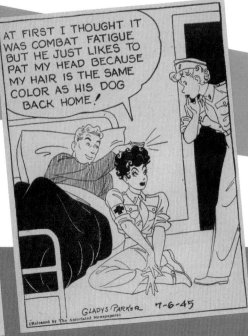

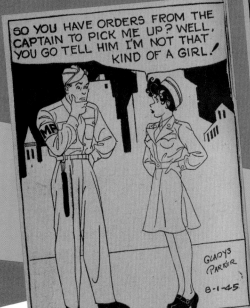

Gladys Parker, MOPSY joins the armed forces, 1944.

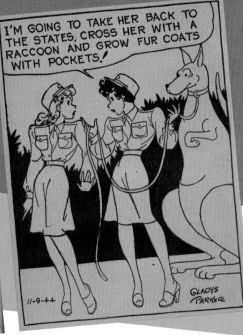

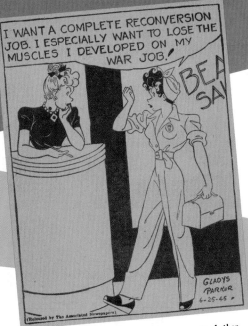
Gladys Parker, MOPSY, 1945. MOPSY, like thousands of other women, prepares to leave her war job.

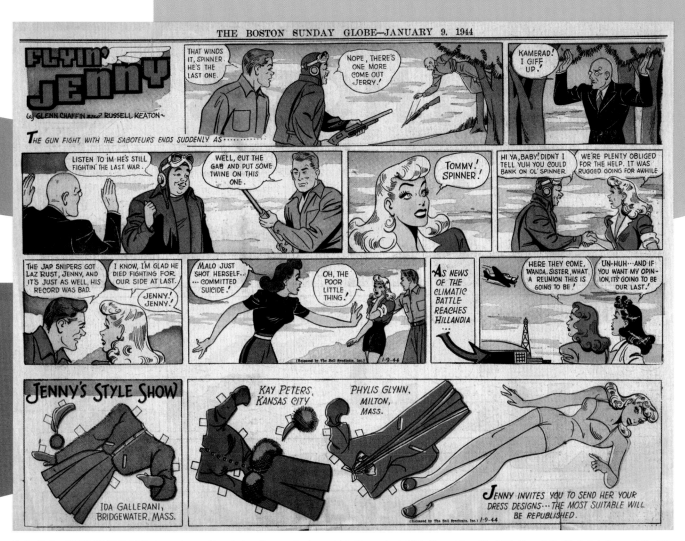

Gladys Parker, FLYIN' JENNY, 1944. Parker took over this strip from Keaton when he went into the service in 1943. Many strips of the 1930s through the 50s included paper dolls. This was usually a sign that women and girls liked the strip, as most boys were unlikely to cut out and play with dolls.

Jenny was a blond aviatrix who, like many wartime heroines, battled Nazis.

corps. Parker also took over the newspaper strip **Flyin' Jenny** when its regular artist, Russell Keaton, went into the service in 1943. Jenny was a blond aviatrix who, like many wartime heroines, battled Nazis.

Of all the comic book companies in the 1940s, one publisher hired more women cartoonists than any of the others. That was Fiction House, a company started in 1936 by Jerry Iger and Will Eisner, artist/creator of **The Spirit** comic strip.

The six Fiction House comic book titles — **Jumbo**, **Jungle**, **Fight**, **Wings**, **Rangers**, and **Planet** — specialized

in luridly sensationalistic stories with strong and beautiful female protagonists. Unlike comics from some of the other publishers, where the female characters seemed to exist only as foils for the hero to rescue, these women were in charge. Depending on the comic, they could be jungle girls, pilots, girl detectives, or outer-space heroines. Dressed in two-piece leopard skin bathing suits or ripped Army nurse uniforms, they leaped across the page in a graphic role reversal, guns blazing or knife in hand, to rescue some man. And they were likely to be drawn by women. Jean Levander and Fran Hopper drew the girl detective strip **Glory Forbes**; Ann Brewster, Lily Renée, and Fran Hopper drew **Jane Martin**, who started out as a

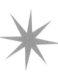
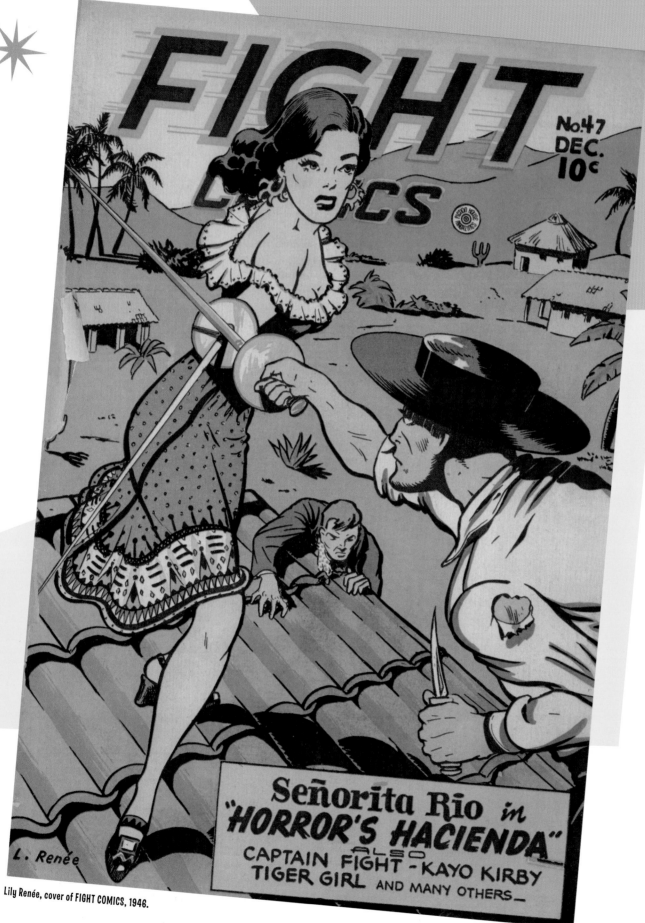

Lily Renée, cover of FIGHT COMICS, 1946.

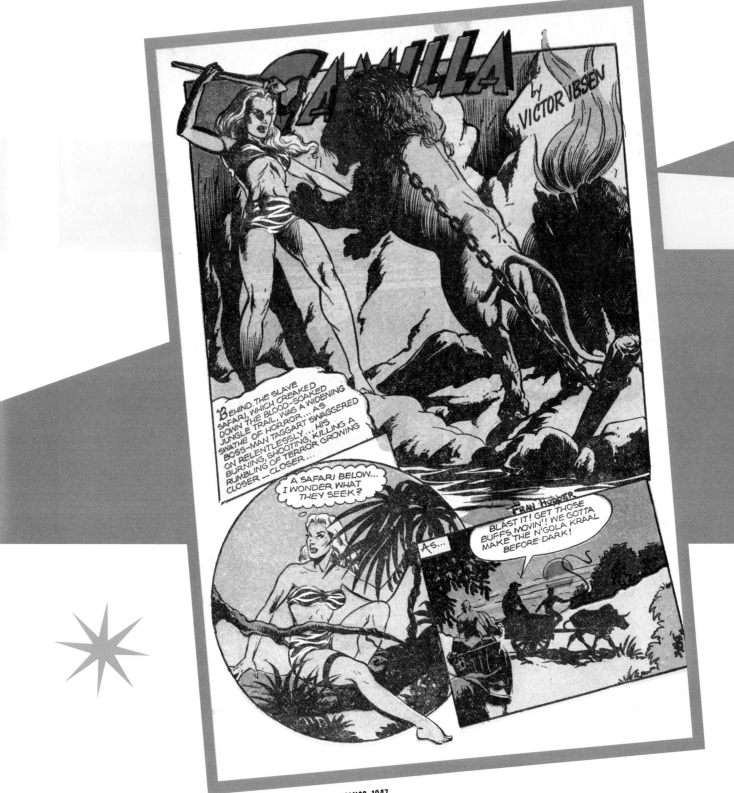

Fran Hopper, CAMILLA, from JUNGLE COMICS, 1947.

war nurse and wound up as an aviatrix; Marcia Snyder and, again, Hopper, drew the jungle heroine **Camilla**. Ruth Atkinson, who was also the company's art director, was an exception to the rule, drawing **Skull Squad**, a series about male flyers, and **Wing Tips**, a series of single pages about planes.

For Fiction House's science fiction title, **Planet Comics**, the prolific Hopper drew **Gale Allen and Her All Girl Squadron** and **Mysta of the Moon**. While Mysta was a sort of goddess who lived on a satellite of planet Earth, the All Girl Squadron were more like Wacs of the future, battling evil on other planets. Like many female artists,

Ruth Atkinson, WING TIPS, from WINGS COMICS, circa 1945 or earlier.

Ruth Atkinson at Coney Island, during the period when she was art director for Fiction House.

Hopper drew women beautifully, but her weak point was men. These stories, with mostly female characters, suited her perfectly.

Unquestionably, the star woman cartoonist on the Fiction House staff, and the only woman who ever drew a cover for them, was Renée. From 1943 through 1948, her elegant art graced the pages of their books. Although she contributed some light and cartoony filler pages, such as **Tess Taxi**, her best work could be seen in **The Lost**

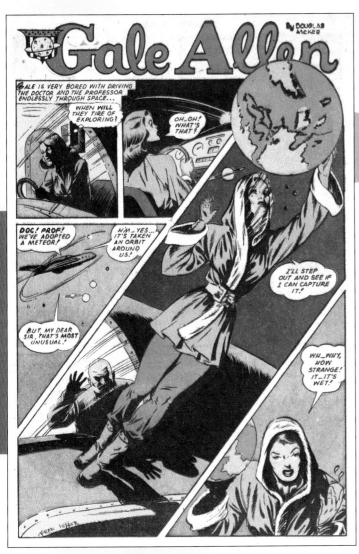

Fran Hopper, GALE ALLEN, from PLANET COMICS, 1945.

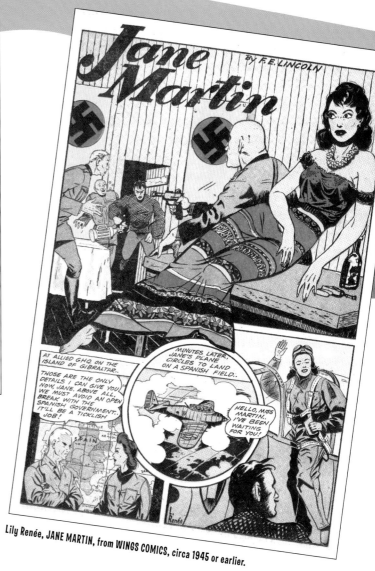

Lily Renée, JANE MARTIN, from WINGS COMICS, circa 1945 or earlier.

World, **Senorita Rio**, and **Werewolf Hunters**. **The Lost World**, the lead story in **Planet Comics**, took place in a post-apocalyptic future. Amid ruins of New York City a plucky group of survivors, led by Hunt Bowman and his fetchingly ragged companion, Lyssa, battled the Voltamen, their green-skinned and Nazi-like alien conquerors. **Senorita Rio**, who starred in **Fight Comics**, was a Brazilian nightclub entertainer who fought Nazis in her spare time. The character bore a strong resemblance to Tarpe Mills's Brazilian anti-Nazi guerrilla leader, Era.

Renée was another artist whose renderings of women far surpassed that of men, and **Werewolf Hunters**, a horror/fantasy strip, inspired some of her most decorative and imaginative art, with stories that often involved some mystic or supernatural woman character.

While newspaper strips were usually written and drawn by the same person, the comic book industry was less personal, and none of the women cartoonists wrote the strips they drew. In the case of Fiction House, the stories were

often written by a woman, too. From 1940, when she was only 20 years old, until 1961, Ruth Roche, sometimes using the male pseudonym Rod Roche, was first the company's major writer, and later editor. Although women writers worked for both Fiction House and other comic book companies, Roche probably wrote more comics during the 1940s than any other woman who was not also drawing her own strip.

When the war ended, women in every industry were encouraged to vacate their jobs in favor of the returning men. In the world of comics, where women had been working since 1901, the back to the kitchen movement took a different form. Although women continued to draw lighter strips through the 1950s, the men took back action comics. By 1951, when **Miss Fury** ended, **Brenda Starr** was the only adventure strip that starred a woman and was drawn by a woman. The women had stopped drawing action strips.

Lily Renée, THE LOST WORLD, from PLANET COMICS, 1946.

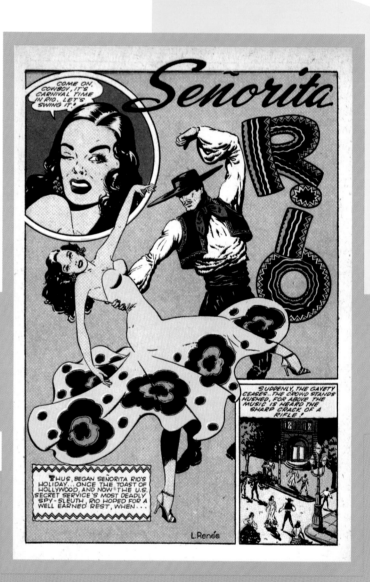

Lily Renée, SEÑORITA RIO, from FIGHT COMICS, 1945.

By 1951...women had stopped drawing action strips.

Lily Renée, WEREWOLF HUNTER, from RANGERS COMICS, 1946.

Olive Bailey, cover, LAND OF THE LOST, 1947.

Part Five

Tradition

All during the 1940s, women continued drawing comics about children, as they had been doing since the beginning of the century. Now, with the advent of action-oriented comic books, came action strips featuring children. As early as 1938, Claire S. Moe drew a series of children's adventure strips with circus-related themes for Centaur's **Funny Pages**. **The Circus and Sue**, **Circus Days**, and **Little Mary of the Circus** were all exciting serials reminiscent of films from the period featuring Shirley Temple.

Olive Bailey, 1947,

That same year, 1938, Corrinne Boyd Dillon produced a strip called **Jigger**, and Jean Hotchkiss drew one called **Donnie Stuart**, both for **Globe's Circus, the Comic Riot**. Despite the book's title, these comics were not about the circus; both strips told the story of a young boy, one with his dog, and one with his sister.

In 1946 and 1947, the team of writer Isabel Manning Hewson and artist Olive Bailey adapted the popular radio program, **Land of the Lost**, into comic book form. The strip chronicled the adventures of two children, Isabel and Billy, in an undersea fantasy kingdom, pitting them against such villains as Spondo, leader of the notorious devilfish, and Uriah Slug.

Throughout the 1940s, Vee Quintal Pearson illustrated a series of strips for Catholic comic books such as **Heroes All** and **Treasure Chest**. These comics, distributed free at parochial schools and churches, featured stories of saints and other role models for Catholic children.

Meanwhile, on the Sunday pages of the newspapers, it seemed as though all the cute kids from the early years of the century had finally grown into teenagers. The new teens of the 1940s differed from the carefree coeds of the 1920s and the sincere, hard-working Depression kids. Clad in cuffed dungarees and big shirts, they lounged around in rag doll positions, talking interminably on the phone. The girls moped about boys, and the boys, perpetually skinny, raided the refrigerators of their girlfriend's parents.

December 7, 1941 was not a day in which people were likely to spare much time for the funny pages of their local newspaper, so many Americans missed the debut of Hilda Terry's **Teena**, the first of many teen girl strips to be drawn by women throughout the next twenty-odd years. Terry's adorable bobbysoxer survived the war and, in fact, lasted until 1966.

Teena had been running successfully for eight years when, in 1949, Terry sent the following letter to the then all-male National Cartoonists Society:

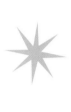

The new teens of the 1940s differed from the carefree coeds of the 1920s and the sincere, hard-working Depression kids.

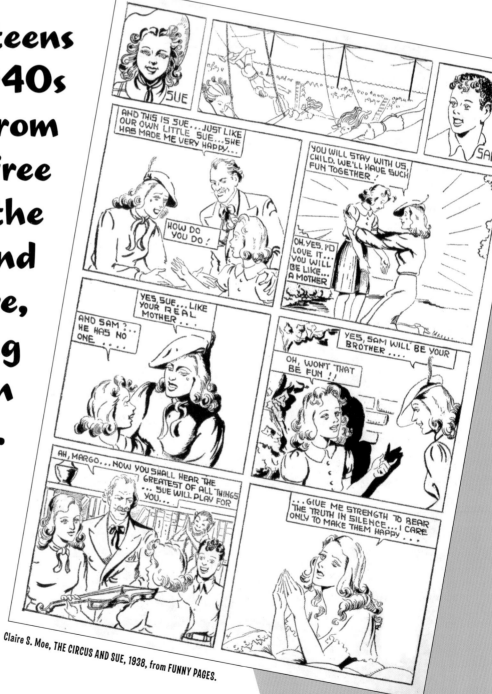

Claire S. Moe, THE CIRCUS AND SUE, 1938, from FUNNY PAGES.

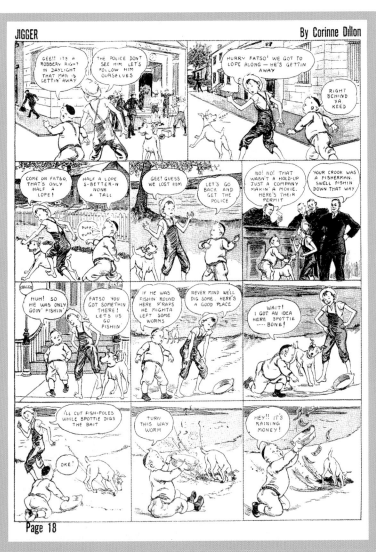

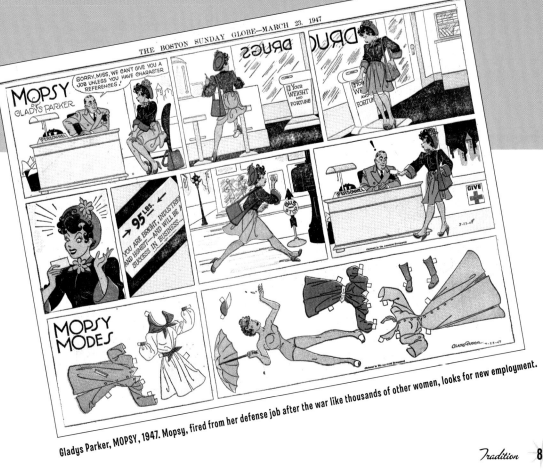

Gladys Parker, MOPSY, 1947. Mopsy, fired from her defense job after the war like thousands of other women, looks for new employment.

In the late 1930s, Dorothy Hughes drew the syndicated panel cartoon, ANGELINA'S LINE A DAY, in the manner of all the Ethel Hays-inspired cartoons of the 1920s and 1930s. By the mid-1940s she was drawing another single panel cartoon, JINGLE BELLES, and the charming teen strip, PAT AND JUDY. Despite the lovely art, it is not known whether the last two strips ever saw print.

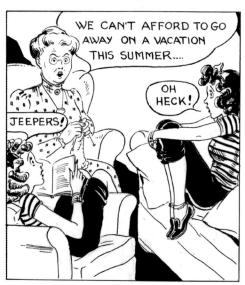

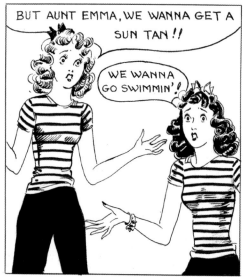

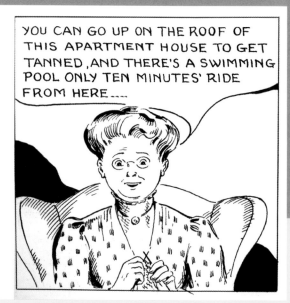

Dorothy Hughes, PAT AND JUDY, mid-1940s.

"Gentlemen:

"While we are, individually, in complete sympathy with your wish to convene unhampered by the presence of women, and while we would, individually, like to continue, as far as we are concerned, the indulgence of your masculine whim, we find that the cost of your stag privilege is stagnation for us, professionally. Therefore, we appeal to you, in all fairness, to consider that: **WHEREAS** there is no information in the title to denote that it is exclusively a men's organization, and **WHEREAS** a professional organization that excludes women in this day and age is unheard of and unthought of, and **WHEREAS** the public is therefore left to assume, where they are interested in any cartoonist of the female sex, that said cartoonist must be excluded from your exhibitions for other reasons damaging to the cartoonist's professional prestige, we most humbly request that you either alter your title to the National Men Cartoonists Society, or confine your activities to social and private functions, or discontinue, in effect, whatever rule or practice you have which bars otherwise qualified women cartoonists to membership for purely sexual reasons.

Sincerely,

The Committee for Women Cartoonists
Hilda Terry, temporary Chairwoman"

Hilda Terry, TEENA, 1955.

Marty Links in 1954.

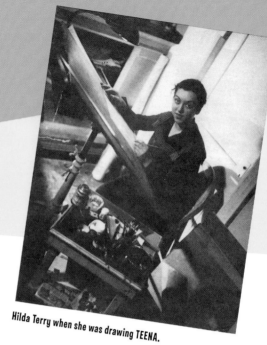

Hilda Terry when she was drawing TEENA.

"The language in the press box gets pretty salty for a lady's sensibilities."

Despite fifty years of women cartoonists, the NCS, founded in 1946, gave as their reason for excluding women that if women were present at meetings of the prestigious group, the men wouldn't be able to curse. Sadly, this was not the last time this excuse was used to exclude women from all-male groups. In a July 12, 1992 column for the **San Francisco Examiner**, journalist Stephanie Salter reminisced about how, in the late 1960s, she was denied press box credentials to cover a football game for her college paper. She was told it was "for [her] own protection. The language in the press box gets pretty salty for a lady's sensibilities."

After Hilda Terry's letter, it was agreed that women should be allowed to join the organization, and in fact a second woman, magazine cartoonist Barbara Shermund, was also nominated for membership. However, when Terry's and Shermund's membership came up for a vote in 1950,

despite the recommendation of **Flash Gordon** artist Alex Raymond, chairman of the membership committee, who said, "I believe that we should admit people for professional ability alone," Terry and Shermund were blackballed. This vote prompted a major conflict within the group; several cartoonists objected to it vigorously and vociferously — among them Milton Caniff and Al Capp. The result was another vote, and this time, the two women were accepted into the organization. As soon as Terry became a member, she put forth the names of Gladys Parker and her other women cartoonist friends, thus breaking the gender barrier of the NCS.

After the demise of her strip, Terry went on to pioneer in yet another field, computer animation. Going from city to city, she animated caricatures of major league baseball stars for sports stadium scoreboards around the country. Terry, who had wanted to be a sports cartoonist

before doing **Teena**, finally attained her goal, and in 1979, she was given an award for best animation cartoonist from the same organization that had blackballed her thirty years before, the National Cartoonists Society. Today, although she could hardly be considered retired (she teaches classes twice a week at New York's Art Students League, and swims at the Y every day), she stays home and writes.

The bobbysoxer, a creation of the 1940s, had by 1944 also become the name of a new teen strip by Marty Links, **Bobby Sox**. Links joined the National Cartoonists Society shortly after Terry, and found that even after she had sent the NCS an announcement of the birth of her first child, all the correspondence she received from them was still addressed to "Mr. Links." She admits to being annoyed enough to briefly consider mailing them her bust measurements.

While Terry, who had no children, got her inspiration from volunteer work with various girl groups — Blue Birds, Campfire Girls, and American Youth Hostels —

Links had to look no further than her own home. When she needed to draw the classically messy bedroom of her character, Emmy Lou, she would just peer into the bedroom of her own teenaged daughter. Links decided to retire **Bobby Sox** in 1979, saying that she felt the strip no longer represented the teens of the day. Today she draws greeting cards for Hallmark, but at a time when there are so few newspaper strips by women, and when even fewer are as well drawn as **Bobby Sox**, her strip is sorely missed.

A third comic, similar in style and equal in quality to **Teena** and **Bobby Sox**, was **Susie Q Smith**, drawn by Linda Walter and written by her husband, Jerry Walter. **Susie Q Smith** was syndicated to newspapers and also had its own comic book, published by Dell.

The same year **Bobby Sox** started in newspapers, Virginia Clark, who had drawn so many beautiful flapper strips during the 1920s and 1930s under the name Virginia Huget, took over the strip **Oh, Diana!** from cartoonist Don Flowers. Flowers, best known for his strip **Modest**

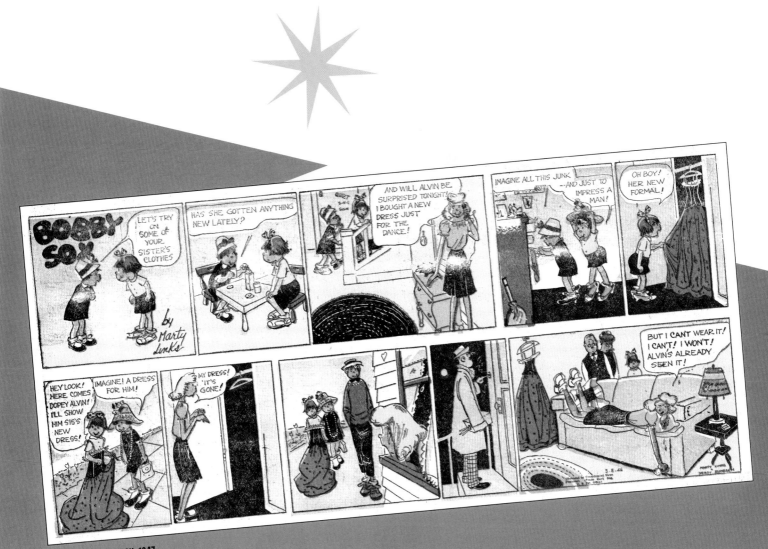

Marty Links, BOBBY SOX, 1947.

Virginia Clark, OH, DIANA!, 1944.

Reprinted with special permission, King Features Syndicate.

Linda Walter, SUSIE Q. SMITH, written by Jerry Walter, 1951.

Promotional article for OH, DIANA!

Maidens, drew women in a uniquely pin-up style. A promotional article from The Associated Press News Features, the syndicate that distributed **Oh, Diana!**, describes it as an adventure strip drawn by Flowers. However, when Virginia Clark took it over, she turned it into another teen strip, "... to fit the trend," said the article, "toward pleasing youth." The amazingly versatile Clark, who ten years earlier had been able to perfectly mimic Percy Crosby's style, now changed her drawing to imitate Flowers.

It should be no surprise that a trait held in common by all these artists of teen strips was an acute awareness of fashion. Walter, Terry, and Links had all worked in the fashion field before going on to comics, and another promotional article about Virginia Clark's **Oh, Diana!** reads, "Diana's authentic, smartly- styled clothes have added appeal for women readers."

It didn't take comic books long to catch up with newspaper strips. In 1945, Sergeant Stan Lee, newly mustered out of the armed forces, resumed his prewar position as editor and art director at a line of comic books published by his uncle, Martin Goodman. These books, bearing many different names, would eventually become Marvel comics, the largest comic book publisher in America. They included super hero titles and comics with a teen theme, aimed primarily at young girls. That same year, Ruth Atkinson, one of the many women who drew for Fiction House, had been promoted to art director. Unhappy with her new position, which left her unable to draw, she quit Fiction House and became a freelancer. Two of her first jobs were for the comic books edited by Lee, and consisted of drawing the first issues of both **Millie the Model** and **Patsy Walker**. Of all the teen comics edited by Lee for the next twenty years, those two titles became the most successful and longest lasting. Although Atkinson only drew the first

Virgina Clark, around the time that she was drawing OH, DIANA!

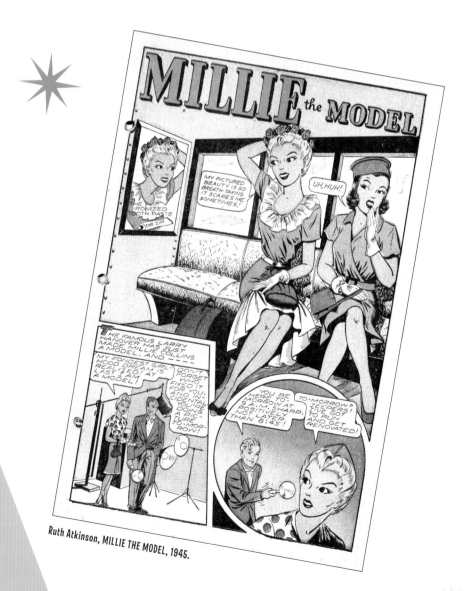

Ruth Atkinson, MILLIE THE MODEL, 1945.

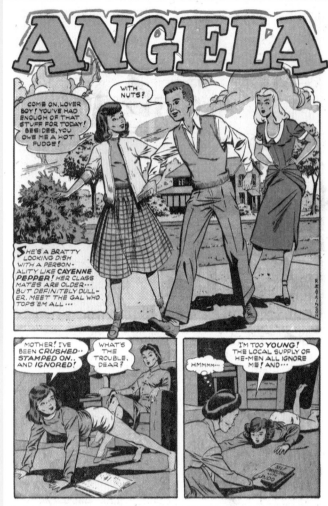

Ruth Atkinson, ANGELA, from CLUB 16, 1948.

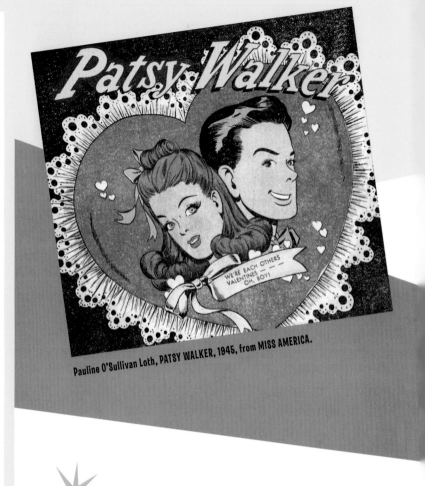

Pauline O'Sullivan Loth, PATSY WALKER, 1945, from MISS AMERICA.

...when drawing for Esquire, she was not own female first name, and so had

issue of **Millie the Model**, she stayed with **Patsy Walker** for the comic's first two years, moving from there to yet another teen comic called **Club 16**, for which she drew yet another teenage girl, Angela.

Patsy Walker first ran in 1944, in a magazine called **Miss America**, subtitled **Teen Life**. The magazine also featured comics starring the teenaged super heroine named for the magazine, **Miss America**. Then, both **Patsy Walker** and **Miss America** were drawn by Pauline O'Sullivan Loth, who doubled as the magazine's fashion editor.

In 1946, **Miss America** printed **Taffy**, a two page teen-advice column done in comic strip form by Phyllis Muchow, who had already drawn for **Coronet** and **Esquire** (when drawing for **Esquire**, she was not allowed to use her own female first name and had to sign her art P. Muchow). By 1947, the magazine had switched from **Taffy** to **Rusty**, a similar strip drawn by a woman who signed her work either with her initials, D.M.S., or with her first name, Dottie.

By the mid-1940s, the comic book industry, concerned with turning out comics quickly and cheaply, had evolved

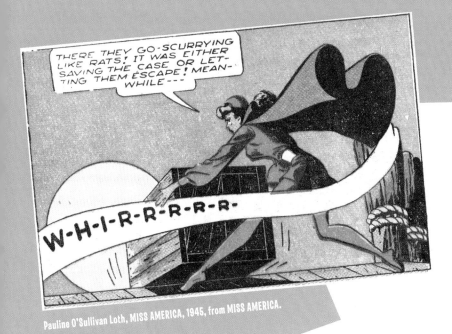

Pauline O'Sullivan Loth, MISS AMERICA, 1945, from MISS AMERICA.

Pyllis Muchow at Coney Island, with a copy of ESQUIRE,
to which she had contributed under a man's name.

allowed to use her to sign her art P. Muchow.

Phyllis Muchow, TAFFY, 1946, from MISS AMERICA.

into an assembly-line process in which one person wrote the scripts, another illustrated them in pencil, another artist inked over the penciled art, and a fourth did the lettering. Oddly, despite the long history of women writers and artists in the field, women inkers remain a rarity to this day. Why this particular part of the comic book process should remain the last bastion of maleness is a mystery.

However, there are and have been exceptions. In Stan Lee's 1947 book, **Secrets Behind the Comics**, he refers to "Violet Barclay, glamorous girl inker of **Rusty** and many other strips." Barclay, who was only 18 years old when she went to work for Lee, and later changed her first name to Valerie, was another woman who was heavily

Violet Barclay, "Glamorous Girl Inker," from SECRETS BEHIND THE COMICS, 1947.

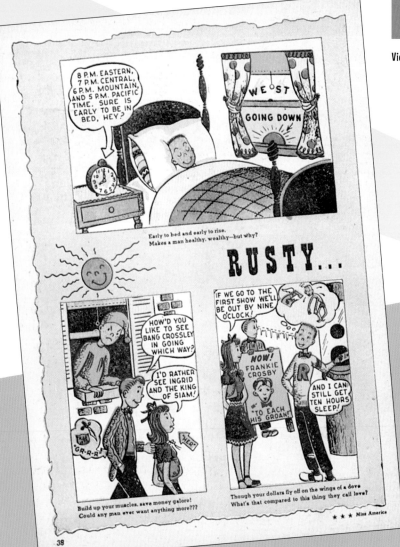

Dottie (last name unknown), RUSTY, 1947, from MISS AMERICA.

Valerie (Violet) Barclay when she was working for TIMELY COMICS.

Lilian Chestney, ARABIAN NIGHTS, 1943, from CLASSICS ILLUSTRATED.

influenced by Nell Brinkley as a child. She never really liked working on the more cartooney comics of the Stan Lee-Martin Goodman teen line, preferring romance comic books, for which she could draw beautiful women. She remembers that Stan Lee used to give his artists two-hour breaks, during which they would drink coffee and go through magazines, cutting out illustrations by "pretty girl" artists like Al Parker and Jon Whitcomb, which they would add to their "swipe file," for copying later in their love comics. After comics, Barclay went into fashion illustration and commercial art, and fittingly, eventually drew a number of Pop art ads in her old romance comics style.

Today she paints portraits in the style of John Singer Sargent for her own enjoyment.

Ann Brewster, one of the Fiction House artists, inked over the pencils of Robert H. Webb for the Classics Illustrated adaptation of **Frankenstein and Mr. Midshipman Easy**, as well as drawing for Classics Illustrated herself. Another woman who drew for Classics was Lillian Chestney. With a style much more closely related to fairy tale illustration than to comics, she was perfectly suited to adapt **Gulliver's Travels** and **Arabian Nights** into comic form. Back in 1937, Merna Gamble adapted **A Tale of Two Cities** into

comic book form, not for Classics, but for National Comics, which later became DC Comics.

Editors of the post-war years, who seemed to reject the idea of women drawing action strips, obviously found no fault with these artists drawing teenage comics. Another genre in which women were welcome was the burgeoning field of romance comics, which had started in 1947. With few exceptions, the stories in these books were hackneyed and cliched, but the art was often stylish and elegant, allowing women artists to draw what they seem to prefer drawing: Graceful closeups of women's faces. Kirkpatrick, Brewster, Atkinson, and Barclay all found their niche in books with such titles as **Love Romances**, **Lover's Lane**, **Young Love**, and **Complete Love**.

If women cartoonists were still accepted in the more traditional teen and romance comics, one would expect to also find them in funny animal comics. However, research has uncovered few women working in that

Valerie Barclay, SPURNED!, 1954, from COMPLETE LOVE.

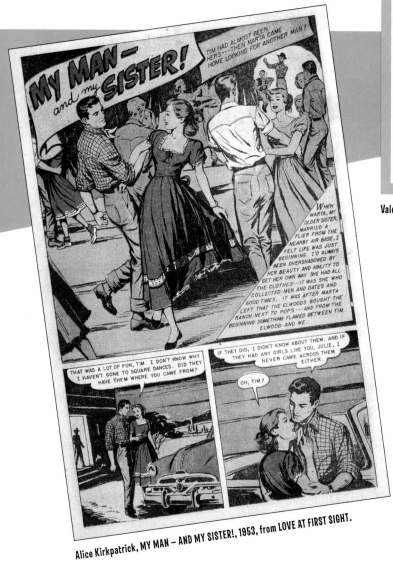

Alice Kirkpatrick, MY MAN – AND MY SISTER!, 1953, from LOVE AT FIRST SIGHT.

field. Dotty Keller drew funny animal strips for Timely Comics briefly during the war and Etta Parks drew **Red Rabbit**, a funny animal parody of cowboy comic hero Red Ryder, from 1949–1951. Now working under her married name of Etta Hulme, she draws editorial cartoons for the **Fort Worth Star-Telegram**. Hulme, who has worked in this field for twenty years, confesses to being at least "mildly offended" upon reading in a

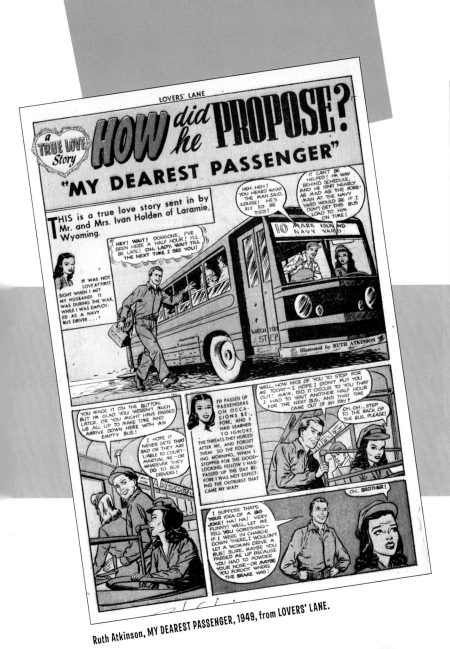

Ruth Atkinson, MY DEAREST PASSENGER, 1949, from LOVERS' LANE.

Ruth Atkinson, HOW DID HE PROPOSE?, 1949, from LOVERS' LANE.

Another genre in which women were welcome was the burgeoning field of romance comics, which had started in 1947.

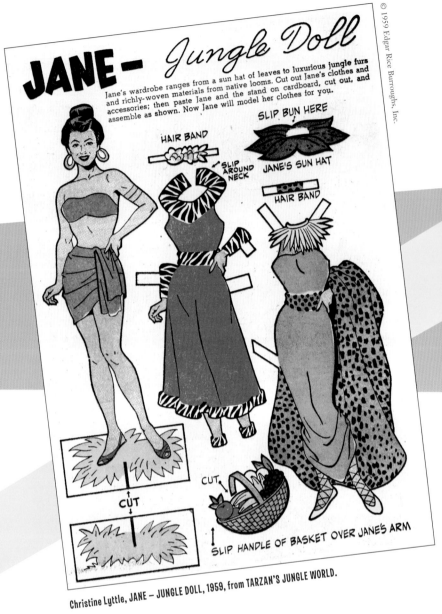

JANE— *Jungle Doll*

Jane's wardrobe ranges from a sun hat of leaves to luxurious jungle furs and richly-woven materials from native looms. Cut out Jane's clothes and accessories; then paste Jane and the stand on cardboard, cut out, and assemble as shown. Now Jane will model her clothes for you.

HAIR BAND

SLIP BUN HERE

SLIP AROUND NECK

JANE'S SUN HAT

HAIR BAND

CUT

CUT

SLIP HANDLE OF BASKET OVER JANE'S ARM

Christine Lyttle, JANE — JUNGLE DOLL, 1959, from TARZAN'S JUNGLE WORLD.

Christine Smith, from THE WESTERNER, 1956. Smith is the third from left, holding a coffee cup, facing front. She was the only woman artist at Western. All the others were secretaries.

book about editorial cartooning, **The Ungentlemanly Art**, that there are no women editorial cartoonists.

In the mid-1950s, Christine Lyttle, then using her married name Christine Smith, applied for work at Western Printing and Lithography, the company that produced comics for both the Dell and Whitman publishing companies. After being told that Western "didn't hire girls," the company took her on to do erasures and corrections for six weeks before reluctantly allowing her to draw. During her years with Western, Lyttle wrote and drew novelty pages, comic pages, and inside front and back covers for various comic books including **Roy Rogers**, **Little Lulu**, **Tarzan**, and such Walt Disney books as **Mickey Mouse Almanac**, **Silly Symphonies** and **The Sleeping Beauty**. During all

these years, the only artistic credit she was ever given in print was in an **I Love Lucy** coloring book, which she drew in 1959.

After she left comics, Lyttle went on to become a painter and a courtroom artist, covering among other trials, that of serial killer Ted Bundy.

Marie Severin, possibly this country's most respected woman super-hero artist, has a similar recollection. During the same years Lyttle worked for Western, Severin's employer, EC Comics, was experiencing difficulties due to the recession in the industry, and she knew it was time to look for other work. Severin had heard that Walt Disney Productions had offices in New York City, so she looked

Christine Lyttle, rough sketch for a rejected novelty comic book page, along with a letter from the editor, explaining the reason for rejection.

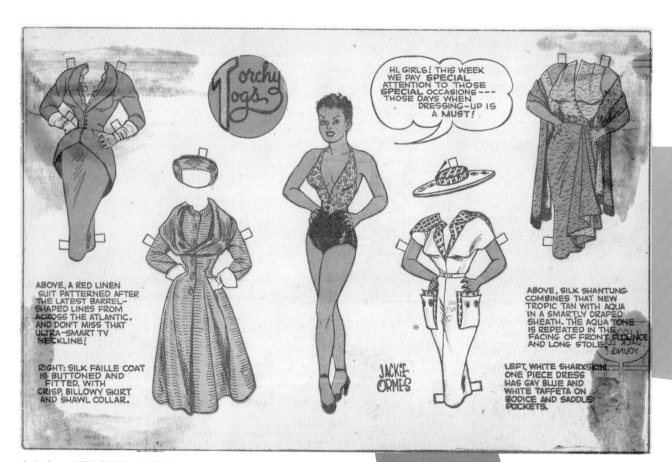

Jackie Ormes, TORCHY'S TOGS, circa 1950.

them up. At the front desk, a small man with a Disney mustache did not bother to look at her portfolio. Instead, he informed her that Disney didn't hire women. "No women? Not at all?" stammered the aghast artist, who had been used to more egalitarian treatment at EC. The little man replied, "Follow me, I'll show you." He led her to a huge room with orderly rows of desks. At each desk was a lamp, and under each lamp sat a man in a white shirt, drawing. "See?" said the little man. Severin realized that she wouldn't want to work at a place like that, anyway.

It goes without saying that all those white-shirted men working for Disney were white, white-shirted men. If, after the war, action-oriented comics became a male-only domain, all nationally syndicated comics were and had been a white-only domain. Only three African-American cartoonists had managed to break the color barrier in comics during the entire first half of the century, and they had all been men. It is safe, then, to assume that it never occurred to Jackie Ormes, an African American woman, to attempt selling her comic strip, **Torchy Brown**, to any white-owned newspaper or syndicate. So, in 1937, **Torchy Brown** in **Dixie to Harlem** debuted in the black-owned **Pittsburgh Courier**, and was syndicated to fourteen other black newspapers around the country. The start of

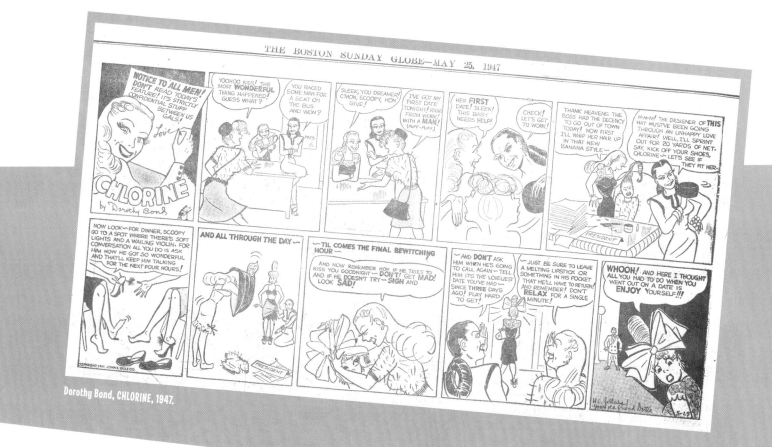

Dorothy Bond, CHLORINE, 1947.

Ruthee, THE GIRL FRIENDS, circa 1950s, a strip in the same sarcastic vein as CHLORINE. The artist's last name is unknown.

the strip found its young heroine leaving her farm in the South to find work in New York's famous Cotton Club. As the story proceeded, she encountered romance and danger in Harlem. In 1940, Ormes's strip went on a ten-year hiatus, during which time Ormes drew two single-panel cartoons — **Candy**, about a black maid, and **PattyJo 'n'Ginger**. PattyJo, her little girl heroine, was manufactured as a doll in the late 1940s and early 1950s and is believed to be America's first black character doll. Then, in 1950, Torchy returned to the comics page of the **Courier** in **Torchy Brown's Heartbeats**. In the style of her popular white sister, Brenda Starr, the beautiful black heroine found herself lost in the jungles of Brazil, caught in the clutches of a boa constrictor, or on a tramp steamer, fighting off the advances of a villainous first mate in the middle of a hurricane. Always she moved from love interest

to love interest. Like so many other women cartoonists before her, Ormes included paper dolls on the Sunday page, **Torchy's Togs**. But instead of a Mystery Man, Torchy Brown was more likely to fall in love with a jazz musician or a young black doctor struggling to keep his clinic together in the rural South. What kept **Torchy Brown** from being a black soap opera was Ormes's treatment of segregation, bigotry, and, in an age when ecology was a virtually unknown word, environmental pollution.

Jackie Ormes is believed to be the first (and until recently, the only) black woman to have her own syndicated comic strip, but at least one other black woman cartoonist has been found. During the 1950s, Doris McClarty drew the jivetalking **Fireball Freddy** for **Hep**, a black humor magazine based in Texas, and published by Sepia.

Dorothy Bond.

Edna Kaula, SALLY, 1958.

Her wit had a tendency to be sassy.

If the heroines of woman-drawn strips could no longer be detectives, counter spies or aviatrixes, the more traditional jobs were still open to them. Included in the teen line written by Stan Lee were **Tessie the Typist** and **Nellie the Nurse**, and during the late 1940s, Dorothy Bond syndicated a strip dedicated especially to secretaries, **Chlorine**. Bond's strip is so sarcastic that one can almost hear the lines of her long-suffering office worker read by wise-cracking dames of film noire like Rosalind Russell or Eve Arden.

Chlorine had a gimmick: A real woman posed for the title character. She was Dee Mulvey, Bond's secretary, just out of business college. In an interview, Mulvey described her years with Dorothy Bond:

"I walked into an ancient and fading office building in Chicago's loop, where the 'cage' elevator took me up, up until soon I knocked on the door with the letters in bold print 'Dorothy Bond — Cartoonist.' She was very blonde, and her over-permed hair was pulled back behind her ears, quite slender, and her movements were quick and sponta-

neous ... and her eyes sparkled and wrinkled when her smile filled her face. Her wit had a tendency to be sassy. She was standing in her slip and very high heels. She could have been in her late 30s early 40s.... I never knew, but she welcomed me and with very few preliminary questions, I was hired.

"The office was something from a Mickey Spillane movie. Two darkly cluttered rooms ... the inner room being her work area where light showered through large windows, when available through the towering forest of commerce that pulsated outside. My outer office was an old wood desk with files and a coffee pot. She had many adoring fans, as shown by the stacks of letters that had been backing up, and my duties were to reply to each and enclose a small cartoon booklet. She had quite a few newspapers from coast to coast and was supplying daily and Sunday cartoons to her publisher. Her feature cartoon was called The Ladies, and it was that cartoon that spawned Chlorine, Champion of the Working Girl. We grew very close as we worked together. I loved it when

LITTLE LULU

Marge Henderson, LITTLE LULU, 1937, from THE SATURDAY EVENING POST.

after struggling for hours for an idea, lightening would strike and an enormous HAH' would erupt from her office nearly sending me to the floor.

"Dorothy liked a little 'nip' but was cautious not to let it interfere with her work. Her bottle of Cointreau was kept in my bottom desk drawer, out of her immediate reach when she was frustrated for ideas (going through a 'dry' spell). She made a deal with God, that she would never take a drink in the office, and when the ideas were totally vacant, she would storm into my office and grab the bottle and run out into the hall in her slip and high heels,

with, I assume, a clear conscience. Never was the absence of clothing fully explained, but it seemed so compatible with her free spirit that it became acceptable to myself and to the various and curious that worked in the offices around us.

"I believe it was one of the 'dry' periods when Dorothy was using my (then) slender figure as a model while drawing Chlorine in a sassy pose. 'Why not make Chlorine into a real live girl? YOU will be Chlorine!!!!' The publishers loved it and Dorothy came alive with ideas. There were interviews, pictures, and now I was receiving fan mail."

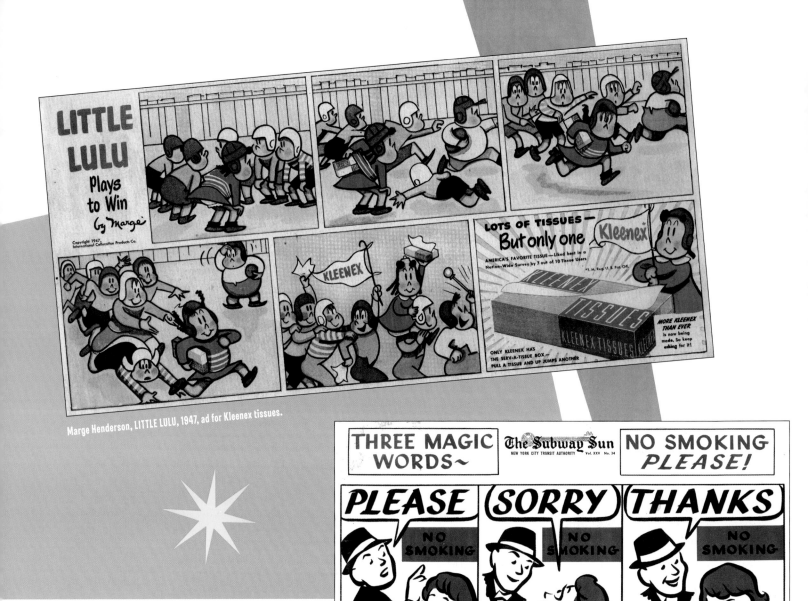

Marge Henderson, LITTLE LULU, 1947, ad for Kleenex tissues.

Amelia Opdyke Jones (Oppy), THE SUBWAY SUN, circa 1960s.

By the 1950s, comics were no longer limited to the funny pages of newspapers, or to the garishly colored pages of comic books. Fashion is a field that has always been open to women, and in the 1950s, Edna Kaula drew **Sally**, a strip which ran in the trade publication, **Fabrics**. **Fabrics** had realized the potential of messages sent out in strip form, and comics had long been used to sell products, from soap to soup. Throughout the 1940s and 1950s, Marge Henderson's **Little Lulu**, moonlighting from her monthly panel in **The Saturday Evening Post**, sold Kleenex in the

Sunday comics section of national newspapers.
Surely one of the most unusual use of comics was **The Subway Sun**, which took the form of a single-sheet subway car poster, appearing in New York City's subways from 1935 to 1966. Originally drawn by Fred Cooper, the strip, which stressed good subway manners in comic form to millions of straphangers, was taken over in 1946 by his assistant, Amelia Opdyke Jones, who signed her work Oppy. Opdyke Jones, who also created **Reddy Kilowatt**, is credited with introducing the word "litterbug." Her first

Ruth Atkinson, married and back in the kitchen, 1950.

Elizabeth Berube, THE STRANGER NEXT DOOR, 1970, from GIRL'S LOVE.

Oppy with some of her fans, from a newspaper article, 1979.

Subway Sun poster in 1946 was headlined "Nobody loves a litterbug." In a newspaper article from the 1960s she said, "Jitterbug was a popular expression at the time. I just changed the letter as part of a cleanup campaign." As is often the case when women cartoonists do not use obviously feminine names, most assumed Oppy to be a man. The newspaper article says, "Irate women would want to know who was this Mr. Oppy who depicted women inadvertently jabbing strangers with their umbrellas or clunking heads with handbags."

Teen and romance comics continued to employ women throughout the 1950s, but slowly the number of women in the field dropped. Some women, like Atkinson, left the industry for the traditional role of wife and mother, an action that was expected of young wives at the time. In an interview she relates, "I stayed home, babied, and was miserable, and made everyone else around me miserable." But when she finally decided to find work in comics again, she discovered that no work was to be had. As Barclay put it, "the bottom just dropped out."

There was, indeed, a recession in the comics market during the late 1950s, due in part to the new medium, television, and in part to **Seduction of the Innocent**, a book written by Dr. Fredric Wertharn in that decade, claiming that comics were responsible for juvenile delinquency. Although today his book is considered little more than a curiosity, he proved his point enough for the 1950s mentality. **Seduction of the Innocent** resulted in Senate hearings on comics and juvenile crime, the formation of a self-regulating Comics Code, and eventually the failure of

most of the comic book publishing companies. As with any industry slump, many artists and writers were let go, and as with any industry, the first fired were women. **Patsy Walker** comics died in 1967. **Millie the Model**, Stan Lee's favorite book in the teen line, hung on until 1974. By this time, neither book had been drawn by a woman for over twenty years. The two major comic book publishers that survived the comics depression of the mid- to late 1950s were Marvel and DC, and both companies had, since the mid-1960s, been gearing themselves toward super heroes and the young male market. Female-oriented comic books were slowly being phased out.

The last woman to illustrate a romance comic was Elizabeth Berube, for DC's **Girl's Love** and **Girl's Romances**, in the

early 1970s. Berube had previously drawn, in her distinctive and decorative style, a syndicated strip called **Karen**, which ran in forty newspapers. For the DC romance line she produced two love stories and decorative single horoscope and fashion page fillers. Her career with them lasted until the company ended their romance line in 1974.

At that time, there were exactly two women artists left working for mainstream comic books.

In 1953, EC Comics cartoonist John Severin had gotten his kid sister Marie a job with the company. In a 1988 interview with Steve Ringgenberg, published in Russ Cochran's reprint of **Psychoanalysis** magazine (an EC title), Marie Severin described the work she was hired to do:

Marie Severin, illustration for ESQUIRE, 1966.

Ramona Fradon, AQUAMAN, 1956, from ADVENTURE COMICS.

Marie Severin, DOCTOR STRANGE, 1966.

"... They needed a colorist, sort of like a Girl Friday, and I did stuff like that. Mostly I was the colorist there and did some odd jobs."

Marie Severin had come from a family in which literally everyone drew, and, as she said in the interview, "I just took it for granted that's what one did in this house, so I did."

She was not to find work actually drawing comics, however, for another thirteen years. In 1955, when EC cut back its line, partially as a result of public and industry reaction to Dr. Fredric Wertham's **Seduction of the Innocent**, she went to work for the Stan Lee-edited Timely/Atlas comics line, doing the same kind of work she had done at EC. A year and a half later, Timely also cut back its line, a victim of the recession that affected the entire industry. Severin freelanced as a commercial artist until 1964, when she returned to work for Lee at what had become Marvel Comics.

For two more years Severin continued to do production work at Marvel. By 1966, the company, with its contemporary super hero concepts, was enjoying a new popularity among college students. Characters like the angst-ridden Spider Man, or the psychedelic Doctor

Strange had become Pop art, and Marvel was suddenly "in" enough for **Esquire** magazine to feature it. None of Marvel's artists felt that the article was important enough to take time out from their regular work to illustrate, so the job of providing five pages of art went by default to Severin. In the 1988 interview, she related how this finally resulted in her getting work as an artist:

"When Mr. [Martin] Goodman [the Marvel publisher] saw my stuff in Esquire, **he said, 'Why is she in production? You have a drawer.'**

"So Stan says, 'Would you like to draw? I need you, Steve Ditko left.' So, okay."

Beginning with **Doctor Strange**, Severin became the regular penciler on such titles as **King Kull**, **Sub Mariner**, and **The Cat**, also penciling innumerable covers, as well as inking and coloring other artists' stories.

In contrast to Severin, Ramona Fradon, fresh out of art school in 1950, got the first comics illustration job she applied for. For almost ten years, she drew **Aquaman** for DC Comics, going on to co-create the character Metamorpho for the company. Then in 1965, a year

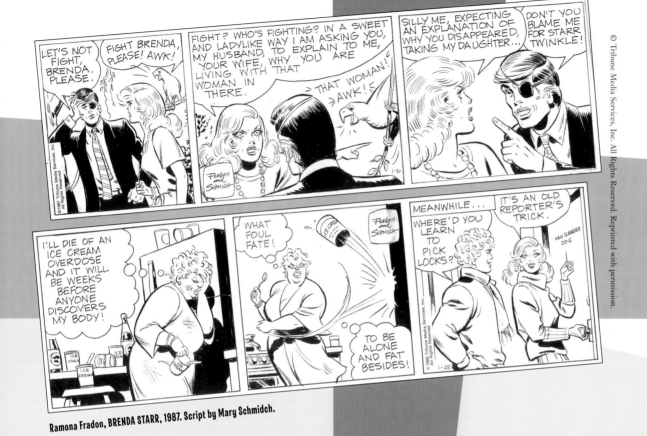

Ramona Fradon, BRENDA STARR, 1987. Script by Mary Schmidch.

June Brigman, BRENDA STARR, 2000.

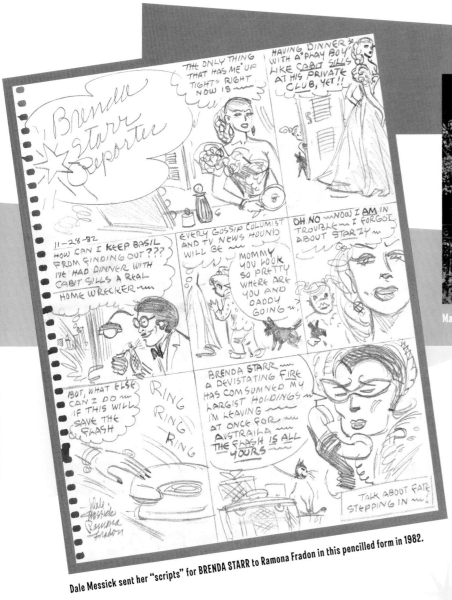

Dale Messick sent her "scripts" for BRENDA STARR to Ramona Fradon in this pencilled form in 1982.

Marie Severin (left) and Ramona Fradon (right) in 1999.

I always felt rather strange, like a fish out of water or something.

before Severin started drawing for Marvel, Fradon took a seven year leave of absence to raise her daughter. Upon her return to DC, she worked on such titles as **Superman**, **Batman**, and **Plastic Man**, until leaving in 1980 to take over Messick's **Brenda Starr** strip, upon the creator's retirement. After Fradon retired in 1995, the strip was taken over by June Brigman and still runs today.

Fradon had never been totally enthusiastic about working in the male-directed super hero genre. In a 1988 interview with Andy Mangels in **Amazing Heroes** magazine, she describes her feelings:

 "I always felt rather strange, like a fish out of water or something. Here I was in a totally male-dominated field. I had a lot of trouble with the subject matter as well. I was really not interested in drawing super heroes — male fantasies, you know? People hitting each other or scheming to take over the world.... Something that has always jarred my eyes is to see the kind of heaviness and ugliness about most [male] comic art. There's not much sweetness to it. It's the tradition ... the look. That always troubled me."

Despite the fact that they were the only two women working in the industry, and possibly because they worked for rival publishers, Severin and Fradon did not actually meet face to face until a 1996 comic convention in upstate New York.

With the exception of Fradon and Severin, comics were no longer an industry that welcomed women. Luckily, women didn't care, because by then, young aspiring women cartoonists in America had turned their attention to a new kind of comic, one that seemed to hold more promise for their way of thinking, writing and drawing: The underground.

Willy Mendes, back cover of IT AIN'T ME, BABE, 1970.

The artists of IT AIN'T ME, BABE, 1970. From left to right: sitting, Trina Robbins (with Casey Robbins),
Lisa Lyons. Standing, Carole (last name lost), Peggy (last name lost), Michelle Brand Wrightson,
Willy Mendes. In ovals, Meredith Kurtzman and Hurricane Nancy Kalish.

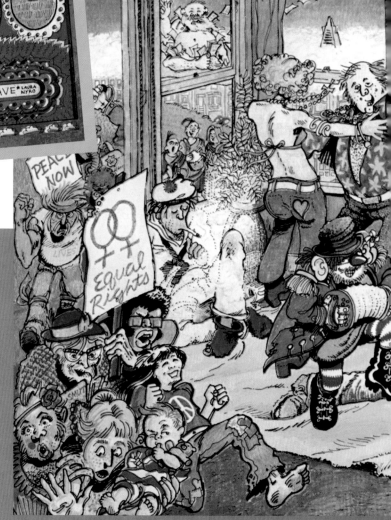

Part Six

Chicks and Womyn

*Marie Severin and Ramona Fradon possessed the (for women) unusual ability to draw muscular super heroes and violent action, even though they didn't necessarily like what they were drawing. But what of the majority of women cartoonists, in a field that had converted almost entirely to the super hero genre? Carol Kalish, vice-president at Marvel comics, gave her opinion in an interview with Heidi MacDonald for the same issue of **Amazing Heroes** in which Fradon was interviewed:*

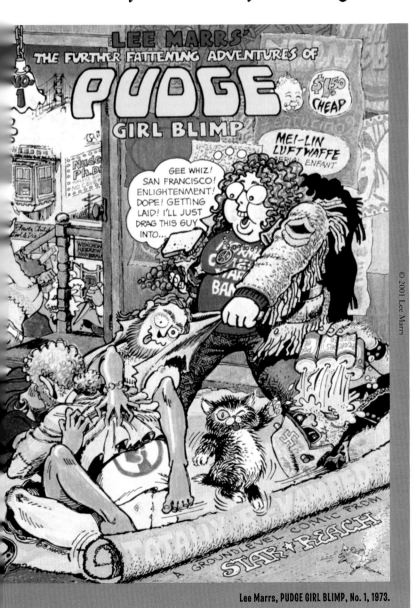

Lee Marrs, PUDGE GIRL BLIMP, No. 1, 1973.

"Comic books now are mainly oriented toward boys; they mainly deal with boys' power fantasies, so they might not be very attractive to a female creator. It's not that you have to create books for women before you have female creators who could work in the industry. You also have to have a change in the attitudes of female creators ... that this is a commercial operation, and that if they want to play in the comic book industry they're going to have to bend their creative talents.... I've been in a lot of discussions with female creators who keep finding that their style of art isn't something that the comic book companies want to see. Instead of saying, well I can work in a variety of styles, they say, well, I don't want to work for you at all.... We don't have a lot of female creators who are willing to compromise."

I suggest the possibility that most woman cartoonists are not able to compromise, and although they may very well be able to work in a variety of styles, that variety rarely includes super heroes. Following are a series of quotes, all from the above mentioned issue of **Amazing Heroes**, by some of the few women who could and have drawn super hero comics over the past fifteen years:

MARY WILSHIRE: "We [women] seem to be interested in telling different kinds of stories. I wish there wasn't so much obsession with violence ... when it's gratuitously violent and horrible, it doesn't do anything for me."

CARA SHERMAN-TERENO: "My experience has been that we don't see things quite the same way [as male creators]."

CYNTHIA MARTIN: "There are things that I can't stand drawing ... I can't handle drawing guns or cars, or anything like that. I like to draw ballet and dancers, real life stuff."

COLLEEN DORAN: "If it offends me, I probably can't draw it!"

107

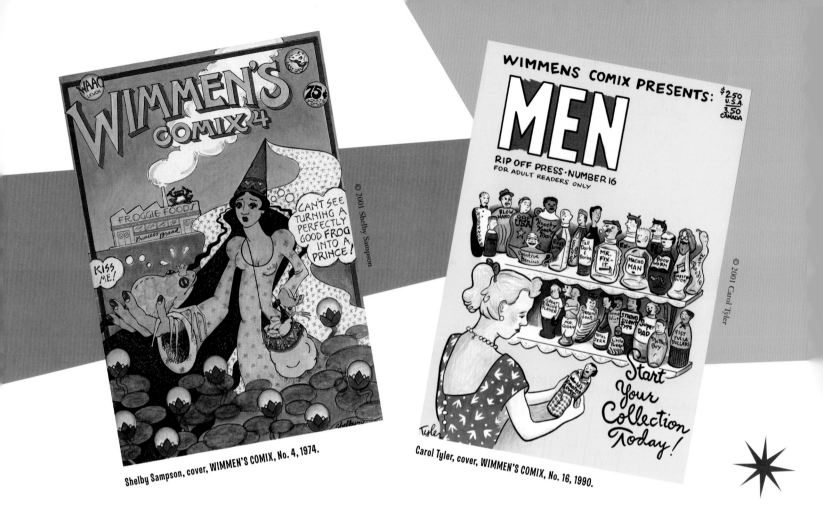

Shelby Sampson, cover, WIMMEN'S COMIX, No. 4, 1974.

Carol Tyler, cover, WIMMEN'S COMIX, No. 16, 1990.

Luckily for many aspiring women cartoonists, at the same time that the kind of comics which most women could draw had all but vanished, a new kind of comic appeared on the cultural horizon. In 1965, I saw my first underground newspaper, the **East Village Other** (EVO), a counter-culture tabloid from New York City. One of the pages was filled with a strange conglomeration of drawings, almost abstractly put together in loose panel form. It was not yet called by the name it would later earn from appearing in underground newspapers — underground comics (or "comix," as they were called, to distinguish them from the super hero genre). The comic in the **East Village Other**, signed "Panzika," was called **Gentle's Tripout**, and was the first of its kind that I ever saw. I did not know at the time that "Panzika" was a woman, Nancy Kalish. I was, however, inspired to try producing some of my own strips, and by 1966 I too was being published sporadically in EVO. Two years later, Kalish and I were joined by Willy Mendes on the pages of **Gothic Blimp Works**, a comic tabloid published by EVO. At the same time, in Berkeley, the fanciful work of Kay Rudin, who had left a job drawing greeting cards in Ohio, was being published in another comic tabloid, **Yellow Dog**.

The comics these women drew were as different from the comics being published by Marvel or DC — or most comics published today in the alternative comics industry — as a tie-dyed T-shirt is from a business suit. The word that best describes early underground comix is psychedelic.

Plot was not considered important. One got the impression that if the reader got stoned enough on controlled substances, he or she would understand the comic — or at least think so. The underground artist, more concerned with design than content, simply put felt tipped pen to paper and let it flow, man.

During the years that these women were doing their own thing, college student Lee Marrs was working part-time as assistant to **Little Orphan Annie** cartoonist Tex Blaisdell and contributing gags to the syndicated strip **Hi & Lois**. By late 1969, Marrs, Robbins, and Mendes converged in San Francisco, and Marrs discovered the Underground. "I didn't know they existed until I moved [to San Francisco]," she said in an interview. "The things that were being done were so much more exciting and interesting [than what was being done at Marvel and DC]."

In 1971, along with John Berger and Mal Warwick, Marrs formed the Alternative Features Service (AFS), which distributed news, features, and comics mainly to college and underground newspapers. The woman cartoonists distributed by the syndicate during its more than six-year existence included Marrs, Trina Robbins, Shelby Sampson, Bulbul, and Suzanna Lasker, who signed her name "Suzu."

When it came to comic books, however, Marrs "ran into another version of the closed system … in the

Lee Binswanger, PARTY TIME, from WIMMEN'S COMIX, No. 11, 1987.

Wimmen cartoonists just wanna have fun. The Wimmen's Comix Collective at a 1975 gallery exhibit of their work. Left to right, standing: Becky Wilson, Trina Robbins, Shelby Sampson, Ron Turner (publisher), Barb Brown, Dot Bucher. Sitting: Melinda Gebbie, Lee Marrs.

Underground … It was kind of like a boy's club … a closed club … There was no way a beginning artist could break in, no place for it. All the underground comics consisted of friends printing friends. They were all buddies; they didn't even let us in."

Mendes and I had made the same discovery, and we reacted to exclusion by producing our own comic books. In 1970, I started working on **It Ain't Me, Babe**, California's first feminist underground newspaper, and together with the staff, I produced **It Ain't Me, Babe** comics, the first all-woman comic book. Later in 1970, I put together **All Girl Thrills**, which included the work of Mendes and Julie Wood, who signed herself "Jewelie Goodvibes." 1971 saw the publication of Mendes's **Illuminations**, which featured psychedelic pages by Nan Pettit, as well as by Goodvibes and myself.

In 1972, Sharon Rudahl, fresh from Madison, Wisconsin, where she had been drawing political comics for the local underground paper, **Takeover**, was living at the San Francisco Good Times commune, and working on their underground paper. Terre Richards, who had come to San Francisco in 1969 from Pennsylvania, was working for **It Ain't Me, Babe** comic book publisher Ron Turner. Lee Marrs, who had found out about **It Aint Me, Babe** too late to be included in the book, was working on her own comic, **Pudge, Girl Blimp**, which would not see print for two more years. **It Ain't Me, Babe** had sold well enough for Turner to decide to put out an ongoing women's comic book. In a 1979 interview in **Cultural Correspondence** magazine, Richards told about the formation of this new book:

> "… I was looking for a more creative outlet, one that would incorporate a growing interest in writing and animation…. As a result of the Women's Movement, there was a growing aware-ness of women in all areas of the arts as well as a newly developing market for women's work in pub-lishing, so the time was right for an all-woman's comic. And when I heard from my boss … that Pat Moodian was editing a women's comic and they were looking for contributors, I jumped at the chance…. Thus, Wimmen's Comix was born."

Moodian, Richards, Robbins, Rudahl, and Marrs joined with Michelle Brand, Lora Fountain, Shelby Sampson, Aline Kominsky, Karen Marie Haskell, and Janet Wolfe Stanley to produce the first ongoing all-woman comic book, which survived for twenty years. Influenced by the political consciousness of the early 1970s, in which many underground newspapers were being manufactured collectively, the founders of **Wimmen's** put their book together in a way in which no male-produced comics, underground or otherwise, had been done. Richards, from the same interview:

SEX AND POLITICS! Joyce Farmer, cover, TITS & CLITS, 1977.

Lyn Chevely (Chin Lyvely), from TITS & CLITS, 1977.

"The decision to be vulgar rather than high class arose out of sheer ignorance..."

"... We decided that ... we would produce an on-going title of comics by women and that we would function as a collective, a term used rather loosely in those days to mean there would be no leader or editor, but instead a rotating editorship, with everyone contributing their energy to the paperwork and general supportiveness of the group."

Another title beat **Wimmen's Comix** to the comic book stores by two months. **Tits & Clits** was the work of two Southern California women, Joyce Farmer and Lyn Chevely (under the pseudonym Chin Lyvely), who had formed their own publishing company, Nannygoat Productions, as a reaction to the sexism they saw in male-produced underground comics. Interviewed in

Cultural Correspondence, Chevely talked about the creation of the title, which has always dealt with sex from a woman's point of view:

"The decision to be vulgar rather than high class arose out of sheer ignorance. Neither of us was much of a comics fan, but at the time we started, I owned a bookstore, sold u.g.s [undergrounds], and was impressed by their honesty but loathed their macho depiction of sex. Our work, originally, was a reaction to the glut of testosterone in comics.... As most of us know, sex is a very political business. All we want to do is equalize that by telling our side.... Our original commitment was to concentrate on female sexuality, and our titles indicate that."

In 1973, struggling fine artist Melinda Gebbie discovered **Wimmen's Comix**. In a 1980 interview with me, she talked about her experience:

"... I went to the Hall of Flowers, in Golden Gate Park. It was a publisher's fair. Lee Marrs was sitting at a booth and I got very interested in hearing about women's comics so she told me to come to the next meeting. They put out two issues and I ended up being in issue number three.... And they told me I could do what I wanted, so when I went home I thought, 'Now what am I gonna do?' I'd never drawn anything in windows before, and the only thing that I could think of, to draw with any kind of sincerity, since I'd never been into fuzzy animals or jokes, that I'd draw something about

my sexual confusion ... it was mostly the fact that I was a woman that ... made my story valid."

In 1974, Roberta Gregory, the second-published lesbian comic artist (Mary Wings, with her self-published books, **Come Out Comics** and **Dyke Shorts**, holds the title of first lesbian cartoonist) was introduced in the pages of **Wimmen's**. In **Cultural Correspondence** she says:

"The thing that got my first story in print was seeing the virtually straight Wimmen's Comix No. 1 ... and I thought, hey, what's going on? So I wrote a lesbian story.... It didn't turn out quite like I wanted it to, but at least it was a valid place to be coming from."

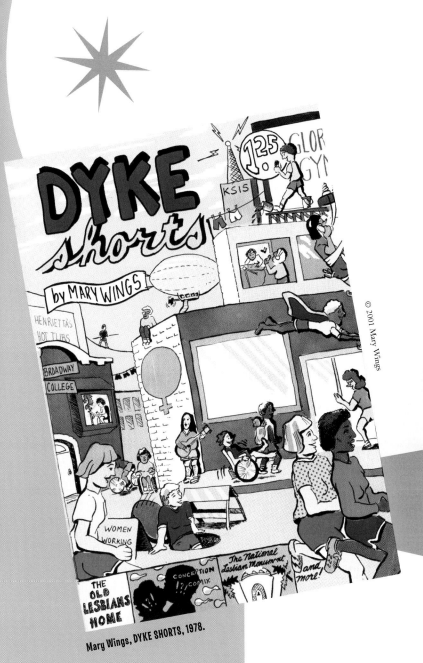

Mary Wings, DYKE SHORTS, 1978.

Roberta Gregory, DYNAMITE DAMSELS, 1976. The second self-published lesbian comic book ever.

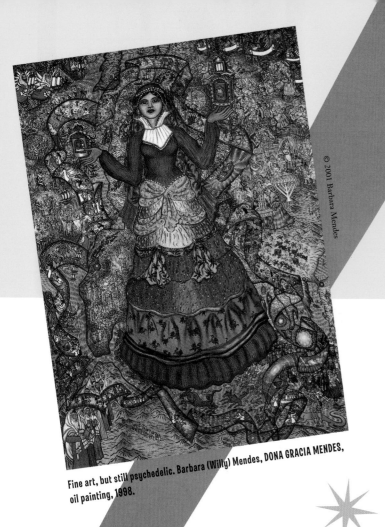

Fine art, but still psychedelic. Barbara (Willy) Mendes, DONA GRACIA MENDES, oil painting, 1998.

© 2001 Barbara Mendes

© 1997 Leanne Franson

Sharon Rudahl, CRYSTAL NIGHT, 1980.

© 2001 Joan Hilty

Joan Hilty, ELVIS/K.D., from REAL GIRL COMICS, No. 5, 1993.

Every issue of **Wimmen's** and **Tits & Clits** included new women. Not all of them remained with the books. By 1972, Willy Mendes, one of the earliest and most enthusiastic of the women underground cartoonists, had moved to Southern California, where today she is a respected painter. But by the end of the 1980s, most of the regular contributors had produced at least one comic book of their own. Some of these are Carol Lay's **Good Girls**, Roberta Gregory's **Naughty Bits**, Krystyne Kryttre's **Death Warmed Over**, the late Dori Seda's **Lonely Nights**, Mary Fleener's **Slutburger**, Sharon Rudahl's **Crystal Night**, and Aline Kominsky-Crumb's **Power-Pak**.

Wimmen's Comix showcased woman cartoonists for twenty years, and saw its last issue in 1992. The 1980s and early 1990s gave rise to more woman-edited anthology comics, which printed either all women or a majority of women cartoonists, such as **Last Gasp's Weirdo**, especially under the editorship of Aline Kominsky-Crumb; **Real Girl** and **Girl Talk**, published by Fantagraphics; **Twisted Sisters**, from Kitchen Sink, and **Action Girl**, from Slave Labor Graphics. Of these, **Action Girl**, a plucky, grrrl-oriented book that showcases talented young artists, survives today.

ACTION GIRL then and now. Elizabeth Watasin, ACTION GIRL, No. 2, 1995, and Sarah Dyer, ACTION GIRL, No. 19, 2000.

Lee Marrs, CHOICES, 1990.

A new phenomenon of the 1980s was comic books with specialized themes. **World War 3**, a political comic magazine, featuring feminist and other left-of-liberal comics, included a good number of women, and devoted one issue to the problems of sexism. Many lesbian comic books and magazines could be found in gay or women's bookstores, as well as in the more open-minded comic book stores.

The 1980s saw the rise of the benefit comic book, inspired by the benefit rock concerts of the past ten years. In two of these books, half or more of the contributors were women: **Choices** (1990), a pro-choice benefit book for the National Organization of Women; and **Strip AIDS USA** (1988), an AIDS benefit book. **Strip AIDS USA** included all the gay and lesbian cartoonists the editors could contact, something one would expect from editors putting together a book about AIDS. Yet, a 1989 British comic book about homophobia actually contained few homosexual contributors.

Shary Flenniken, TROTS AND BONNIE, from NATIONAL LAMPOON, 1986.

ELFQUEST then and now. Wendy Pini, ELFQUEST, No. 1, 1978.

Some magazines were also carrying comics. **The National Lampoon**, during the years that Shary Flenniken was cartoon editor, became a showcase for new women cartoonists such as Holly K. Tuttle and Mimi Pond. Not all women's or girl's magazines have been as conscientious. In its earliest issues, **MS** magazine ran a regular strip called **Mary Selfworth**, which was credited to Vincenza Colletta, although the editors knew the artist was actually Marvel cartoonist Vince Colletta.

Independent comics, which had emerged in the late 1970s, were small press black-and-white comics of a higher printing quality than undergrounds. Many of them published women and some had women publishers. Chief of these was WaRP Graphics, run by cartoonist Wendy Pini and her writer husband, Richard. After the Pinis tried unsuccessfully to sell their comic concept, **Elfquest**, to every major publisher, they formed WaRP Graphics and self-published what became one of the most successful black-and-white comic series of the 1980s and one of the most popular among female readers. Ironically, Marvel

Comics, which had rejected **Elfquest**, eventually reprinted it in color under the Marvel logo. WaRP Graphics expanded to publish work by other writers and cartoonists, and has inspired several generations of young female fans.

WaRP was the first publisher of Colleen Doran's **A Distant Soil**, a cosmic saga the artist first created at the age of twelve. Doran continues to write and draw **A Distant Soil**, which is now regularly published by Image Comics, and also draws for both Marvel and DC Comics.

Eclipse Comics, edited by catherine yronwode, published comics by Leila Dowling, Lea Hernandez, Cynthia Martin, Donna Barr, and Trina Robbins. In 1985, they published the long out-of-print **Women and the Comics**, the first book about women in the comics industry, co-written by myself and yronwode.

Renegade Press, run by Deni Loubert, was another woman-owned independent publisher. For a two-year period, until its dissolution, Renegade published

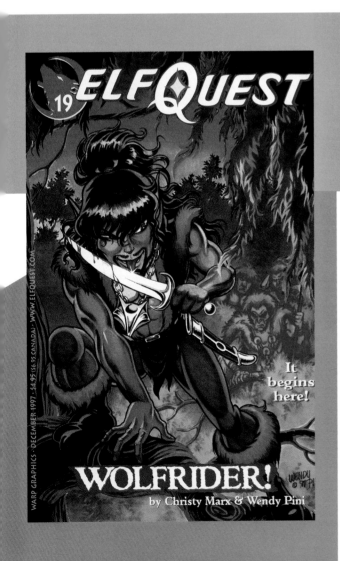

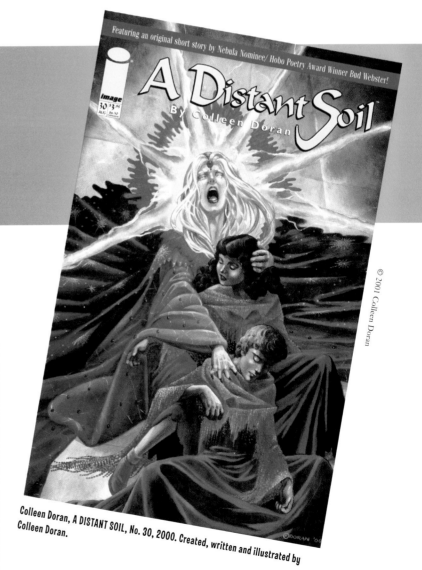

Colleen Doran, A DISTANT SOIL, No. 30, 2000. Created, written and illustrated by Colleen Doran.

© 2001 Colleen Doran

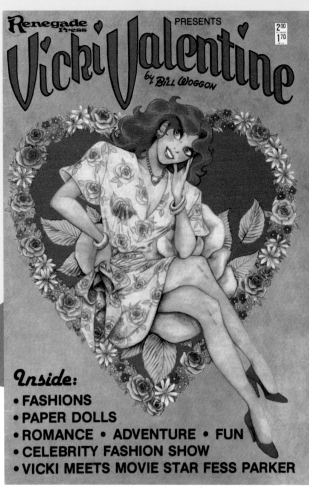

Two attempts at reviving girls' comics. Barb Rausch, artist, Bill Woggon, writer, VICKIE VALENTINE, No. 1, 1985.

© 2001 Barb Rausch

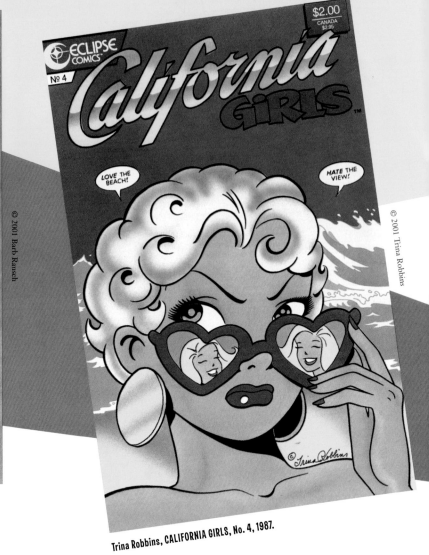

Trina Robbins, CALIFORNIA GIRLS, No. 4, 1987.

© 2001 Trina Robbins

Unlike America, the Japanese comics industry produces a whole line of comics specifically aimed at girls and women...

Wimmin's Comix. Loubert also attempted to revive both the "girl comic" with the publication of **Vickie Valentine**, created by Katy Keene artist Bill Woggon and drawn by Barb Rausch, and the romance genre with two issues of **Renegade Romance**, an anthology comic book that included both male and female cartoonists.

During the 1980s and early 1990s, Marvel and DC also made sporadic, if half-hearted, attempts to regain their lost female audience. Twenty-five years after the publication death of typical teenager **Patsy Walker** (in the

1970s, there was an attempt made to turn her into a super heroine named Hellcat, but the less said of that, the better), Marvel published two books for young girls: Two **Barbie** titles, and another, **Barbara Slate's Sweet XVI**, briefly.

DC made one brief attempt at the young girl market in 1987, with **Angel Love**, also by Barbara Slate. Their other girl title, briefly, was **Wonder Woman**. Originally created by psychologist William Moulton Marston in 1940, and intended from the first to appeal to girls, the story of

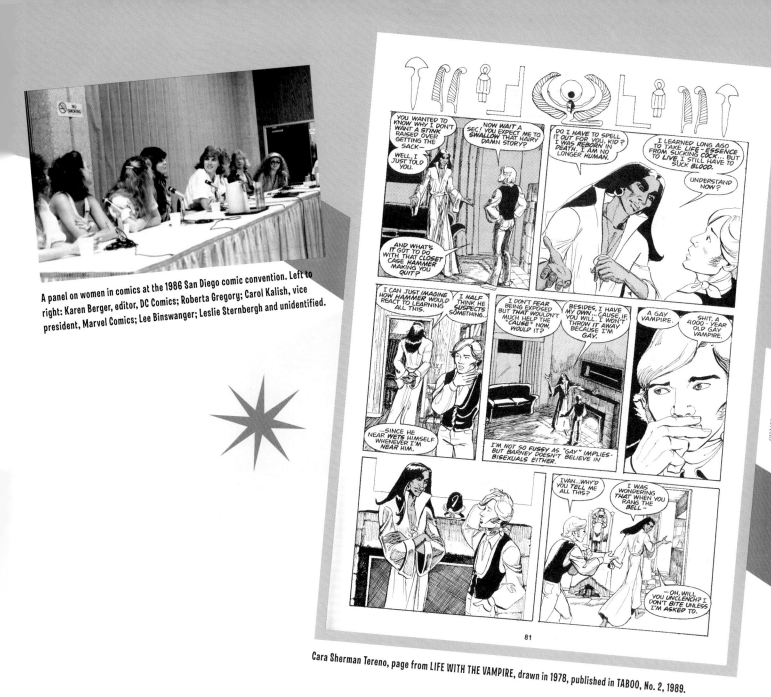

A panel on women in comics at the 1986 San Diego comic convention. Left to right: Karen Berger, editor, DC Comics; Roberta Gregory; Carol Kalish, vice president, Marvel Comics; Lee Binswanger; Leslie Sternbergh and unidentified.

Cara Sherman Tereno, page from LIFE WITH THE VAMPIRE, drawn in 1978, published in TABOO, No. 2, 1989.

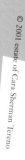

the Amazon princess has indeed, for fifty years, been a girl's book. However, for its first forty-six years, the book was drawn and written exclusively by men. Finally, in 1986, I was hired to draw a four-part **Wonder Woman** miniseries, **The Legend of Wonder Woman**. Shortly after the mini-series, Mindy Newell became one of the writers of the newly revamped book, and in 1989, DC produced a special **Wonder Woman** annual which was illustrated by ten woman cartoonists. After the annual, Cynthia Martin drew one special issue, and then the book was taken over by Jill Thompson, who became its artist until 1992, when she moved on to another title.

By the end of the century, neither Marvel nor DC published any comics for girls. Proposals for comics aimed at young girls (or women) are discouraged at both companies, because "girls (or women) don't read comics." This is, of course, circular logic. Girls, indeed, do not read comics if there are no comics published for them.

More tragic than the loss of girl titles in mainstream comics was the untimely loss of two talented women cartoonists: Dori Seda and Cara Sherman-Tereno. Sherman-Tereno, who succumbed to leukemia in 1996, had an accessible style that allowed her work to be published by mainstream comics publishers like DC Comics, but for herself and the non-mainstream press she produced gay vampire eroticism before Anne Rice's vampire books popularized the subject. Her work is reminiscent of Yaoi, a comics genre that has become popular today in Japan. Unlike America, the Japanese comics industry produces a whole line of comics specifically aimed at girls and women, called Shoujou.

Yaoi, a subset of Shoujou, deals with male-to-male eroticism drawn to attract a mostly female following.

Speaking of vampires, Dori Seda called herself the vampire bookkeeper. Because her chronic insomnia didn't permit her to keep normal hours, Last Gasp publisher Ron Turner hired her to keep the company's books after working hours. Turner himself is only one of the many characters Seda put into in her hilarious autobiographic comics. The main characters in her stories were the artist herself, gap-toothed and goofy, and her terrible dog, Tona. Seda fell victim to her own chain-smoking lifestyle, and died of emphysema in 1988. She can be seen in the Les Blank film, **Gap Toothed Women**, for which she drew the poster. Today Seda is remembered as a cult figure in the world of underground comics, but it is sad to speculate just how well known and successful both women might have become if they had survived.

Leslie Sternbergh chronicles her personal Dori memories in ...THERE'S A WAY, FROM DORI STORIES, 1999.

Dori Seda, DORI STORIES, 1999.

Marie Severin parodies a superhero that she once drew for MARVEL COMICS in this cover of SUPERNATURAL.

Anne Timmons, GOGIRL!, No. 1, 2001.

Women draw superheroes too, but in a very different way. Elizabeth Watasin, ACTION GIRL, 2001.

Joyce Chin, XENA, WARRIOR PRINCESS, 1997.

Part Seven

Options

Imagine walking into a bookstore, hoping to find a good mystery or historical novel, and discovering that the store carries nothing but Westerns. Upon inquiry, a clerk points out that they do actually carry some mysteries, but the few he shows you are crowded on a bottom shelf together with the other non-Western titles and are printed on cheap paper without color covers. The bookstore is out of the particular mystery you want, the clerk informs you. They only ordered two copies of it, he adds, because, as everyone knows, mystery book readers don't go into bookstores. Of course, logic tells you, mystery book readers won't go into bookstores that carry only Westerns.

Melinda Gebbie, COBWEB, 2001.

For roughly thirty years, this has been the situation in American comic book stores. Most people over the age of forty remember buying comic books at a drugstore or candy store, but since the 1970s, most comic books have been sold only in comic book stores. While there are exceptions, the majority of comic book stores tend to carry super hero comics by the major comic publishers, Marvel and DC, with a smaller stock of super hero comics produced by independent publishers. Some of these stores may grudgingly display a few underground or experimental comics, some of which include women among their contributors. The stores are even more grudging about stocking comic books that specifically appeal to women or young girls, rightfully reasoning that girls and women don't come into comic book stores. The reason why? Mystery readers won't bother coming into a store that stocks only Westerns.

™ and © 2001 Alan Moore and Melinda Gebbie

Hedy Lamarr, drawn by Ramona Fradon, for the cover of DIGNIFYING SCIENCE.

Dignifying Science, an anthology written by Jim Ottaviani, is devoted to stories of women scientists, all illustrated by women. Dignifying Science is copyright Jim Ottaviani. Art copyright Ramona Fradon, Carla Speed MacNeill, Jen Sorenson, Stephanie Gladden, Donna Barr, Roberta Gregory, Linda Medley, Lea Hernandez, Anne Timmons, Marie Severin, Mary Fleener.

Carla Speed McNeil, on Hedy Lamarr.

Jen Sorenson, on Lisa Meitner.

Stephanie Gladden, on Rosalind Franklin.

Donna Barr, more on Rosalind Franklin.

Roberta Gregory, more on Rosalind Franklin.

Linda Medley, more on Rosalind Franklin.

Lea Hernandez, on Barbara McClintock.

Anne Timmons, on Birute Galdikas.

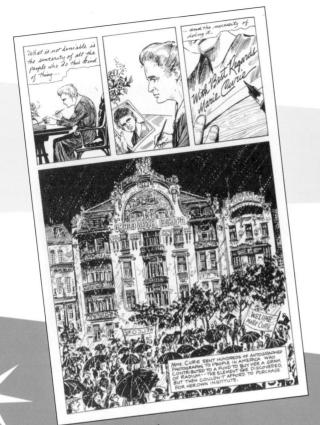

Marie Severin, on Marie Curie.

Mary Fleener, on Emmy Noether.

© 1999 Christine Shields

Some small press anthologies: Christine Shields, FRANKENSTEIN MY
LOVE... FROM ZERO ZERO, No. 26, 1999.

© 1999 Ariel Bordeaux

Ariel Bordeaux, LITTLE STEFFIE, from MEASLES, No. 3, 1999.

In today's comic book industry, the majority of woman cartoonists are either self-published or published in black-and-white comic books from small presses. This is another way or saying that the majority of today's woman cartoonists need to have day jobs. For the most part, small press rates for a finished, penciled and inked page range from a low of $25 to a high of $75. Self-published cartoonists consider themselves lucky if they break even, and many, like Jane Fisher, who produces the full-color girl-friendly comic **WJHC**, lose money with every issue, even though **WJHC** was picked by the MS Foundation as a comic to distribute on their Take Your Daughter to Work Day. Others, like Cathy Hill, published seven issues of her brilliantly drawn and written **Mad Raccoons** before giving up because, to paraphrase Valerie Barclay's' words of fifty years ago, "It just fizzled out."

Character designs and pencils by Kirsten Petersen, WJHC, created and written by Jane Fisher, 1999.

Joyce Farmer, CHING, from ZERO ZERO, No. 27, 2000.

Cathy Hill, MAD RACCOONS, No. 7, 1997. Uncle Erf, the raccoon with multiple personalities, has a jealous fight with one of his other personalities, Pansy.

World War 3, No. 30, the special **Bitchcraft** issue, was mainly drawn by women. Cover by Sabrina Jones.

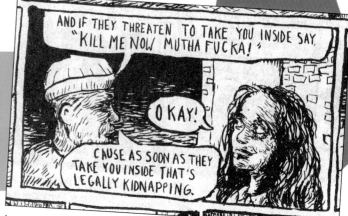

Lauren Weinstein, BITCH LESSONS BY LENNIE, 2001.

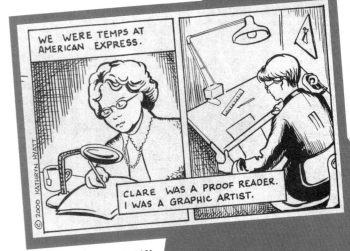

Kathryn Hyatt, CLARE'S CATS, 2001.

...there are now more woman cartoonists then ever before...

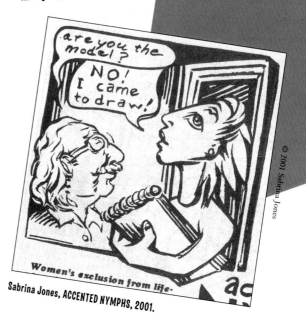

Sabrina Jones, ACCENTED NYMPHS, 2001.

Katherine Arnoldi, SINGLE MOMS OF THE WORLD, UNITE, 2001.

E. Fitz Smith, LOSS & FOUNDRY, 2001.

FLY, K-9'S FIRST TIME, 2001. Story by K-9, art by Fly.

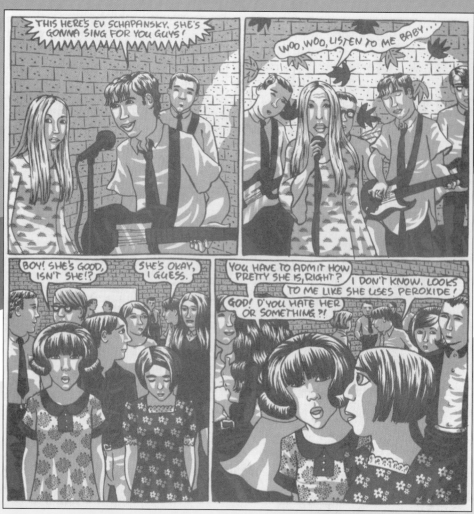

Debbie Drechsler, NOWHERE, 1999.

Catherine Doherty, CAN OF WORMS, 2000.

Penny Van Horn, RECIPE FOR DISASTER, 1998.

Despite the fact that small press and self-publishing can be such a heartbreaking labor of love, there are now more woman cartoonists then ever before, and their work spans the styles and genres. The commonly accepted stereotype has been that women cartoonists produce autobiographical comics. Indeed, a good many of them do, and much of their subject matter ranges from vaguely depressing to very depressing. Debbie Drechsler and Catherine Doherty employ somber colors to compliment the moods of their stories, while Penny Moran Van Horn's tales of working-class madness are rendered in dark scratchboard. Medical illustrator Phoebe Gloeckner puts her precise drawing techniques to work in dismal tales of child abuse, while Madison Clell presents a more expressionist take on the same subject in her story of living with multiple personality disorder, **Cuckoo**.

© 1998 Phoebe Gloeckner

Phoebe Gloeckner, A CHILD'S LIFE, 1998.

© 2000 Madison Clell

Madison Clell, CUCKOO, 2000.

Not all autobiographical comics are dark. Ellen Forney's **I Was Seven in '75** is a cheerful memoir of all the baggage that comes with growing up with hippie parents, including pot busts (the babysitter turns in her parents) and visits to nudist camps. French Canadian cartoonist Julie Doucet relates her life adventures in a charmingly fractured English, and Canadian cartoonist Leanne Franson uses loose pen lines and subtle humor to tell stories of Montreal bisexuals. A character in one of her stories says, "I was out as a lesbian for eight years … then I fell in love with my sperm donor." And Mary Fleener offers the reader glimpses into the life of a surfer girl/ artist/bass player in an all-girl band, all in her unique cubist style.

On the other hand, as many woman cartoonists break the mold as fit into it, with as many different styles as there are artists. Horror comics and stories of the supernatural are not the topics where the average person would expect to find women, but they are there in comparatively large numbers, although their take on vampires, witches, and monsters is very different from that of the guys. Women seem to bring to the genre that sweetness that Ramona Fradon said was missing from men's comics. Elena Steier and Canadian cartoonist Janet Hetherington both work in traditional styles to produce non-traditional horror comics. In Steier's **The Vampire Bed and Breakfast**, drawn in broad cartoon style, Count Vladu and his mother open a (duh!) bed and breakfast. Hetherington's romance comics parody, **Eternally Yours**, drawn in traditional romance comics style, stars Destine, a satire on all the Vampirella-type horror heroines.

…as many woman cartoonists break the mold as fit into it, with as many different styles as there are artists.

BUSTED!!! Ellen Forney's hippy mom gets turned in by the babysitter in MONKEY FOOD: THE COMPLETE I WAS SEVEN IN '75 COLLECTION. (Fantagraphics Books, 1999) Art and story by Ellen Forney.

Julie Doucet and her friend play girl detectives in THE MADAME PAUL AFFAIR, 2000.

Leanne Franson, ASSUME NOTHING.

Mary Fleener, SLUTBURGER, No. 4, 1993.

The Goth Scouts strike again.
Elena Steier's THE VAMPIRE BED AND BREAKFAST, 1999.

WEIRD DATES, from Janet Hetherington's ETERNALLY YOURS, 2000.

Campy television horror queen Elvira, who is herself a Vampirella satire, stars in her own comic book, which is drawn by various artists, including Cynthia Martin and Anna Maria Cool, who was also one of the **Barbie** artists. Elvira's publisher, Claypool comics, also publishes **Soulsearchers**, a lighthearted romp through the world of demons, witches, and vampires, which has been drawn by Marvel comics veteran Marie Severin, with covers by yet another ex-**Barbie** artist, Amanda Conner.

Artist Jill Thompson, who drew **Wonder Woman** for two years, follows the tradition of Gladys Parker and Tarpe Mills when she puts herself into striped purple-and-green tights, a witch's hat, and a tutu in the title role of her beautifully drawn and colored series, **Scary Godmother**. In her comics, which appeal to adults as much as to children, little Hannah Marie has learned how to get up on the "Fright Side" of her bed, and wind up on the "Fright Side", where her orange-haired "Scary Godmother" lives, and it's always Halloween. As charming as **Scary Godmother**, Elizabeth Watasin's ongoing series, **Charm School**, is about a high school for witches, fairies, and vampires, who also all happen to be lesbians.

Only rarely, it seems, does a woman cartoonist produce genuine, nightmare-producing horror. One of those rare ones is Renée French. Her comics resemble children's nightmares, and feature little girls, scary grown men, and slightly repulsive, sad-eyed animals that usually die.

ELVIRA drawn by Cynthia Martin, inked by Rick Magyar, 2001.

Jill Thompson, SCARY GODMOTHER, THE MYSTERY DATE, 1999.

Elizabeth Watasin, CHARM SCHOOL, No. 3, 2000.

Renee French, THE NINTH GLAND, 1997.

Molly Kiely, DIARY OF A DOMINATRIX, 1997.

Roberta Gregory today: BITCHY BITCH gets political (sort of) in NAUGHTY BITS, No. 33, 2000.

Alison Bechdel, SPLIT-LEVEL DYKES TO WATCH OUT FOR, 1998.

Hothead and her beloved cat, Chicken, strut their stuff in HOTHEAD PAISAN, HOMICIDAL LESBIAN TERRORIST, 1999.

HOW THE SUBGURLZ GOT THAT WAY, from SUBGURLZ, 1999.

Graphic sex is another field into which women rarely wander, but for Molly Kiely, who doesn't take it as seriously as the guys. She manages to combine sweetness and humor with sex in her comic book series, **Saucy Li'l Tart**, and her graphic novel, **Diary of a Dominatrix**. Kiely draws in a cute, girly style, and even includes paper dolls. Some of the outfits: "Society Deb, I wore this dress the night I sodomized my cotillion escort …" and "Beatnik Bondage Baby, works equally well for intense interrogation or poetry recitation scenes…."

Since Gregory and Wings produced their first lesbian comic books in the 1970s, lesbian cartoonists have entered the field in growing numbers, and it would be a mistake to think that they are all alike. Two of the most well known, Alison Bechdel and Diane DiMassa, work in completely different styles. Bechdel's **Dykes to Watch Out For** are the lesbians next door, a lesbian sitcom, drawn in a warm, friendly style that would appeal to anyone except perhaps Jesse Helms. On the other hand, DiMassa's **Hothead Paisan**, **Homicidal Lesbian Terrorist**, might prove a bit of a test for the average heterosexual male. In a riot of revenge fantasies, DiMassa's manic character slices, dices, and purees symbols of male supremacy. Another cartoonist who is not particularly kind to heterosexual males in her comics is Jennifer Camper. Her **SubGurlz** are mutant lesbian super hero-ines who live in the New York City subways. Like the X-Men, they each have their special powers: Liver can bring back the dead, but because she grew up under-ground, she needs huge amounts of toxic chemicals to keep going. Byte is so brilliant that no hair can grow on her head. When one day she wakes up with one single hair on her head, she obsesses about it for days, tying ribbons on it, trying new shampoos, staring at her single hair in the mirror, thinking, "Hmm … maybe I should part it on the left…." The third SubGurl, Swizzle, described as "bartender and reluctant killer," is the strongest person in the world. When a man bothers her on the street, she snaps his neck, then sobs out the story to her friends:

"I didn't mean to! I only meant to push him away! But then his neck snapped! sob**! I hate it when I kill people. I always think how sad their mothers will be…."**

The bearded lady Saint Wilgeforte, in CASTLE WAITING, No. 3, 2000.

Dame Darcy, MEATCAKE, No. 10, 2000.

Donna Barr, MIKI, the DESERT PEACH, No. 26, 1997.

A couple of zines:

BAD THOUGHTS by Amanda Padilla, and BOOK OF SLEEP by Gabrielle Bell, both 2001.

There are women cartoonists whose work doesn't fit into any categories at all. When I told Linda Medley I thought that in her comic, **Castle Waiting**, she stood the brothers Grimm on their heads, she added, "And I shake the loose change out of their pockets." The castle of the title is Sleeping Beauty's castle, after the fairytale princess has departed with her prince, leaving behind various fairytale characters. In issue No. 3, Medley injects a note of early Christian feminist mythology into the mix, retelling the story of Saint Wilgeforte, the bearded woman and "patron saint of unhappily married and independent women."

Dame Darcy's work also has a fairytale quality to it, mixed with gothic playfulness. She is the dark daughter of Hans Christian Anderson, transferred to the Appalachians. She fills her pages with mythic characters and Victorian dolls, all drawn in a spiky, girly style.

Donna Barr has been producing **The Desert Peach** and **Stinz** for twenty years and has attained a large cult following for her very personal visions. **Stinz** takes place in a mythical Germanic world where centaurs and peasants co-exist. **The Desert Peach** is a real-world story, but in its own way it's just as mythic as **Stinz**. Pfirsich Rommel, the "Peach" of the title, is Rommel's little-known gay younger brother, but Barr's stories go way beyond funny Nazis. Barr's comics are distinguished by the artist's well-researched knowledge of World War II and all things German, and by her ability to draw more easily than most people can write.

Younger and newer women cartoonists can often be found in zines, self-published comics that run the gamut from simple Xeroxed pamphlets to slick booklets produced by computer, which all have in common very small print runs, often under 100. The word comes from fanzines,

small self-published magazines that were originally produced by science fiction fans as far back as the 1930s, and moved into comics fandom around the late 1950s. Zines, often sold through the mail or traded for other zines, are an excellent way to get your work out to the public, as long as you don't expect to make any money at all. Multitudes of artists and writers of both sexes must indeed care more about reaching an audience than earning a living, because, according to Seth Friedman, publisher of the zine review, **Factsheet 5**, in 1998 there were approximately 50,000 zines being published.

There seems to be a tenuous line dividing zines, with their small print run, from mini-comics, with their small print run. In the end, the distinction lies with the creator. Rachel Hartman, who has self-published over a dozen issues of her medieval fantasy, **Amy Unbounded**, runs off 100 copies at a time of her comics, printing more when she runs out. She considers her book a mini-comic, as does Lark Pien, whose very arty and slick **Stories From the Ward** started with a print run of 100 and with the third issue had grown to 300. However, a 2000 article in the **San Francisco Examiner** included Pien's book in an article on zines.

Rachel Hartman, AMY UNBOUNDED. This is Hartman's first comic book-sized issue of her book, and her first color cover. Previous issues measured 8½ X 5½, and were simply photocopied black and white.

© 2001 Lark Pien

Lark Pien, STORIES FROM THE WARD, 2001.

Magazines, from the in-your-face grrrl magazine, **Bust**, to the chic **International** (published in New York, London, Paris, and Monte Carlo!), continue to print comics. For seven years, Mary Wilshire drew two monthly pages for **National Geographic's** children's magazine, **National Geographic World**.

Chances to produce educational comics for pay are far rarer in the United States than in England, where cartoonist Suzy Varty regularly produces educational comics for the City of Newcastle. However, the occasional educational comic job does pop up. Megan Kelso drew **Lost Valley**, an educational comic book about recycling, for the non-profit organization Laughing Crow, with funding from the Washington State Parks and Recreation committee, and both Gabbie Gamboa and Nina Paley contributed comics to **Smartmouth**, an anthology funded by the San Francisco Arts Commission.

The Web is the newest option for cartoonists of both sexes who are less concerned about making money than with getting their work in front of the public. In an e-mail interview, Jenni Gregory echoes the problems women have in trying to get their comics into comic shops, when explaining why she puts her comic, **Abby's Menagerie**, online for free instead of selling it in stores:

> "... I'm telling this story on the Web because I can't LOSE money doing it that way. From late 1995 through late 1999 I produced seventeen issues of a creator-owned print comic called DreamWalker

.... I didn't lose any money on those, but I didn't make any either. I was very frustrated by the direct market (comic book stores) ... the reviews were very positive (but) I just couldn't get stores to bite."

Paige Braddock put her comic, **Jane's World**, on the Web as a way to bypass repressive syndicates:

> "It all started as a rebellion against the syndicates who think because they have one or two female voices on the comics page that this represents humor for all women.... I just decided I wouldn't let my voice be run over by the current editorial climate so I started publishing on the Web."

Both Braddock and Gregory make a little extra money by selling related items in their online "gift shops" — Braddock sells mugs, T-shirts and refrigerator magnets printed with her characters, and Gregory sells mugs and past issues of **DreamWalker**, making enough to pay for server fees and annual domain registration. They both intend to eventually collect their comics into hardcopy book form and when that happens they will have a ready-made audience.

In the first year that **Abby's Menagerie** was up on the Web, it had one million viewers. Lauren Wienstein, who draws comics for the online girl's magazine **gURL**, has received about 10,000 e-mails about her strips, mostly from teenage girls. She says, "I did a comic called **AM I**

Ariel Bordeaux and Ellen Forney, HAIR IN OUR EYES, from BUST, 1999.

Barbara Slate, VIOLET, from INTERNATIONAL MAGAZINE, summer 1995.

Mary Wilshire, THE AMAZING TRAVEL BUREAU FROM NATIONAL GEOGRAPHIC WORLD, February 2000. Color by Pollywog Productions.

© 1999 Ariel Bordeaux and Ellen Forney

© 1995 Barbara Slate

© 2000 National Geographic Society

Megan Kelso, LOST VALLEY, 1999.

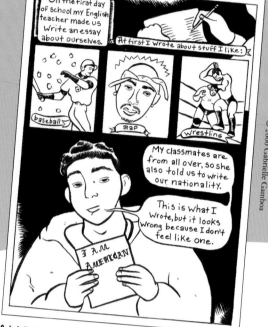

Gabrielle Gamboa, THE GREY AREA, from SMART MOUTH, 2000.

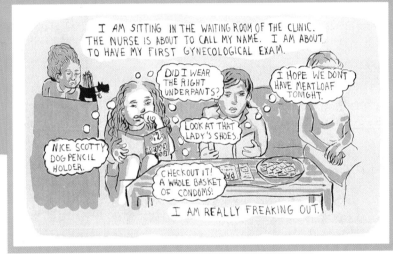

Lauren Weinstein, THE WINDING ROAD TO WOMANHOOD, done for Planned Parenthood of Tomkins County, Ithaca, New York, 2001.

Jenni Gregory, DREAMWALKER, 2001. Color by Barry Gregory.

Paige Braddock, JANE'S WORLD, 2001.

FAT that got a tremendous response, so much that there are about 1,500 e-mails that I have never looked at." Compared to comic books, the world of newspaper strips is on another planet. One self-syndicated woman cartoonist defines comic books as "comics," and newspaper strips as "cartoons," thereby separating the worlds in her mind. Having already decided on my own definition in the introduction to this book, I will continue to call both industries comics.

The benefit of newspaper strips for women cartoonists is obvious: Women do read newspapers. There are also drawbacks: It is difficult to get accepted by the largest syndicates, which often have their own prejudices against or for certain styles. The syndicates also take as much as 50 percent of the cartoonists' earnings. Once accepted, the artist must often sign away the rights to her comic creation. As Braddock notes, the syndicated cartoonist is at the mercy of the syndicate, which can tell her what or what not to say or draw. A result is that syndicated cartoonists rarely make controversial statements in their strips, and when they do, they run the risk of having their strips canceled.

When Lynn Johnston started a sequence dealing with homosexuality, in March 1993, twenty newspapers canceled her strip. In her best-selling strip, **For Better or Worse**, Johnston had previously dealt with such subjects as child battering and anorexia, but newspaper editors, who seem to believe that the comic-reading public prefers cat gags, felt that this time she went too far. During the 1988 presidential elections, Cathy Guisewite did a series of strips dealing with the problems a working mother encountered in a Republican administration. These too were canceled by many papers. While Garry Trudeau can be — in fact is expected to be — outspoken in **Doonesbury**, editors apparently want women cartoonists to stick to jokes about families and yuppie "career girls."

Although the number of syndicated strips by women has risen from a low of about four in the early 1990s to about twenty in 2000, the subject matter tends to remain comparatively conservative for the above reasons, and a good many of the strips are still about families. Granted, however, that while **For Better or Worse**, which had its start in the 1970s, revolves around a nuclear family, today's family strips are about single, working mothers and non-traditional families and their creators are not afraid of the F word: Feminism.

One of the more creative syndicated strips is **Six Chix**. Six different women cartoonists: Isabella Bannerman, Margaret Shulock, Rina Piccolo, Ann Telnaes, Kathryn LeMieux, and Stephanie Piro, all share the same space on the comics page. In a comic strip version of job sharing,

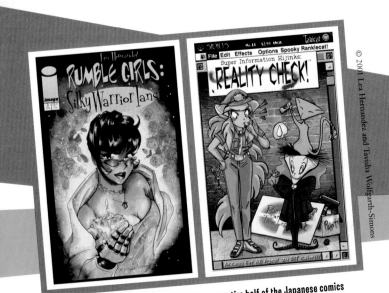

American Manga. In stark contrast to America, an entire half of the Japanese comics industry is devoted to shoujo manga, or comics for girls and young women. As a result, manga-style comics are increasingly popular among young American women. Two American women who draw in that style are: Lea Hernandez, RUMBLE GIRLS, and Tavisha Wolfgarth, REALITY CHECK, both 2001.

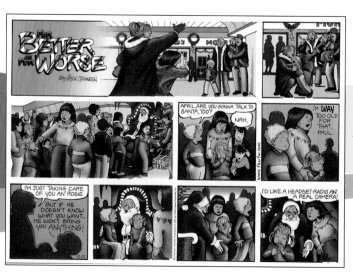

Lynn Johnston, FOR BETTER OR WORSE, 2001.

Cathy Guisewite, CATHY, 2000.

THE SIX CHIX: Stephanie Piro

Kathryn LeMieux

Ann Telnaes

Rina Piccolo

Margaret Shulock

Isabella Bannerman

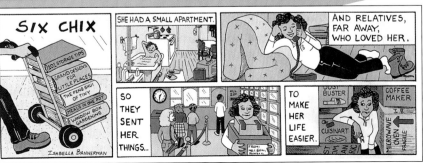

each cartoonist's strip appears one day a week and they take turns on Sundays.

An option that hardly existed thirty years ago is self-syndication. Self-syndicated cartoonists have the freedom to say what they want in their strips, and they get to keep their earnings. By the mid-1970s, the underground papers of the 1960s had evolved into something known as "the alternative weekly," a free tabloid, usually paid for by ads from local merchants. Most large American cities and college towns have at least one weekly newspaper. These papers are often given away in local bookstores and coffeehouses, attracting a more bohemian or intellectual readership than the average daily. Today even mainstream newspapers carry self-syndicated cartoonists, so the possibility finally exists of appearing in daily papers without having to work through a syndicate. Among the self-syndicated cartoonists are Lynda Barry, Nicole Hollander, Caryn Leschen, Nina Paley, Carol Lay, and Marian Henley.

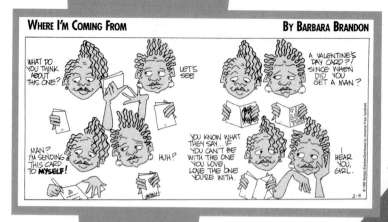

WHERE I'M COMING FROM — BY BARBARA BRANDON

Barbara Brandon, WHERE I'M COMING FROM. Brandon is still the only African-American woman since Jackie Ormes to draw a nationally syndicated strip.

Self-syndicated cartoonists have the freedom to say what they want in their strips

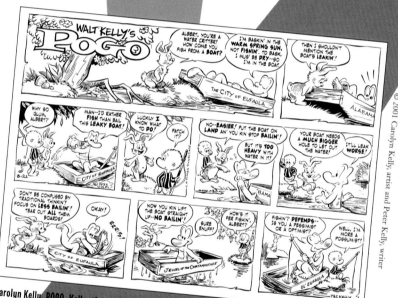

WALT KELLY'S POGO

Carolyn Kelly, POGO. Kelly, the daughter of POGO creator Walt Kelly, carried on her father's strip from 1992 to 1993.

Hilary Price, RHYMES WITH ORANGE, 2001. Price's own version of some famous superheroes.

Self-syndicated cartoonists: Lynda Barry, ERNIE POOK'S COMEEK, 2001.

Caryn Leschen, AUNT VIOLET'S TRAVEL TIPS, 2001.

Nicole Hollander, SYLVIA, 2001.

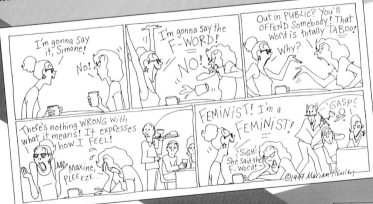

Mariane Henley, MAXINE, 2001.

Nina Paley, NINA'S ADVENTURES, 2001.

Carol Lay, STORY MINUTE, 2001.

© 2001 Lynda Barry

© 2001 Caryn Leschen

© 2001 Nicole Hollander

© 2001 Marian Henley; reprinted by permission of the artist.

© 2001 Nina Paley (www.ninapaley.com)

© 2001 Carol Lay

© 1985 Trina Robbins, artist and Tanith Lee, writer

Trina Robbins, from Tanith Lee's THE SILVER
METAL LOVER, 1985.

© 1996 Kathryn Hyatt

Kathryn Hyatt, from her graphic novel, MARILYN, 1996.

Another major drawback to newspaper strips is the size limitation. Newspapers today run their comic strips in a much smaller format than they did thirty years ago, and the result is there's no room for more than four panels at the most. Johnston and Brigman still manage to tell continued stories in **For Better or Worse** and **Brenda Starr**, and Lay's unique two-tiered layout allows her to tell entire stories, but most syndicated cartoonists have to be gag writers rather than storytellers. Cartoonists who want to tell stories still need the comic book format, and for women cartoonists who are storytellers and who want to reach an audience, the most promising option is the graphic novel.

Graphic novels are comics that are published in book form, with a spine and with far more than the usual thirty-two pages that make up a comic book. Although they've been around since the 1980s — I produced a graphic novel adaptation of fantasy writer Tanith Lee's **The Silver Metal Lover** in 1985 — they really proliferated during the 1990s, and now scores of women cartoonists publish their work in graphic novel format or collect their comic books into that format. Bookstores and libraries, which prefer not to carry flimsy comic books, are willing to carry graphic

novels. And the books sell so well that a January 2001 article in **Publishers Weekly** reports return rates for graphic novels from bookstores are extremely low. Return rates for graphic novels of the popular Japanese girls' comic, **Sailor Moon**, are less than 5 percent.

Interviewed in the **Ottawa Citizen**, Janet Hetherington explains why she compiled the best of her comic, **Eternal Romance**, into graphic novel form: "Girls don't go into comic book stores, so it wasn't being seen where they would buy it. On the shelf at Chapters (a local Ottawa bookstore), my book was going to get into the hands of women comic buyers."

Hetherington is right: Girls and women do read books, and do go into bookstores. Gallup poles from 1998, 1999, and 2000, report that women tend to read more books than men do and are heavy book buyers, buying seven or more books in a three month period. They are more likely to give a book as a gift then men and are more likely to be in a book discussion group. As for teenagers, a 1998 survey, co-sponsored by **Publishers Weekly** and BookExpo America, found that 25 percent of teenage girls read for fun versus just 9 percent of teenage boys.

Carla Speed McNeil, from her graphic novel, FINDER, 2000.

© 2000 Carla Speed McNeil

Lorna Miller, from her graphic novel collection, WITCH.

© 1999 Lorna Miller

Katherine Arnoldi, from her graphic novel, THE AMAZING "TRUE" STORY OF A TEENAGE SINGLE MOM, 1998.

© 1998 Katherine Arnoldi

...Malinál, the most beautiful woman in the Pueblo... Young, soulful and innocent.

© 2001 Laura Molina

Laura Molina, LA LLORENA, THE WEEPING WOMAN, from LEGENDS OF THE SOUTHWEST, a collection of illustrated historical events and legends from Chicano history, 2001.

© 1999 Miran Kim, creator and artist, and David Aaron Clark, creator and writer

Miran Kim, from THE FALLEN, a graphic novel by David Aaron Clark, 1999.

Colleen Doran's A DISTANT SOIL, 1997, in graphic novel form.

Jessica Abel's ARTBABE, collected into graphic novel form under the name MIRROR, WINDOW, 2000.

Some Xeric award winners:

Robyn Chapman, THEATER OF THE MEEK, 2000. Jen Sorenson, SLOW POKE COMIX, 1998. Leela Corman, QUEEN'S DAY, 1999.

Cover art © 1999 Christine Shields

Christine Shields, cover, TOP SHELF, a graphic novel anthology, 1999.

A panel discussion at the first Friends of Lulu conference – LULUCON – in 1997.
From left to right, Roberta Gregory, Mary Fleener, Jimmie Robinson.

Today meets yesterday at the 1998 LULUCON. The three standing women grouped around Guest of Honor Hilda Terry are (left to right) writer Rachel Pollack, Board of Directors member Naomi Basner, and cartoonist Leslie Sternberg. In 1949, Hilda Terry broke the gender barrier of the previously all-male National Cartoonists Society; in 1995, Leslie Sternbergh became one of the first women cartoonists to draw regularly for the previously all-male MAD MAGAZINE.

Today aspiring women cartoonists can turn to two organizations, neither of which existed ten years ago, for inspiration and concrete help:

The Xeric Foundation (www.xericfoundation.com) established by Peter Laird, co-creator of **The Teenage Mutant Ninja Turtles**, gives grants to those male and female cartoonists who are brave and hardy enough to attempt self-publishing their work. From 1992 to 2000, the foundation has awarded over $915,000 in grants to a list of cartoonists that includes over fourteen women. Among them: Christine Shields, Linda Medley, Jessica Abel, Fawn Gehweiler, Jen Sorensen, Leela Corman, and Megan Kelso.

Friends of Lulu (www.friends-lulu.org), named for Marge Henderson's spunky little girl comic character, is an organization formed to encourage participation in comics by women and girls, both as readers and as creators. The group formed in 1994, a time when women were all but invisible in mainstream comics and comic conventions. Today Friends of Lulu has a booth at most major comic conventions, and they also hold their own yearly conventions. In a male-dominated industry, where comics are aimed at and read by a mostly male audience, it should come as no surprise that most awards given out by the industry go to the guys. To balance this out, Friends of Lulu gives annual awards, The Lulus, to woman creators.

In 2001, Friends of Lulu produced a comics anthology in graphic novel form, showcasing girl-friendly and people-friendly work by its members. The book was funded by — what else? — the Xeric Foundation.

In the 1950s, a conservative society pushed women out of the comics industry, as they were pushed out of all traditionally male industries, and put them back in the kitchen. It took a good twenty years for them to emerge again, in greater numbers than ever before. A new conservative society may again try to take away the gains of women and minorities, and return America to the white, male-dominated world of the 1950s, but this time it won't work. Woman cartoonists, like women and people of color in all walks of life and all professions, are not about to go away. Our voices are being heard, and this time we won't be silenced.

Women Doing Comics

So many women are creating comics today that it was impossible to squeeze them into one or two chapters of this book. To make up for those I've had to leave out, I present the Women Doing Comics list, which can be found on the Friends of Lulu website (www.friends-lulu.org). The original list is international, and includes writers, editors, and publishers of comics. I have attempted to narrow it down to only English-language cartoonists.

List compiler Elayne Riggs warns that so many new women cartoonists emerge every day that this list becomes obsolete before it's even printed. To that I must add that the last chapter of this book is also obsolete before it has been printed.

And that's the way it ought to be.

Women Doing Comics

Jessica Abel, cartoonist, **Artbabe**

Marisa Acocella, writer/artist, **Just Who the Hell Is SHE, Anyway?**

Ann Tenna; cartoonist, **Ad Age**; **The New Yorker**

Peggy Adam, artist, **Comix 2000**; **Dieu est Cocu**

Dee Adams, cartoonist/writer/artist, **Minnie Pauz**

Leah Adezio, co-writer/inker, **Ari of Lemuria**

Maral Agnerian, artist/letterer, **The Will to Power**

Nami Akimoto, writer/artist, **Miracle Girls**

AM Alberts, cartoonist, **Half-Empty**

Deb Aoki, writer/artist, **Slice o' Life**

Joanne Applegate, cartoonist/illustrator

Katherine Arnoldi, writer/artist, **The Amazing True Story of a Teenage Single Mom**

Ros Asquith, cartoonist/illustrator, **Doris, Teenage Worrier**

Isabella Bannerman, cartoonist, **Girltalk**; **Pacifists in Bomber Jackets**; **Six Chix**

Donna Barr, cartoonist, **The Desert Peach**; **Stinz**; **Dignifying Science**

Lynda Barry, cartoonist, **Ernie Pook's Comeek**

Ruth Barshaw, cartoonist, **Keepsake Kids**; **Homework**

Suzanne Baumann, writer/artist, **Action Girl**; **Damned Bunnies**

Vero Beauprez, cartoonist, **Billy Sings the Blues**

Alison Bechdel, cartoonist, **Dykes to Watch Out For**

Gabrielle Bell, writer/artist, **Book of Sleep**

Julie Bell, cover artist

Sandra Bell-Lundy, cartoonist, **Between Friends**

Julie Bihn, writer/artist, **Mark and Jenny: Vigilantes**

Pam Bliss, writer/artist, **B-36**; **Phantom Airship**

Maria Björklund, artist, **Vacuum**; **Zone 5300**

Leslie Black, writer/artist, **Things Happen: A Fairy Tale**

Angela Bocage, cartoonist; editor, **Real Girl**

Linda Boileau, editorial cartoonist

Lynette Bondarchuck, cartoonist, **Errata**

Ariel Bordeaux, cartoonist, **Deep Girl**; **No Love Lost**

Paige Braddock, writer/artist, **Jane's World, Wendy Inc.**

Barbara Brandon, cartoonist, **Where I'm Coming From**

June Brigman, artist, **Brenda Starr**

Laetitia Brochier, artist, **Comix 2000**; **Hopital Brut**

Brenda Brown, cartoonist

Dawn Brown, writer/artist, **Little Red Hot**

Heather Brown, cartoonist, **Oggie**

M.K. Brown, cartoonist, **Aunt Mary's Kitchen**; **Twisted Sisters**

Elizabeth Bryan, artist, **Gremlin Trouble**

Bulbul, cartoonist

Sarah Byam, writer/artist, **Glyph**

Lucy Byatt, writer/artist, **Dykes Delight**

Jessicka Camilleri, writer/artist, **Living Dead Grrl**

Jennifer Camper, cartoonist, **SubGURLZ, Rude Girls and Dangerous Women**

Maritza Campos, writer/artist, **College Roomies from Hell!!!**

Estelle Carol, artist, Carol*Simpson Productions

Margaret Carspecken, cover artist, **Furrlough**; **Hit the Beach**

Linda Causey, cartoonist, **A Perfect World**

Sandra Chang, writer/artist/colorist, **Akemi**; writer/artist, **Sheedeva**

Silvia "A.D.R.I.A.N." Chang, writer/artist, **shoujo manga**

Robyn Chapman, writer/artist, **Theater of the Meek**

Kate Charlesworth, artist/writer/editor, **Dykes Delight**

Roz Chast, cartoonist/illustrator, **Oxygen.com**; **Childproof: Cartoons, Meet My Staff**

Joyce Chin, penciller, **Superman**; **Silver Banshee**; **Xena**

Svetlana Chmokova, writer/artist, **Yoriko: Maiden of the First Fire**

Madison Clell, writer/artist/publisher, **Cuckoo**

Chynna Clugston-Major, writer/artist, **Action Girl**; **Blue Monday**

Judge Cohen, writer/artist, **See Jane Draw**

Julie Collins, writer/artist, **Chronicle**

Amanda Conner, artist, **Gatecrasher**; **Vampirella**; cover artist, **Soulsearchers & Co.**

Danielle E. Corsetto, cartoonist, **Larry & Caroline**

Cindy Crowell, artist, **Filthy Animals**; **Furrlough**

PJ Daniel, cartoonist, **Virago Justice**

Dame Darcy, cartoonist/illustrator, **Meatcake**

Ann Decker, writer/artist, **Girltalk**

Jacqueline "Jacky" de Gruyter, cartoonist/illustrator

Margreet de Heer, writer/artist, **How To Get Over Your Ex**

Jeremy Dennis, cartoonist, **Rent, 3inaBed**

Abby Denson, writer/artist, **Tough Love**; writer, **Powerpuff Girls**

Jerra Denny, cartoonist, **The Pride**

Laura Depuy, colorist, **StormWatch**; **Planetary**

Isabelle Dethan, cartoonist, **Le Roi Cyclope**

Shavaun Devlin, cartoonist, **Deviltoons**

Susan Dewar, writer/artist, **Us & Them**

Diane DiMassa, cartoonist, **Hothead Paisan**

Catherine Doherty, writer/artist, **Can of Worms**; **Sister Grim**

Liza Donnelly, cartoonist, **Oxygen.com**; **The New Yorker**

Colleen Doran, writer/artist, **A Distant Soil**; artist, **Wonder Woman: The Once and Future Story**; **Power Pack**; **X-Men Annual**

Julie Doucet, cartoonist, **Dirty Plotte**; **The New York Diary**

Debbie Drechsler, cartoonist, **Nowhere**; **Daddy's Girl**

Kris Dresen, writer/artist, **Manya**

Denise Drsata-Peters, artist, **Forty Winks**

Meaghan Dunn, writer/artist, **Action Girl**

Jan Duursema, artist, **Star Wars**; **Tangent: Night Wing**; **Martian Manhunter**

Janee Duval, illustrator

Sarah Dyer, editor, writer/artist, **Action Girl**; colorist, **Amy Racecar Special**

Wendy Eastwood, cartoonist

Pam Eklund, artist, **Sonic the Hedgehog**

Jan Eliot, writer/artist, **Stone Soup**

Benita Epstein, cartoonist

Camilla "Millan" Eriksson, cartoonist

Liz Evans, cartoonist, **Elsinore**

Leslie Ewing, cartoonist

Marianne Eygendaal, artist, **Zone 5300**; **Barwoel**

Ann Reinertsen Farrell, illustrator

Karen Favreau, cartoonist

Jennifer Finch, artist, **Adventures of a Lesbian Schoolgirl**

Mary Fleener, cartoonist/illustrator, **Fleener**; **Life of the Party**; **Dignifying Science**

Ellen Forney, cartoonist/illustrator, **Oxygen.com**; **Tomato**; **I Was 7 in '75**

Ramona Fradon, artist, **Brenda Starr**; **Dignifying Science**

Leanne Franson, writer/artist, **Assume Nothing**; **Teaching Through Trauma**

Renee French, cartoonist, **The 10th Gland**; **GritBath**; **Corny's Fetish**

Lena Furberg, writer/artist, **Totally Horses**

Ann Fujita, writer/artist, **Sky Angel**

Ursula Fürst, artist, **Ballad of the Typhoid Mary**; **Comix 2000**

Bonnie Gardiner, writer/artist, **Attention Shoppers!**

Allison Garwood, cartoonist, **Big Al Cartoons**

Melinda Gebbie, artist, **Lost Girls**; **Cobweb** (Tomorrow Stories)

Fawn Gehweiler, cartoonist, **Bomb Pop**

Francesca Ghermandi, writer/artist, **Rubber Blanket**; **Pastil the Tablit Girl**; **Flock of Dreamers**

Anne Gibbons, cartoonist

Roz Gibson, writer/artist, **Furrlough**; **Genus**

Che Gilson, writer/artist, **Action Girl**

Stephanie Gladden, writer/artist, **Hopster's Tracks**; artist, **The Simpsons**; **Dignifying Science**; **Powerpuff Girls**

Phoebe Gloeckner, cartoonist/illustrator, **Oxygen.com**; **A Child's Life**

Carrie Golus, writer/artist, **Alternator: Grand Junction**; **Alternator: Eight Stories**

Raquel Gompy, writer/artist, **Nerd**; **Generation What?**

Jennifer Gonzalez, writer; cartoonist, **Kronikle Komix**

Nikki Gosch, cartoonist/illustrator

Tygger Graf, creator/co-writer/artist, **Guardian Knights**

Diana Green, writer/artist, **Gay Comics**; **Tranny Towers**

Jenni Gregory, writer/artist, **Dreamwalker**; **Abby's Menagerie**

Roberta Gregory, cartoonist, **Naughty Bits**; **Winging It**; **Dignifying Science**

Cynthia Griffith, illustrator

Louise Gringas, artist, **Ginger Comics**

Grizelda Grizlingham, cartoonist, **Dyke's Delight**

Rhoda Grossman, cartoonist

Rebecca Guay, artist, **The Dreaming**; **Veils**

Cathy Guisewite, cartoonist, **Cathy**

Pia Guerra, writer/artist, **Slip**

Andrea Haid, writer/artist, **Espionage Velocity Express Blue**

Lurene Haines, writer/artist; author, **The Business Of Comics**; **A Writer's Guide To The Business Of Comics**

Corinne Hall, artist, **The Other**; Creative VP/Art Director, Winter Arcane Press

Merritt Hammett, cartoonist, **Popcorn**

Natalie "Naah!" Hanssen, cartoonist/illustrator

Donna Hardy, cartoonist

Maaike Hartjes, writer/artist, **Maaike's Little Diary**

Rachel Hartman, writer/artist, **Amy Unbounded**

Marian Henley, writer/artist, **Maxine**

Inge "ILAH" Heremans, cartoonist

Lea Hernandez, writer/artist, **Cathedral Child**; **Clockwork Angels**; artist, **Dignifying Science**

Lisa Herschbach, editorial cartoonist; writer/artist, **Frost Byte**

Janet Hetherington, writer/artist, **Eternal Romance**

Cathy Hill, writer/artist, **Mad Raccoons**

Joan Hilty, cartoonist, editor, Cartoon Network books, DC Comics

Caroline Holden, cartoonist/illustrator; **The Secret Diary of John Major**; **Adrian Mole** books

Nicole Hollander, cartoonist, **Sylvia**

Stacy Holmstedt, writer/artist, **Cluebomb**; **Generation Hexed**

Judy Horacek, writer/artist, **Life on the Edge**

Shannon "Sheedy" Horgan, writer/artist, **Raver Lovestory**

Tanya Horie, colorist, **Aquaman**; **Superman**

Constance Houck, writer/artist, **Con-Toons**

Etta Hulme, editorial cartoonist

Kathryn Hyatt, writer/artist, **Marilyn: The Story of a Woman**

Holly Irvine, writer/artist, **Ozone Patrol**

Cath Jackson, cartoonist

Caroline Jaegy, artist, **Polystyrene**; **Comix 2000**

Nami Jarrett, writer/artist, **Furrlough**

Lynn Johnston, cartoonist, **For Better or Worse**

G.B. Jones, writer/artist, **JDs**; **Tattoo Girls**

Jeffrey Jones, artist/writer

Sabrina Jones, cartoonist; editor, **Girltalk**

Lisa Jonté, artist/writer, **Tatterhood & Gyda**

Myriam Kalaï, cartoonist/illustrator

Karin Kaltofen, cartoonist, **Off the Beaten Path**

Fiona Katauskas, cartoonist/illustrator

Megan Kelso, cartoonist, **Girl Hero**; **Queen of the Black Black**

Carol Kemp, cartoonist, **Horrorscope**

Molly Kiely, cartoonist, **Saucy Li'l Tart**

Miran Kim, cover artist/illustrator, **X-Files**; **Heartthrobs**; **The Fallen**

Corey Marie Kitley, writer/artist, **Sit and Spin**

Christine Kloss, fantasy artist/cartoonist

Jennifer Kolanek, writer/artist, **Run Amuck**

Aline Kominsky-Crumb, cartoonist, **Twisted Sisters**; **Love That Bunch**

Chryslynne Korolenchuk, artist, **A Day in the Life**

Katrin Kremmler, writer/artist, **Dykes on Dykes**

Krystine Kryttre, writer/artist, **Twisted Sisters**; **Comix 2000**

Lisa Kuprijanow, cartoonist, **The Panda and Dog Funnies**

Michèle Laframboise, cartoonist, **Duk-Prah**; **The Job Hunter**

Daphne Lage, artist, **Tall Tails**; artist/writer, **Furrlough**

Stephanie Lantry, artist/colorist, **Midnight Cross**

Julie Larsen, writer/artist, **The Dinette Set**

Miss Lasko-Gross, writer/artist, **Aim**

Eela "xtine" Lavin, artist, **Heartbreakers Superdigest Year Ten**; **Action Girl**

Mary Lawton, cartoonist

Carol Lay, cartoonist/illustrator, **Story Minute**

Elaine Lee, artist/writer, **Vamps**; **Brainbanx**, other titles

Patty Leidy, artist/writer, **Zero Hour**; **Action Girl**

Kathryn LeMieux, cartoonist, **Miss Adventures**; **Six Chix**

Caryn Leschen, cartoonist, **Ask Aunt Violet**

Michele Light, penciller, **Shanda the Panda**

Michelle Lloyd, writer/artist, **Spike Punk Dyke Comics**

Katy Llwellyn, colorist, **Walt Disney's Comics & Stories**

Jennifer Lopez, cartoonist, **Biz Toons**

Alexandra Lynn, writer/artist, **Winter Arcane Press**

Claire Lytle, editing consultant/assistant artist, **dizABLED**

Melissa MacAlpin, writer/artist, **Action Girl**

Monique MacNaughton, writer/artist, **Arrowflight**

Gail Machlis, cartoonist, **Quality Time**

Helen Maier, writer/artist, **Twin Gods of Maya**

Lee Marrs, cartoonist; writer, **Faultlines**; **Heartbreakers Superdigest Year Ten**

Brenda Marshall, cartoonist, **The Ponderous Woman**

Pauline Martin, artist, **Comix 2000**; **Strips**

Alitha Martinez, penciller, **Iron Man**; **Black Panther**

Angela Martini, illustrator, **Katbot**

Marci McAdam, artist, **Furrlough**

Heather McAdams, cartoonist, **Cartoon Girl**

Cinders McLeod, cartoonist, **Broomie Law**

Carla Speed McNeil, writer/artist, **Finder**; artist, **Dignifying Science**

Linda Medley, writer/artist, **Castle Waiting**; artist, **Books of Fairie**; **Dignifying Science**; colorist, **Batman Adventures**

Lorna Miller, writer/artist, **Witch**

Mary Minch, cartoonist, **Mice Comics**

Natasha Mleynek, writer/artist, **Genus**

Yvonne Mojica, writer/artist, **Bathroom Girls**; **The Adventures of Cybergrrl**

Cynthia Morrow, penciller, **Powerpuff Girls**

Amy Moore, cartoonist, **Tales from Band Camp**; **Tikaboo Peak**

Vicki Morgan-Keith, writer/artist, **Ernor**

Susan Moshynski, editorial cartoonist

Lillian Mousli, writer/artist, **Stray Cats**; **Teufel**; **The Gruesome Alphabet**

Andrea Natalie, cartoonist, **Stonewall Riots**; **Dyke's Delight**

Keiko Nishi, writer/artist, Promise; **Love Song**

Yuriko Nishiyama, writer/artist, **Harlem Beat**

Teresa Nielsen, cover artist, **Xena**

Nitrozac, co-writer/artist, **After Y2K**; **The Joy of Tech**

Talitha Nonveiller, creator/writer/artist/publisher, **Tale-Trader: The Legend of Twarin**; **The DeerFlame Legacy**

Diane Noomin, cartoonist; editor, **Twisted Sisters**

Phyllis Novin, artist, **Battlebooks: Rogue**; **Battlebooks: Storm**; inker, **Batman Chronicles**

Elaine Oldham, writer/artist, **Minstrel Fair**

Julie Pace, cartoonist, **It's Slow Going**

Nina Paley, cartoonist, **Nina's Adventures**; **Fluff**

Gunborg Palme, cartoonist, **On the Psychologist's Couch**

Sara Palmer, writer/artist, **Furrlough**; **Genus**

Deb Parker, cartoonist

Leslee T. Parker, cartoonist, editor; **Action Girl**; **Tug & Buster**

Corinne Pearlman, cartoonist

Deborah Peyton, cartoonist, **Day to Day**

Rina Piccolo, artist/writer, **Piccolo**; **Six Chix**

Wendy Pini, writer/artist/co-publisher, **Elfquest**

Stephanie Piro, writer/artist, **Fair Game**; **Six Chix**

Kirsten Peterson, artist, **WJHC**

Karen Platt, writer/artist, **Dykes Delight**

Sallie Posniak, writer/artist, **Out of the Mouths of Babies**

Hilary B. Price, cartoonist, **Rhymes with Orange**

Cindy Procious, editorial cartoonist

Julie Bini Quinn, artist/writer, **BiniPeople**

Erika Raven, writer/artist, **Thomas Rindt**

Jasmine Redford, creator/writer/penciller, **Cha-Sheets**; publisher, **Clover Comix**

Robin Reed, cartoonist, **The Imp**

Libby Reid, writer/artist, **Do you hate your hips more than nuclear war?**

Shannon Reinbold-Gee, CEO, Rebuking Ockham's Razor, Inc., creator/writer/artist, **War Dogs and Glory Hounds**

Dianne Reum, writer/artist, **Oh...**

Sandrine Revel, artist, **Un drôle d'ange gardien**

Ingrid Rice, cartoonist

Carolyn Ridsdale, writer/artist, **Moist**; **Fishhead**

Trina Robbins, cartoonist; author, **From Girls to Grrlz**; **A Century of Women Cartoonists**; writer, **Go Girl!** ; **Wonder Woman: The Once and Future Story**

Victoria Roberts, cartoonist/illustrator, **Oxygen.com**; **This Is Your Day: But Everybody Has an Opinion**

Hungla Rodriguez, penciller, **Red Krewe**

Helga Romoser, cartoonist/illustrator

Agnes "Aro" Roothaan, writer/artist, **Levenslessen**

Sharon Rudahl, cartoonist

Allison Rushby, cartoonist

Shea Ryan, writer/artist, **Totally Horses**; **Boulder Rocks!**

Chiho Saito, writer/artist, **Girls' Revolution Utena**

Katrin L. Salyers, artist, **Waiting For Bob**; **Broken By Design**

Diana Sassé-Kopetzky, writer/artist, **Loan, Frenchie Doudou**

Daniela Scarpa, cartoonist

Mari Schaal, writer/artist, **Action Girl**; **Estrus**

Olivia Schanzer, writer/artist, **Fragile Honeymoon**

Maria Schneider, cartoonist/editor, **Pathetic Geek Stories**

Ariel Schrag, writer/artist, **Awkward**; **Definition**; **Potential**

Carol Seatory, writer/artist, **Big Girl's Blouse**; **Action Girl**

Marie Severin, artist, **Dignifying Science**; colorist, **Superman Adventures**

Kathy Shaskan, cartoonist, **Blossom Fuller**

Christine Shields, cartoonist, **Blue Hole**; **High Sea Hijinks**

Emiko Shimoda, cartoonist/illustrator, **Ultra Minor**

Margaret Shulock, cartoonist, **Six Chix**

Natacha Sicaud, writer/artist, **Cafè Creed**; **Lapis-Lazuli**; **Mixer**; **Comix 2000**

Julie Sigwart, cartoonist, **Geeks**

Yvette Silver, cartoonist

Posy Simmonds, cartoonist, **Gemma Bovary**

Barbara Slate, cartoonist/writer, **Betty and other Archie titles**

Brigitte Sleiertin, writer/artist/co-publisher, **Totally Horses**

Terrie Smith, artist, **Havoc, Inc.**; **Furrlough**; **Genus**

Fiona Smythe, cartoonist/illustrator, **Twisted Sisters**; **Errata**

Jen Sorensen, cartoonist, **Slowpoke Comics**; **Action Girl**; **Dignifying Science**

Diana X. Sprinkle, writer/artist, **Saiko and Lavender**; **Furrlough**; **Mangaphile**

Elena Steier, writer/artist, **Vampire Bed and Breakfast**

Leslie Sternbergh, cartoonist/illustrator, **Twisted Sisters**

Noreen Stevens, cartoonist

Carol "caz" Stokes, cartoonist, **Punch**; **Oldie**

Wendi Strang-Frost, artist, **Elfquest**

Betsy Streeter, cartoonist

Kellie Strom, cartoonist

Lisa "Mouse" Strouss, cartoonist, **Girl with Glasses**

Kiel Stuart, cartoonist

Chris Suddick, cartoonist

Tara Tallan, writer/artist, **Galaxion**

Diana Tamblyn, artist, **Gunslingers**; **Tequila with Lime**

Kate Taylor, cartoonist/illustrator

Ann Telnaes, editorial cartoonist, **Oxygen.com**; **Six Chix**

Annie Tempest, cartoonist/illustrator, **Tottering-By Gently**

Jill Thompson, writer/artist, **Scary Godmother**; artist, **Finals**

Anne Timmons, artist, **Go Girl!**; **Wild Person in the Woods**; **Dignifying Science**

Bonnie Timmons, illustrator (ghost cartoonist for **Caroline in the City**)

Christine Tripp, cartoonist

Charla Trotman, writer/artist, **Furrlough**

Marie Tucker, writer/inker, **Lunar Donut**

Carol Tyler, cartoonist, **The Job Thing**; **Twisted Sisters**; **Drawn & Quarterly**

Jackie Urbanovic, cartoonist, **Maggie Inc.**

Marguerite Van Cook, artist, **7 Miles A Second**; **Heartthrobs**

Penny Van Horn, cartoonist, **Twisted Sisters**; **Recipe for Disaster**

Christina A. Varela, cartoonist

Debbie Vasquez, writer/artist, **Cookie**

Marj Vetter, cartoonist

Petra Waldon, writer/artist, **Adventures of a Lesbian Schoolgirl**

Kimberly Warp, writer/artist, **Warp Cartoons**

Elizabeth Watasin, writer/artist, **Action Girl**; **A-Girl**

Kathleen Webb, writer/penciller, **Archie** titles

Lauren Weinstein, cartoonist, **Ha!** at **gURL.com**; **Notes from Vineyland**

Diane Wells, cartoonist, **Virtually Yours**

Chris Whalen, artist, **Furrlough**

Signe Wilkinson, editorial cartoonist, **Oxygen.com**; author, **Abortion Cartoons on Demand**

Alison Williams, writer/artist, **The Sorcerer's Children**

Kathryn Williams, founder/art director, Kat & Neko Manga; writer/artist, **A Shadowlander's Dream**

Mary Wilshire, cartoonist/illustrator

Tavisha Wolfgarth, artist, **Reality Check**

Mia Wolff, artist, **Bread and Wine**

Teri Sue Wood, writer/artist, **Wandering Star**; **Darklight Prelude**

Marie Woolf, cartoonist, **MIMI**

Sue Wright, cartoonist

Kellilla Yarwood, writer/artist, **Sundowner**

Index